FOREWORD

Stik

It was only to be a matter of time before I was to meet Claude. He is out in all weathers, all year round and is invariably first on the scene whenever anything new arrives. He has quickly become known as a source of street art information and images. Back when I was still using a plastic disposable camera he provided me with quality photographs of my street work and we still collaborate regularly. He often meets with the artists themselves, and I happen to know that he has even made some of his own street art!

Claude goes to great lengths to capture even the most fleeting of artworks before they are defaced, destroyed by the weather or white-washed by the council. I have seen him crawling through the gutter or teetering up a step ladder, just to get that perfect shot. Perhaps it is because he used to be a birdwatcher that Claude likes to get as close to his subjects as possible. His archive is an intensive study of the minutiae of this microcosm and he takes great pleasure in sharing it.

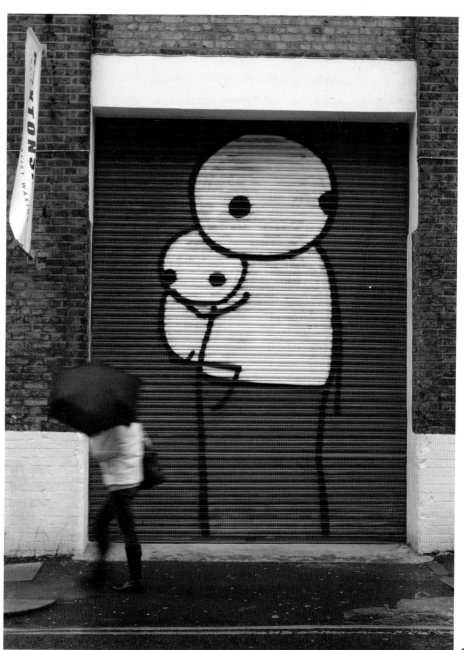

INTRODUCTION

ClaudeLondon

Modern day graffiti started on the East Coast of the USA in the late sixties. Essentially, graffiti is the act of writing your chosen nickname on a wall, and it has its characteristic texts and styles. The perpetrators, the graffiti artists, are called 'writers'. Theirs is quite a closed community; they write primarily to compete with each other and care little what the public thinks about their work. Street art is a descendant of graffiti.

Although street artists might exhibit their work indoors too, street art is essentially unsanctioned art in the street, usually put there by the artist on his or her own initiative. Street art is as illegal as graffiti, but people object to it less because it is usually made more with the public in mind; it's created to provoke a reaction, to protest, to make you think or laugh or to brighten up the street. Unlike graffiti, street art is usually figurative, and the location for a piece is often very carefully chosen, so that it might become a natural part of its environment.

Ernest Pignon, whose work dates back as far as 1966, and Blek le Rat, both French, were the early pioneers of street art. They were followed by figures like Keith Haring and Jean-Michel Basquiat, before a whole new generation appeared on the scene in the nineties, the most well-known among them being Shepard Fairey and Banksy.

Street art can be found in any large city, although New York, London, Paris, Berlin, Sao Paolo and Melbourne are probably the best-known hotspots. You'll most likely find it in the more rundown areas of a city, where the artists are able to rent affordable studios, where the city authorities are less likely to clean up the walls on a regular basis and where, in time, the new and hip galleries begin to appear. Look too in any other cool and hip areas of a city, where street art might actually be appreciated. In London, you would look first – as I did – in Shoreditch, Spitalfields and Hackney Wick.

I moved from the Netherlands to Shoreditch, East London, in 2008. In Amsterdam I was a freelance studio photographer, specialising in taking photos of works of fine art for museums, galleries, magazines, etc. In my new London location I found myself surrounded by great and crazy art out in the open. Realising that street art had a very short lifespan I immediately bought a digital camera, my first, and fanatically started documenting everything I could find, because these stencilled pieces, paste-ups, stickers and sculptures are often torn from the wall, defaced or vandalised within days or even hours. Before I knew it I was out there taking photos at least every other day, trying to capture it all.

I am something of an exception among the street art photographers. I don't come from the world of graffiti, breakdancing and hip-hop. I have a different background. When I was a kid there was no graffiti around; I have never been on a skateboard, never tried breakdancing and don't even like hip-hop. But I changed my workspace from museums and galleries to the street. This background also explains my choice of material for the book. I have no affinity with graffiti, and have therefore ignored it. You might also notice that there are few photos of pieces done in freehand spray painting, or any style that I would call 'graffiti-style street art'. I don't have anything against that kind of art; it just doesn't particularly appeal to me. I haven't attempted to give a representative picture of the London street art scene; instead, I have selected my favourite images for the book, with a strong emphasis on the new generation of artists. I haven't ignored the big names like Banksy and Eine, but I hope you'll find many great pieces here by people you haven't heard of yet.

When I started taking photographs of street art, I concentrated on my own new neighbourhood. Soon, however, I began looking for pieces in other areas of London as well, only to find I was right in the heart of the action all along. Outside of East London the pieces are few and far apart, so, whilst there are photos from other parts of London included in the book, most of the images here are from Shoreditch and, to a lesser extent, Hackney Wick.

That does not mean this book is a local affair. East London is one of the centres in the world when it comes to street art. Artists from all over the globe come to work here. In this book you will find images by artists who are from – or live in – more than 25 countries, and from six continents. Some of the artists who arrive in East London stay, finding a day job or going to university or art school; some struggle to survive; others live off their work.

The street art world is ever changing, just like the city itself. East London is gentrifying at a fast pace, walls are becoming harder to find and pieces get painted over more rapidly as the competition intensifies. You might go to check out a popular wall where you photographed some great pieces just yesterday, only to find that the work (or the wall) has been torn down completely.

Today, street art has become very popular, even in the mainstream. It is not uncommon to bump into at least four different street art tour groups in East London on any Saturday afternoon.

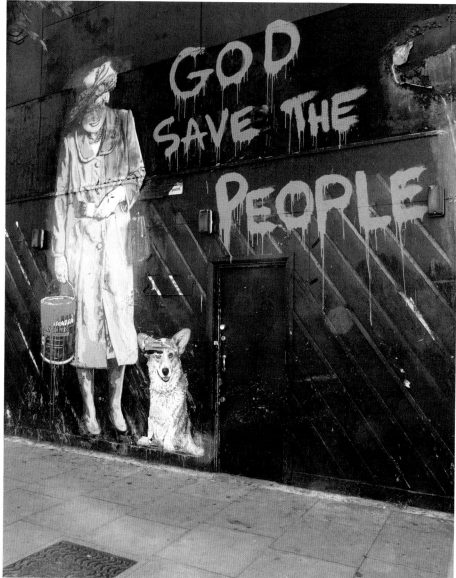

above: Mr. Brainwash
left: Tony Trowbridge

3x3x3

www.flickr.com/photos/x333x

3x3x3 is one of the few street artists who use sculpture in their work, as he explains on his flickr page: "Blocks of cement containing embedded stuff, made using moulds (silicone, wood, card). The cement is mixed with aggregates collected from various sources around the world, and found objects are embedded into the surface (glass beads, river-worn pebbles, quartz crystal, stones, marble from Italy, amethyst, clock mechanisms, etc)."

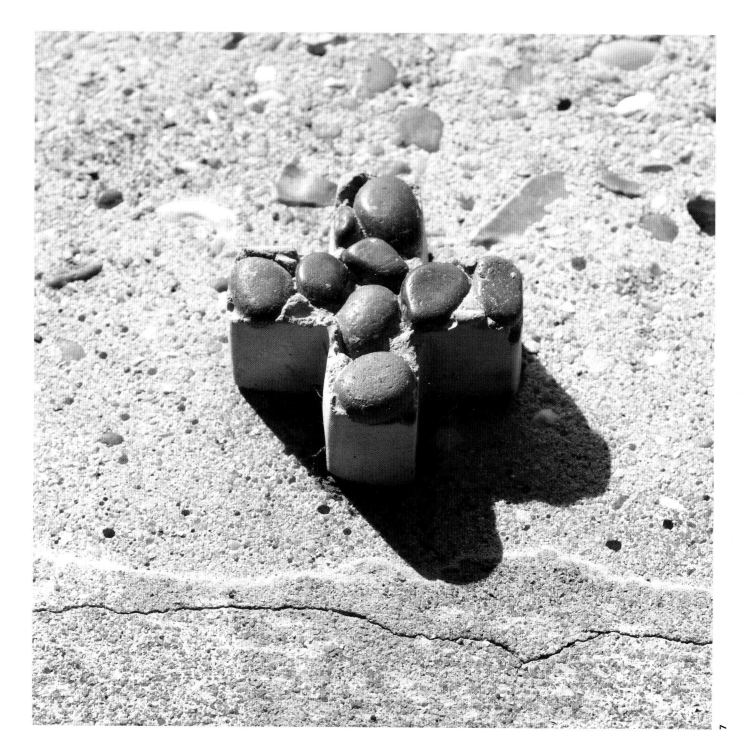

"To be honest I am just an average person," explains 6/6. "I have always loved art and as long as it creates a reaction out of someone, I am happy with the result I wish to create. I certainly need to take some lessons in art, but I am enjoying the journey. Basically, at weekends I go round sticking up stuff I made in the week. Personally for me it is just fun; better than smoking crack and thinking I'm a gangster. It's an Essex thing."

His pieces started to appear in early 2012 and soon they were everywhere; leaf-shaped paste-ups with eyes, decorated heads, maggot-like painted pistachio shells and coconut shells, to name a few. It's completely original work from somebody who considers himself to be just a hobbyist. I don't think he should take lessons in art.

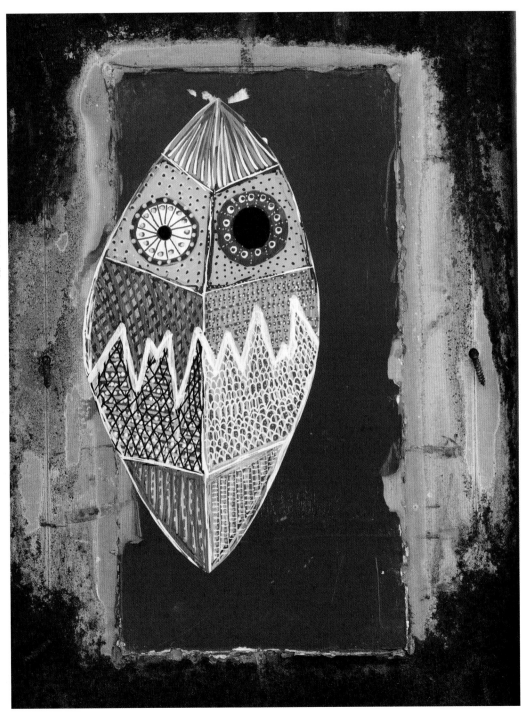

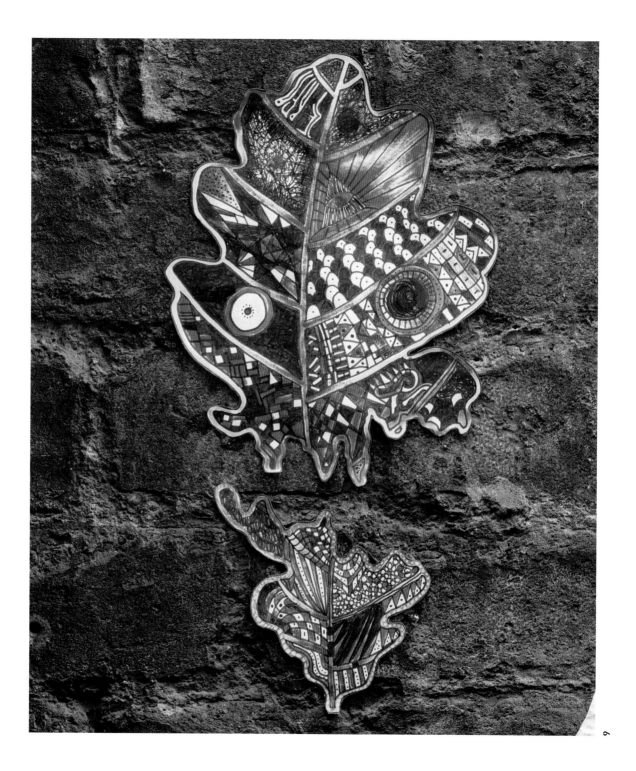

6/6

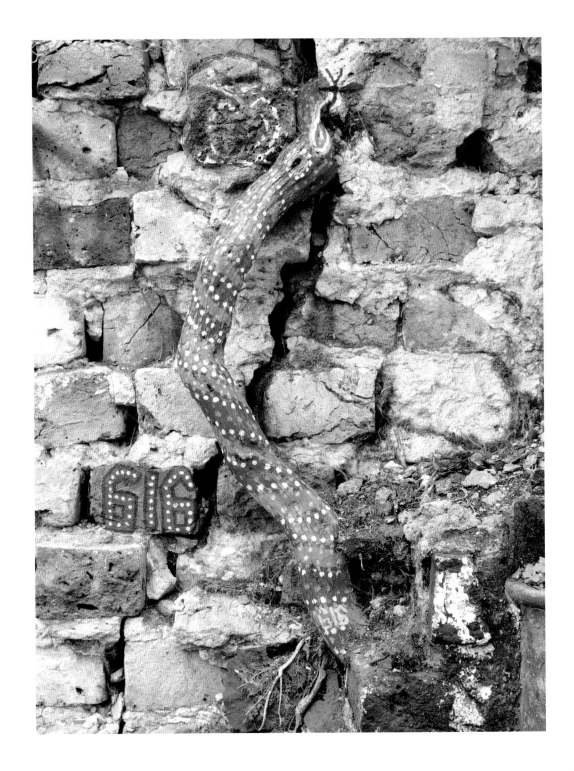

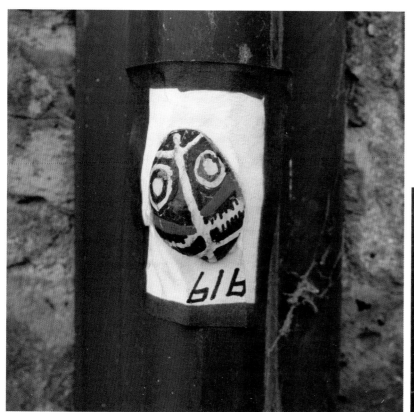

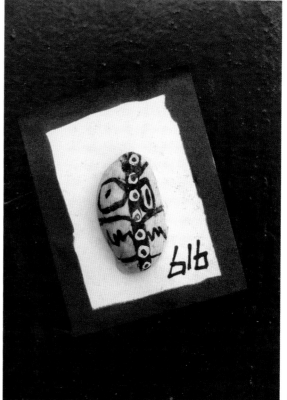

CLET ABRAHAM

www.turismo.intoscana.it/allthingstuscany/
tuscanyarts/street-signs-clet/

Clet Abraham hopes to make us think
about the organisation of our common
space. He feels that signs are dominating
the streets unnecessarily; that they reflect
a culture of avoiding responsibility and
that they are of an invading aesthetic. He
wants us to consider these things and to
make us smile at the same time.

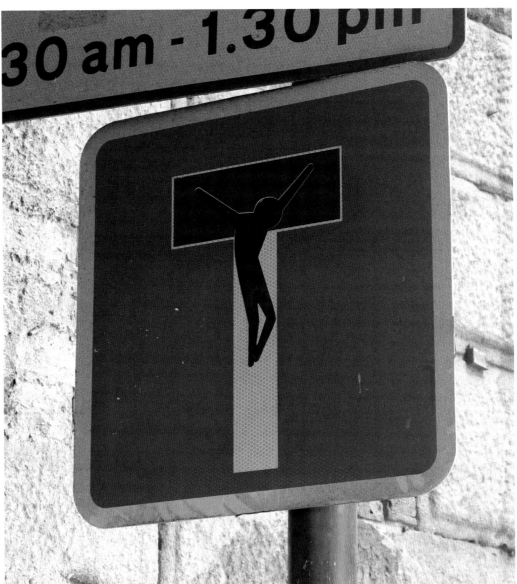

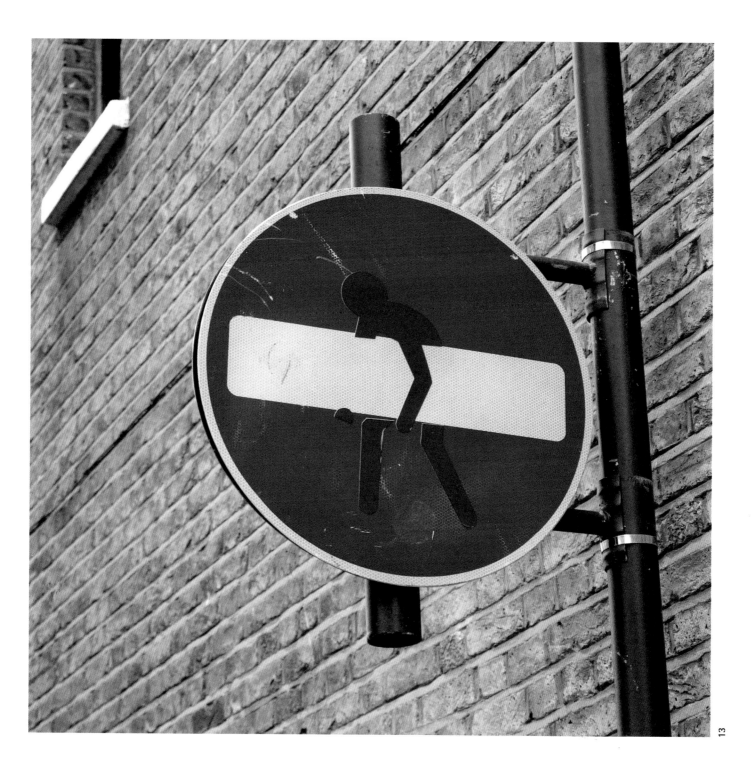

13

A.CE

As a kid A.CE was a fanatical skateboarder ("Skateboarding defined me," he says). Stickers and skate graphics were a part of his world, and one thing led to another. Like most pop artists, he likes to take existing images out of their context and to play with them. London is his big inspiration.

JEF AÉROSOL

www.flickr.com/photos/jefaerosol

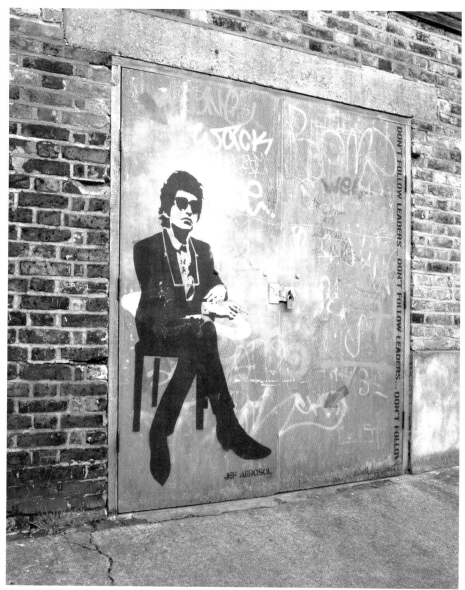

At the time of writing, the photo of Jef Aérosol's Bob Dylan stencil from December 2009, is still the most viewed picture on my website. Thanks very much all you Dylan fans! This stencil artist from Lille, France, has been at work since the early eighties. He usually depicts either the very famous or the completely nameless. There is a beautiful video of him doing a paste-up on the Great Wall of China (http://vimeo.com/8670810).

AIDA

http://aidaprints.com/

Aida came to London as a political
refugee in the eighties, and now teaches
surface design at the London College
of Communication. A silkscreen printer
and consultant, she recently made a
film about the development and role
of screen-printing in the digital world.

ALICÈ

www.alicepasquini.com

AliCè is from Rome. She studied Fine Arts, both there and in London, a city that she finds more open to artistic movements and lacking in prejudice than her hometown. There is a lot of affection and tenderness in her work, which isn't controversial or anti-authoritarian, but is about people, passion and relationships; and note that when she paints a kissing couple, it's usually the girl kissing the guy, not the other way around. AliCè also works as a set designer, illustrator and painter. Wherever you see one of her pieces, you might also find one by C215 (see p44) close by.

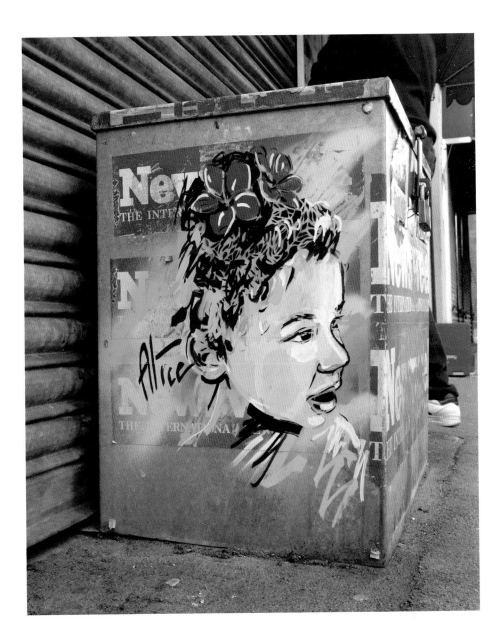

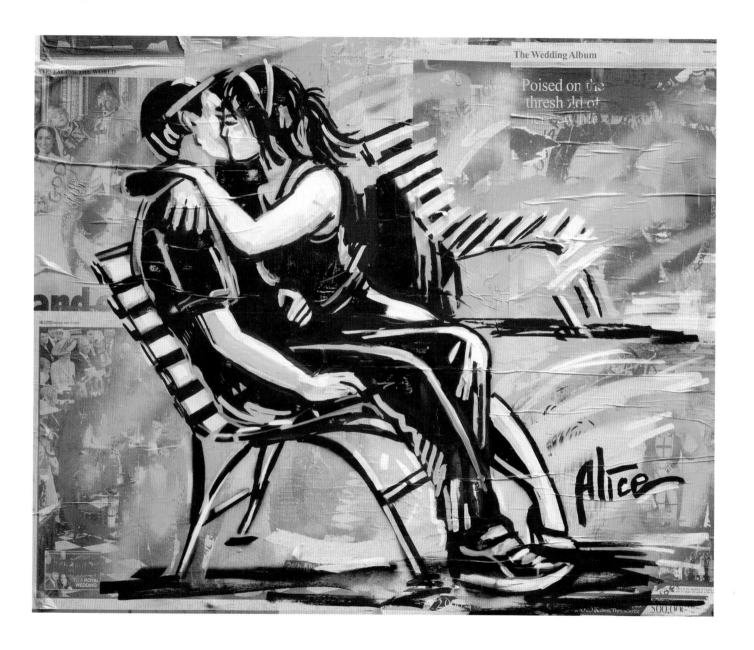

ANGRYFACE

Angryface used to call himself 'Smells like Vomit'. My colleague, street art photographer Deborah, from the photography duo Cocabeenslinky and Surreyblonde, was very happy he changed his name. "I couldn't type something like that!" she said, and instead was crediting his pieces as SLV. Angryface is fine with her; I prefer that name too.

ARTISTHECURE

www.artisthecure.com

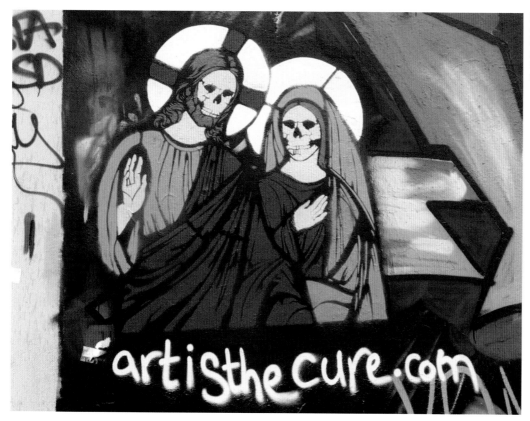

I don't know the name of the maker of this great piece, but I do know that he or she is supporting the movement Artisthecure, an organisation promoting the idea that art can be a good way to treat mental illness.

ASBESTOS

www.theartofasbestos.com

Asbestos, from Ireland, explained the origins of his name to Artasty: "Street art is a little bit like Asbestos. Asbestos is all around us (in the walls and in the fabric of many buildings), but it often goes unnoticed. When we realise that it's there it really gets our attention, it gets under our skin and we question it, it gets discussed. When I started putting work on the streets that's what I wanted my work to do, to become part of the fabric of the city and to cause a reaction that makes people aware of their environment. So, hence the name Asbestos."

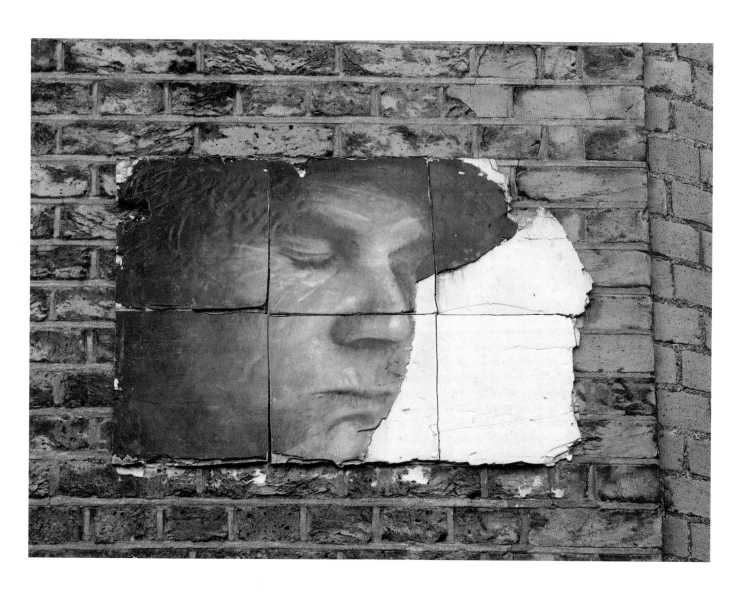

TEDDY BADEN

www.teddybaden.co.uk

I have such a strong dislike of dogs that when I started to take photos of street art, I ignored Teddy Baden's work. Happily, I soon realised that was a bit silly. I still wish he would switch to cats, but of course he never will. Teddy doesn't only paint, he is also very involved in Mutate Britain, The Whitecross Street Party and the Robin Hood Tax Campaign.

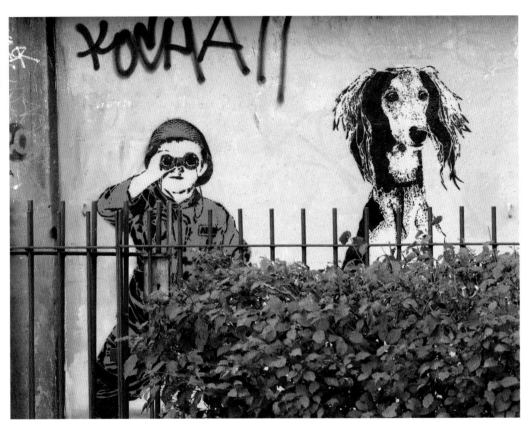

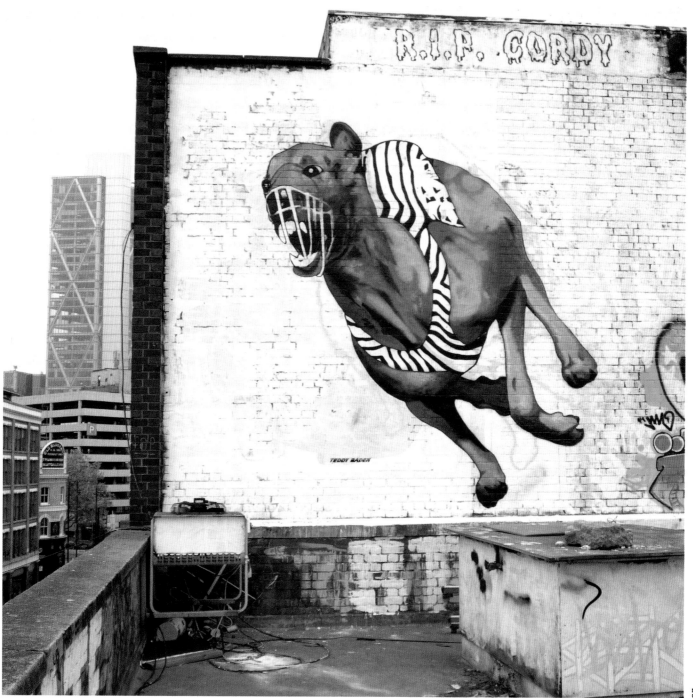

BANKSY

www.banksy.co.uk

After I finished taking some photos of a new piece by T.wat, off Brick Lane, I was approached by a man in a black hoodie who asked me if I was into taking photos of street art. I told him I was. He explained that he was a street artist himself, and that if I wanted I could go with him one night. I could take pictures of him while he put up his stencils. "Could be interesting," I responded. He mentioned that it was "gonna cost me a thousand quid," but that I could sell the shots to the newspapers and make a lot of money, of course. Of course! I must have looked puzzled, but he was quick to explain: "You know, I'm Banksy, that's why I wear this hood." I told him I was sorry, that I didn't have that kind of money and he disappeared into the crowd. Later, I recounted the story and described the guy to somebody who knows Banksy, and, indeed, it was another fake Banksy! Meanwhile, the real Banksy is still one of my favourite street artists.

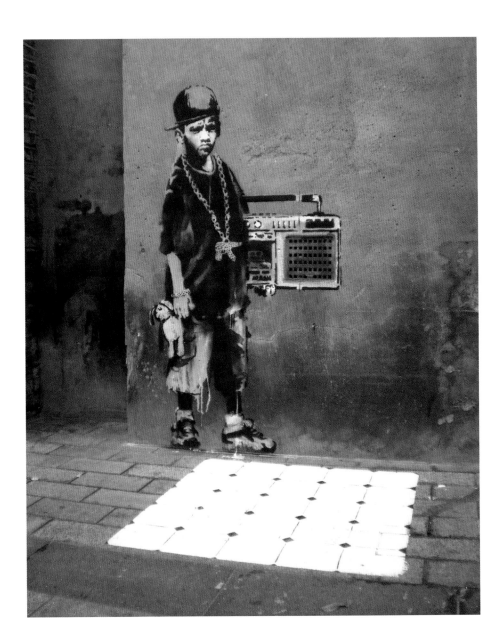

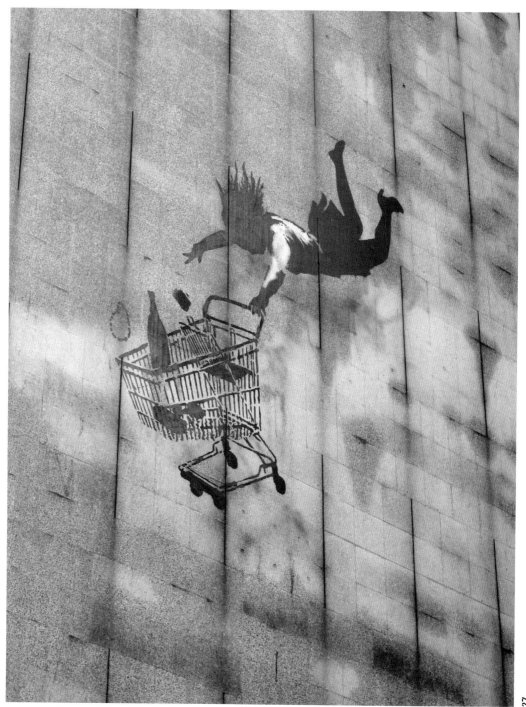

BANKSY

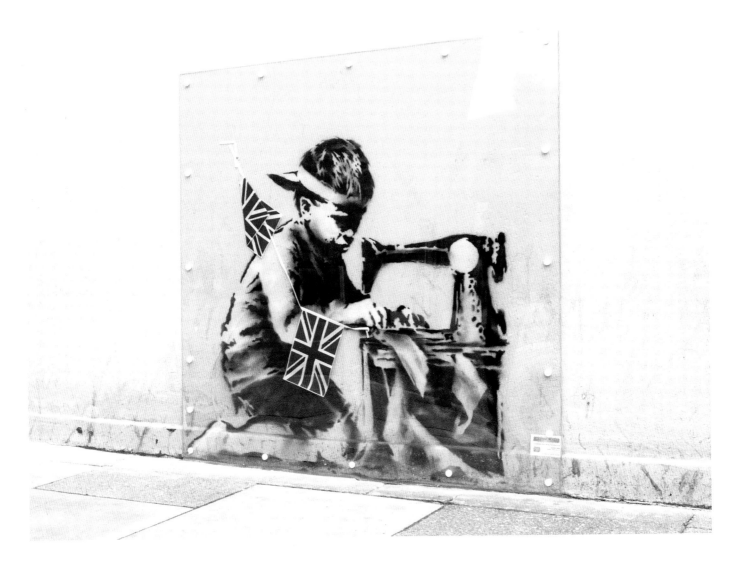

BASTARDILLA

www.bastardilla.org

Bastardilla's impressive, glittering, colourful paintings and paste-ups may be about sadness and doom (those feelings that the other pictures in the street – the advertisements – ignore) or about intimacy. I think these beautiful pieces are about the best the streets of Shoreditch have ever seen, and, happily, they usually go untouched for a long time; they are very well respected by nearly everybody. The Colombian artist is obsessed with painting on the streets. Indeed, she feels uncomfortable without at least a marker in her pocket.

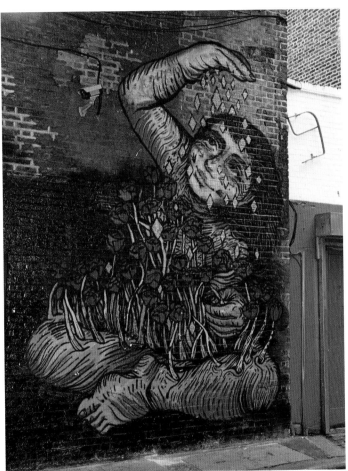

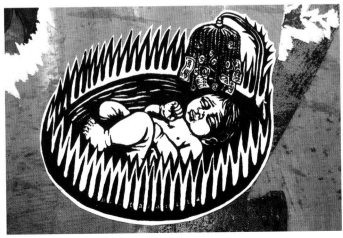

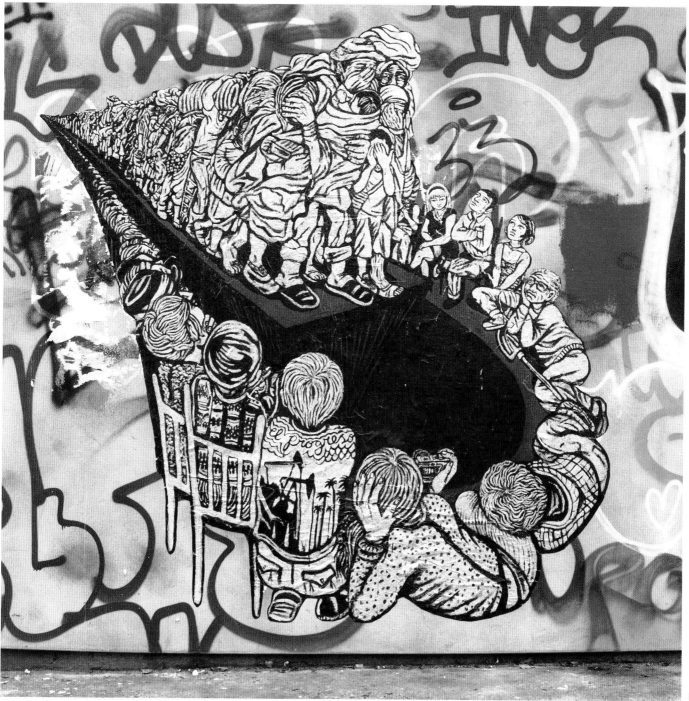

BLAM

I was happy to see this piece returning to the street after an earlier version had been buffed. In 2012 Blam published his first fanzine, available from www.etsy. com/shop/blamella. There is also a very nice painting by him in the yard of Benny's Bar, on Redchurch Street.

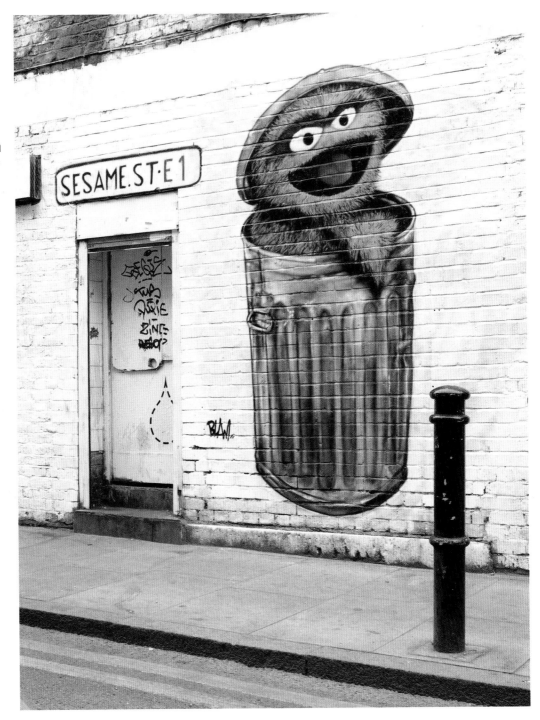

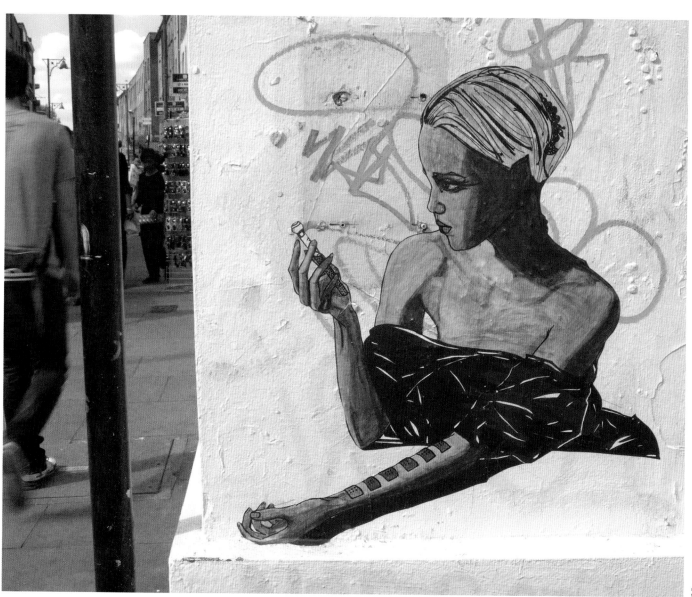

BOON

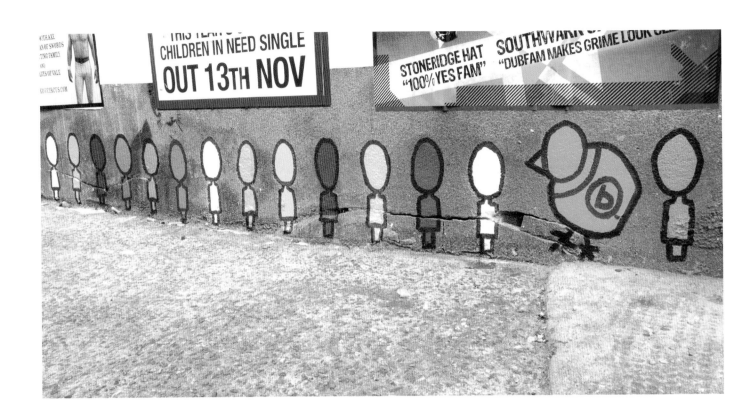

BORF

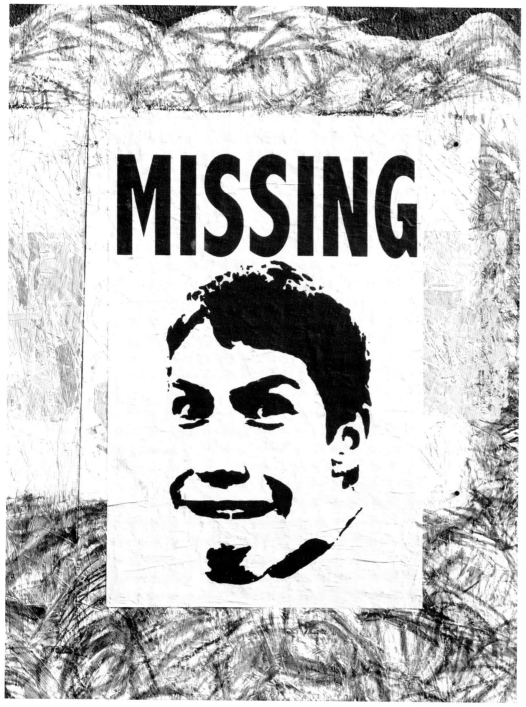

Borf is a graffiti campaign that originated in Washington, initiated by John Tsombikos in remembrance of his friend Bobby Fisher, who committed suicide at the age of 16. Tsombikos was eventually arrested for his actions and sentenced to 30 days in jail, community work and a restitution of $12,000 for "one count of felony destruction of property." In 2009, director Paris Bustillos made a documentary film about the campaign.

NATHAN BOWEN

www.nathanbowenart.com

Nathan Bowen's work looks very chaotic from up close; I prefer the way it looks from a distance. The CEO of British cloud software provider OnApp saw his work all around Brick Lane and commissioned him to contribute a piece to their new office in the area. His After Lives project intends to blow new life into ugly and vandalised walls, to give them an artistic reincarnation.

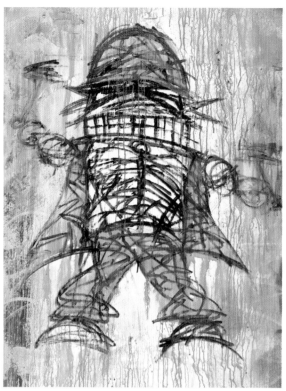

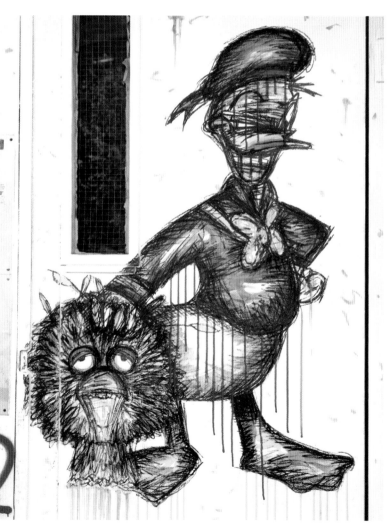

BOXHEAD

Boxhead, a Spaniard born in 1982, caught the attention of blogger Stephanie D: "We don't know whether the box is imposed upon Boxhead, or if she is wearing it by choice. We don't know whether it is a part of her or if she is using it to conceal her true identity. And Boxhead doesn't privilege us with her subject's thoughts... I find it interesting that the subjects are always gendered female, with their typical pocketed dresses and rounded thighs. This speaks to me of a kind of self-awareness, while also conversely pertaining to childhood and uncertainty. According to the artist, Boxhead has 'a rebel attitude in the sense of identity.'"

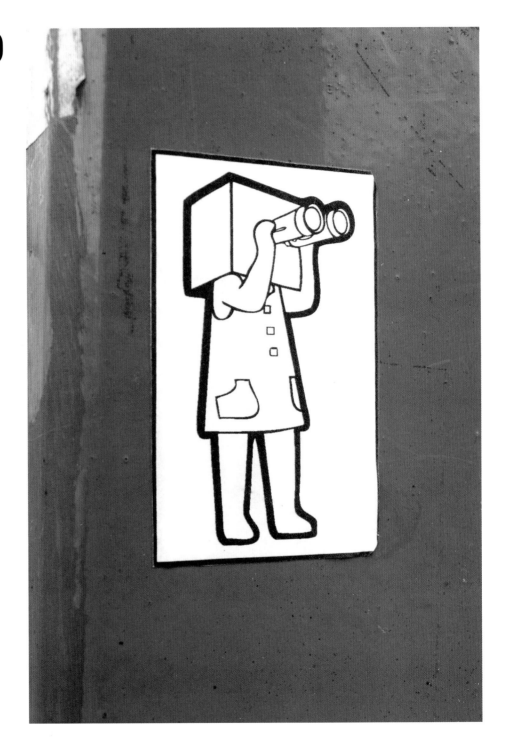

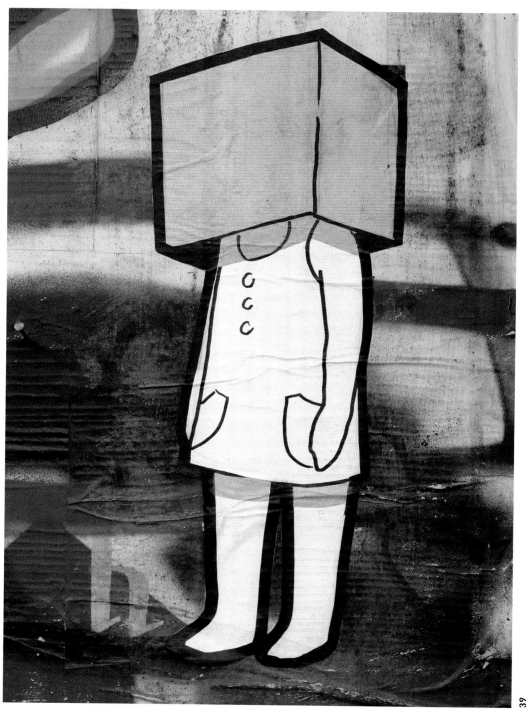

BOXI

www.boxi.eu.com

This amazing piece in Shoreditch remained there a long time. I don't think it was ever vandalised or tagged; nobody 'dared' I guess. Boxi, a stencil artist from Kent with a BA in Fine Arts from Central Saint Martins, now lives in Berlin. He had an amazing show at the Lazarides Galleries, Soho, in 2011.

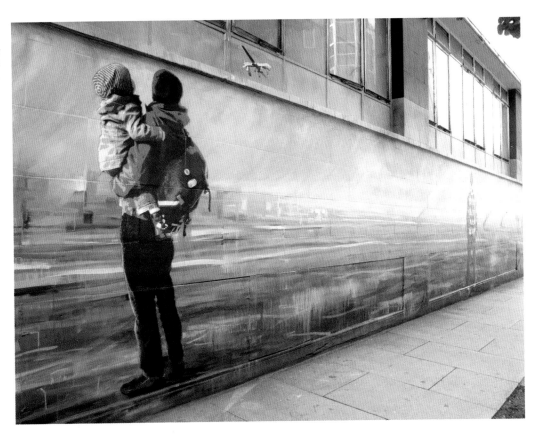

BR1 ART

www.equilibriarte.net/BR1art

The project Same Need, Different Conditions, by Br1 Art, an Italian artist, aims to analyze the figure of the Muslim woman from a sociological and aesthetic point of view. It isn't a protest, it is a visual of what Muslim women are and do in everyday life.

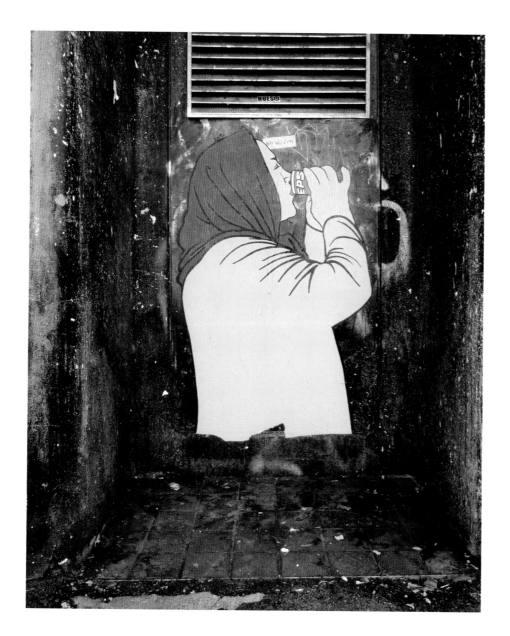

BROKEN FINGAZ

brokenfingaz.com

The core members of Broken Fingaz, a collective from Haifa, Israel, are Unga, Kip, Deso and Tant. "Where we come from everything is politicised," they explain. "The fact that our art is apolitical is a statement in itself; it shows that you can have a normal life away from politics." The collective's hippy-style youth, when they lived in a commune, has informed their work; you believe them when they say that their art relates to, amongst other things, acid and psychedelic experiences. Apart from murals, illustration and posters, Broken Fingaz also make music and videos.

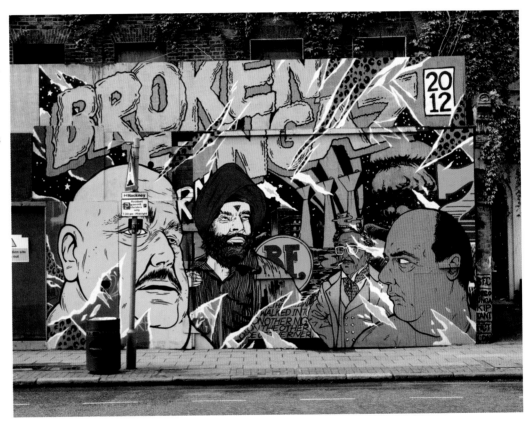

THE BRUNADUDE

www.flickr.com/search/?w=24356234@N04&q=brunadude

The BrunaDude pastes up original sixties pocketbook covers designed by Dick Bruna, the creator of Miffy, as an homage to the great artist who was also a big inspiration to Stik (see p214).

C215

C215 works mainly with stencils. The
first time he used spray paint was at the
age of 14, when his uncle commissioned
him to write 'Midnight Dreams' in the
NYC graffiti writers' style. He puts up his
portraits of "Broken people, the people
rejected by society and capitalism," on
'non-places' such as bins, rusty doors
and weathered surfaces, taking great
care that the pieces blend in well with
the environment. C215 hasn't been to art
school, but does have two masters in
art history. In particular he likes to paint
in Morocco and Brazil where, he says,
"Street painters are simply welcomed
and appreciated." *Community Service*
(Critères Editions), a book of his work,
was published in 2011.

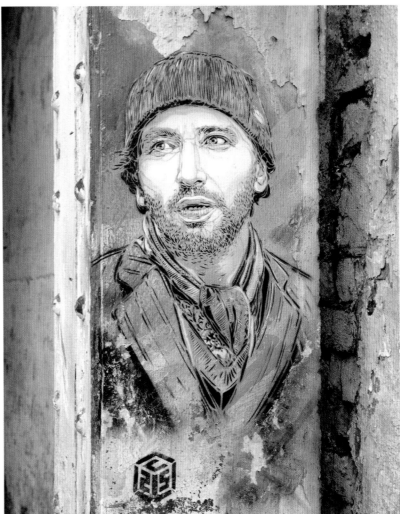

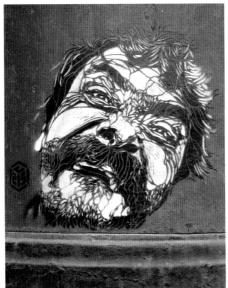

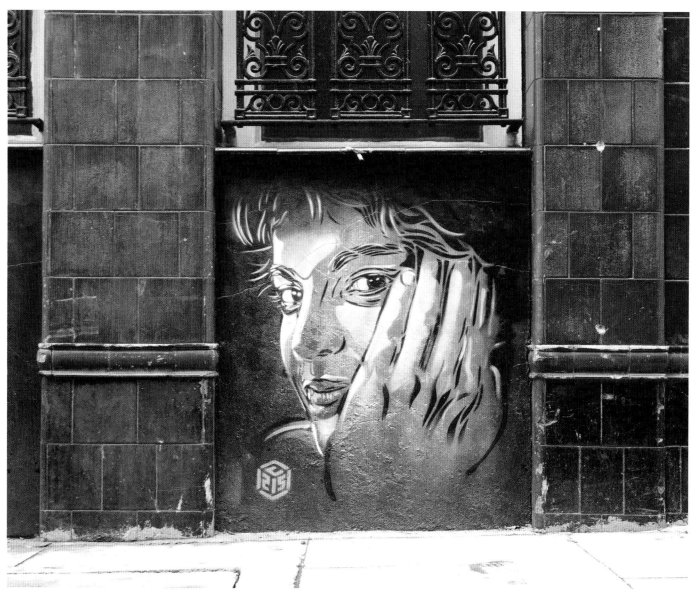

CARTRAIN

www.cartrain.co.uk

To many, Cartrain will always be the boy, then aged 16, who made Damien Hirst look like kind of a moron; Hirst threatened to sue the teenager over the use of his diamond skull image. Cartrain later removed part of an installation by Hirst from a show, smoked weed in Parliament and put smuggled-in artworks up in Tate Modern and the National Portrait Gallery. But for me, most of all, he is a very active street artist.

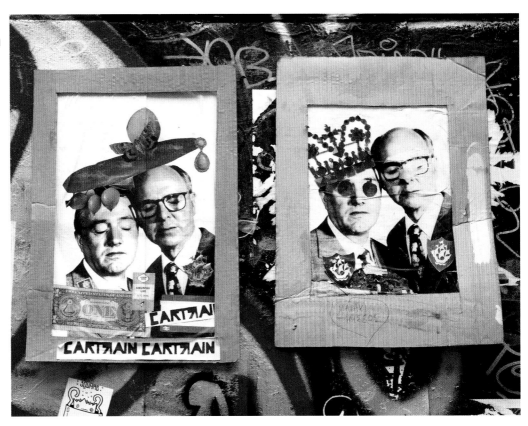

THE CHAIR

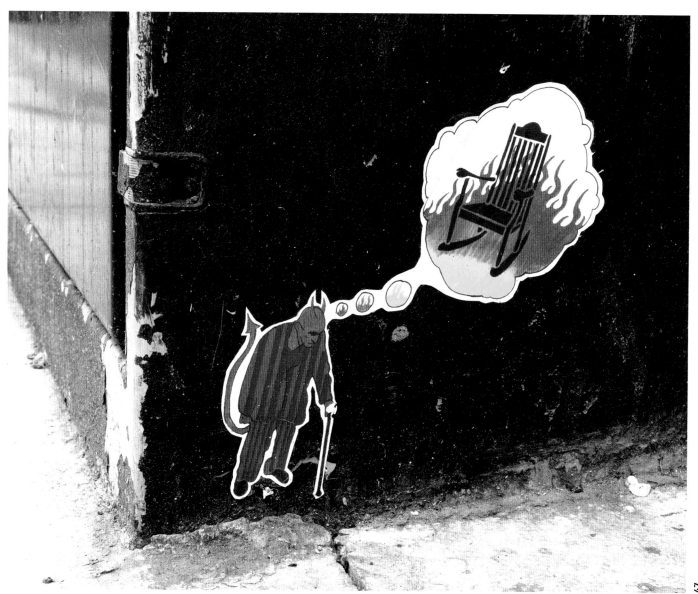

PAUL LE CHIEN

www.flickr.com/photos/paullechien/favorites

Paul Le Chien participated in a show called The History of Queer Street Art in San Francisco and Los Angeles in 2011, but these days you can usually see his work on the walls of Blackall Street, East London. He is well known in the gay fetish scene in Europe, and has provided the artwork for many parties and venues. His book, *Crude, Rude, Nude and Lewd*, was published in March 2009.

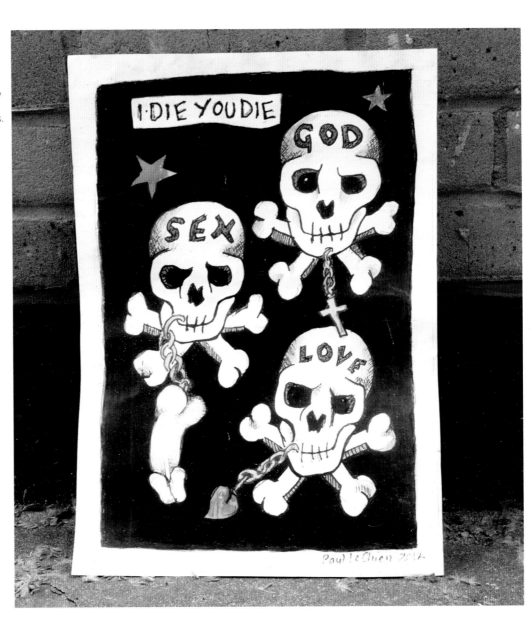

CITYZEN KANE

http://www.youtube.com/cityzenkane108

His mission is simple, he says: "To brighten up the streets and leave the viewer with the impression that they (the sculptures) have been there for millennia." His pieces are casts made from plaster of Paris, and are, as such, atypical examples of street art, being very labour intensive, big and heavy. Of course, they are highly original too!

JAMES COCHRAN

www.akajimmyc.com

Jimmy C, as James Cochran is also known, is an Australian artist currently living in Shoreditch. He started out as a graffiti writer, doing trains and all that, even living on the street for some time, but eventually went to art school and got a Masters from the University of South Australia. He has his very own style – 'drip painting', a form of pointillism. Inspired by the dot painting of the Australian Aboriginals, he makes little dripping dots with the spray can. He often paints male homeless people. In some ways they're self-portraits, but they also show his subjects that there is a way out. After many solo exhibitions in Australia and France, James had his first show in London in 2011. He is a highly respected street artist, his work is rarely tagged or vandalised.

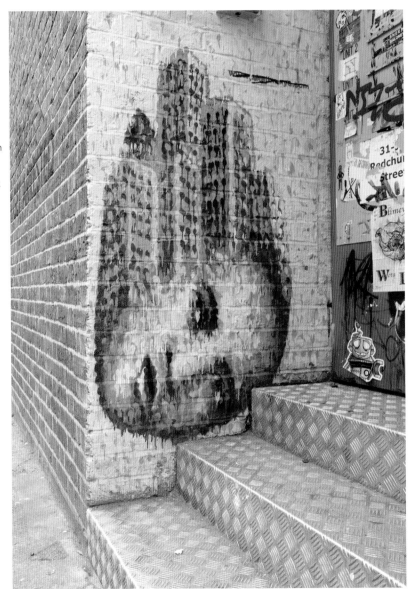

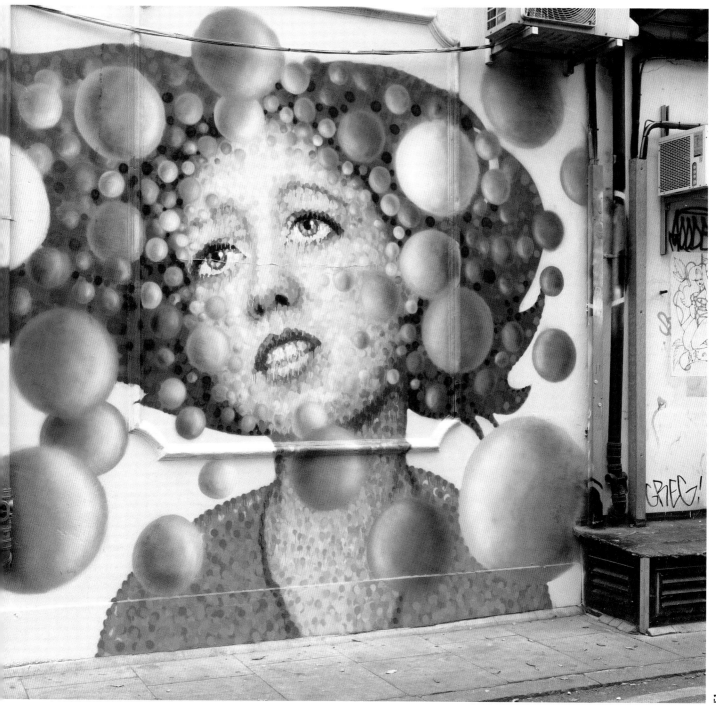

#CODEFC

http://www.codefc.org/

#codefc started out working alongside railway tracks, got a degree from the Chelsea College of Art and then moved on to working on canvas and making videos and animation. The 2012 Olympics were a big inspiration; in 2011 his Olympic pieces started to appear in the East End. By giving his characters a camera for a head, they become spectators, looking back at the viewer.

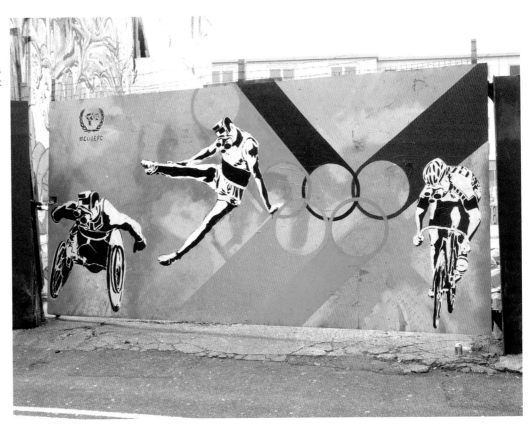

COPYRIGHT

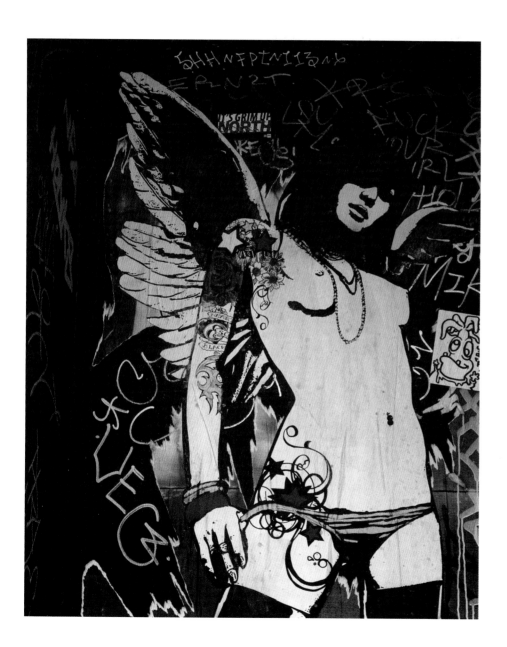

Using a mixture of techniques, Copyright creates images of beauty, often depicting women in black and white, surrounded by colour. It's easy to imagine his work sells well, and it does. He is a very successful artist who has been published in *Harper's Bazaar* and *Reload Magazine*. He also appeared in the BBC show *The Apprentice*.

ISAAC CORDAL

http://isaac.alg-a.org

Isaac Cordal started his Cement Eclipses
project in 2006, making little grey
men cast from moulds, putting them
in the street and photographing them.
Placement is made with extreme care,
with the photos looking like stills from
a dark and unsettling animation movie.
You can't help but feel sorry for these
tiny creatures; they show no expression
or emotion, they seem lost in our world,
they stare at a broken TV, bathe in a dirty
puddle, or use an abandoned bicycle
lock as a swing. On the other hand, they
are somehow funny and cute too, these
lonely men. Melancholy, that's the word.

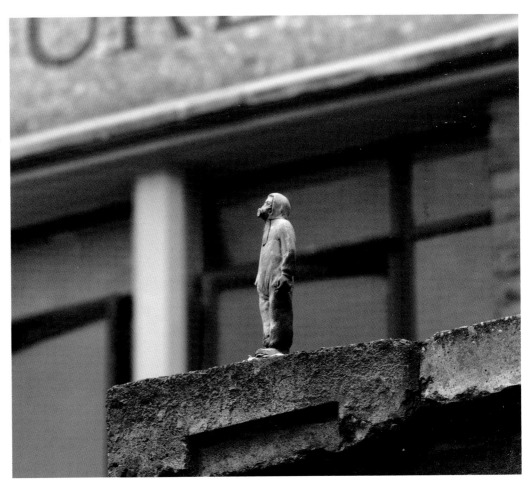

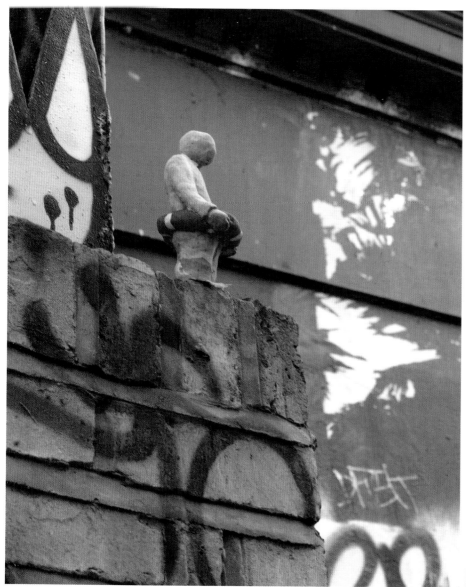

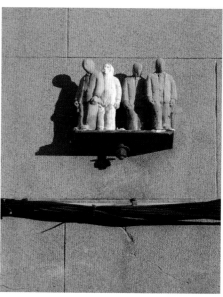

CRACKS

This artist simply identifies cracks in walls. Without them/him/her a lot of cracks would certainly go unnoticed – we should be thankful for this artist's work!

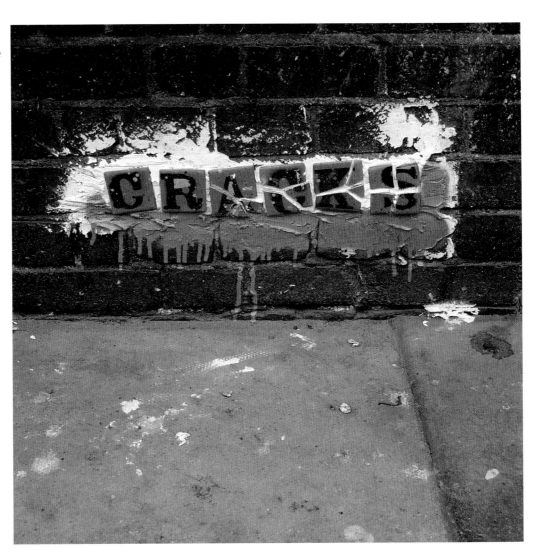

CROSSIE

http://crossie.arloartists.com

Crossie's fascination with winged creatures such as butterflies led to a large series of painted and stencilled pieces. She uses the pages of antique books as a background, the vibrant, coloured animals contrasting nicely with the colour and feel of the old pages.

CYCLOPS

www.lucasprice.com

Cyclops, whose real name is Luc Price, was suspended from school in Bristol when teachers noted the similarity between his doodles and a large piece of graffiti on the school roof. He is a founding member of the Burning Candy Crew, and often collaborates with Sweettoof (see p222). Being a big fan of Peanuts myself, I love his one-eyed Charlie Brown.

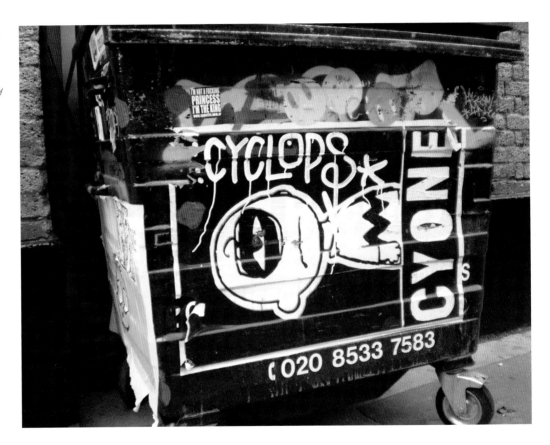

DAIN

http://blog.vandalog.com/2009/05/dain/

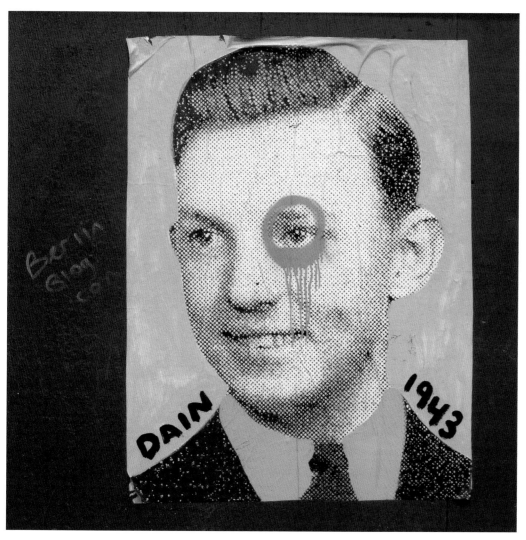

Little is known about this artist, except that he had a show in Brooklyn, New York, in 2009, featuring wonderful reworked portraits from the 1940s, a time which, despite the war, was a time of hope and of post-Depression rebuilding; the time of 'the swing'.

PABLO DELGADO

Mexican artist Pablo Delgado makes these very small paste-ups; he is a modest guy I guess. He began painting at the age of 28, came to London to study contemporary art, ended up in the East End and – just like myself – was struck by the overall presence of street art there. His subjects are often people on the periphery of society, like prostitutes, drunks, the homeless, toilet cleaners or circus artists.

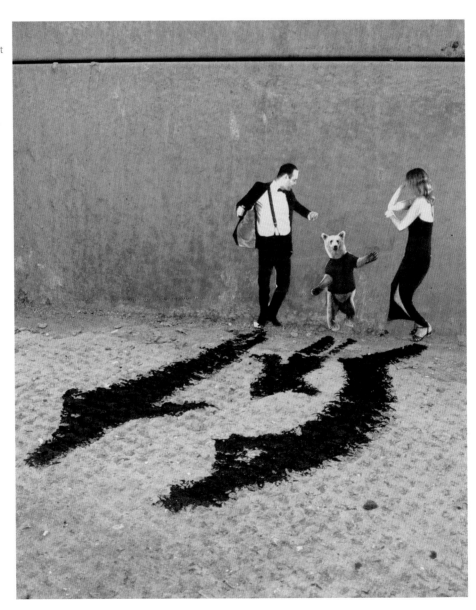

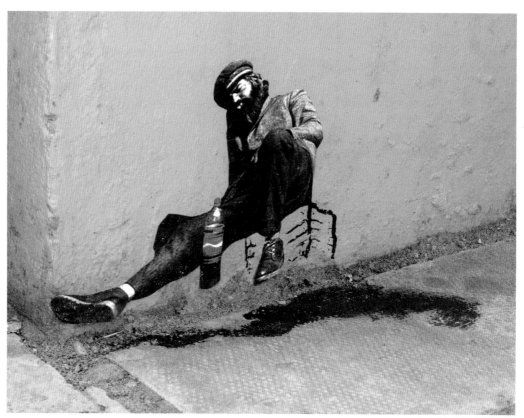

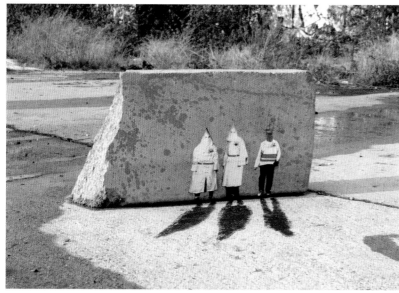

D*FACE

www.dface.co.uk

D*Face is a freelance illustrator and designer from London. Keen on drawing as a kid, he discovered skate-graphics through *Thrasher* magazine, and this style remains a big source of inspiration for him today. He explains: "I rethink, subvert and literally deface imagery drawn from a refuse of materialistic consumption." He sometimes uses existing advertisements in the street to show how we live in a world dominated by commercialism and the media.

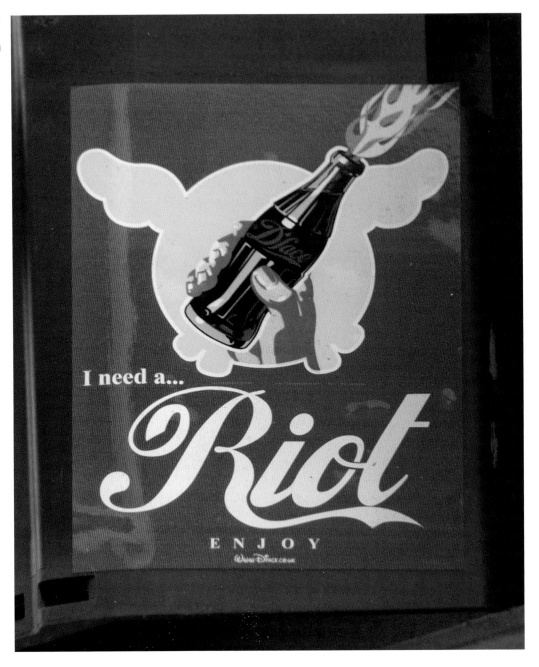

DOCTOR CREAM

www.flickr.com/search/?q=doctor%20cream

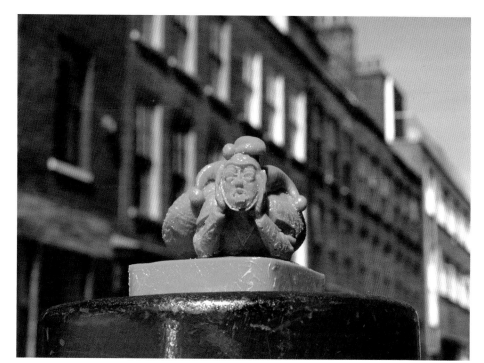

When I started noticing Dr Cream's 'jesters', I found his great little films on YouTube, in which he encourages people to take the small snail sculptures and photograph them in a different setting (search under 'jester' and 'quest'). That's what I did, and I became the proud winner of The First Jester Quest Award, which was handed to me by the doctor personally in 2010. His next project was The Rolling Fool figures, animations of which can also be found on YouTube. In addition, Dr Cream is a master of the ancient weapon of the sling.

DON

www.instagram.com/pauldonsmith/

Having arrived in London from Borneo at the age of 12, Don is now a self-employed graphic designer, productive street artist and painter. He's a highly skilled artist who seems driven by the desire to please his audience, something he does a great job of. Don made several affectionate pictures of the Queen in 2012, jubilee year. Unusually for a street artist, he must be a royalist!

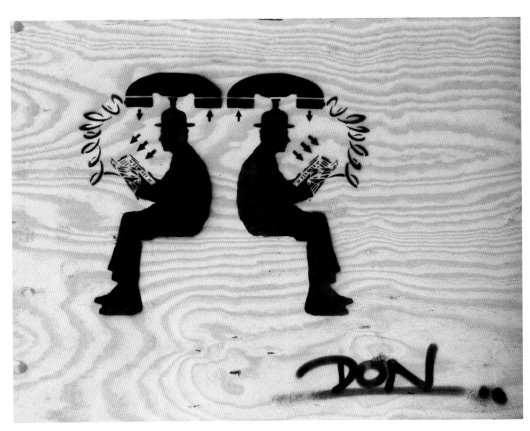

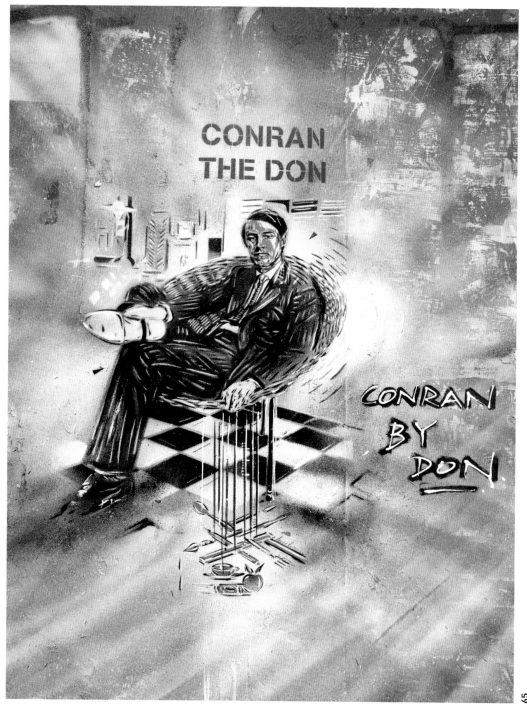

DONK

Born in the eighties, Donk's first involvement with street art came in the graffiti scene of his native Hackney, East London. Having become a professional photographer, he returned to the street in 2008 with paste-ups often depicting his young son. He says: "I suppose what I am aiming for is a kind of contemporary folk art with a kind of pathos," adding that he'd like his art to be, "An act of defiance or, more importantly, of freedom of expression, born from a creative/social desire and frustration, resulting in some kind of democratisation of art."

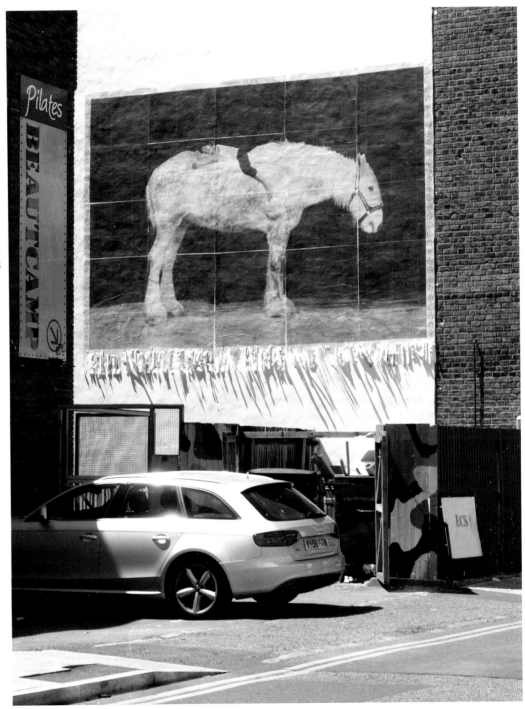

DOTMASTERS

http://dotmasters.co.uk

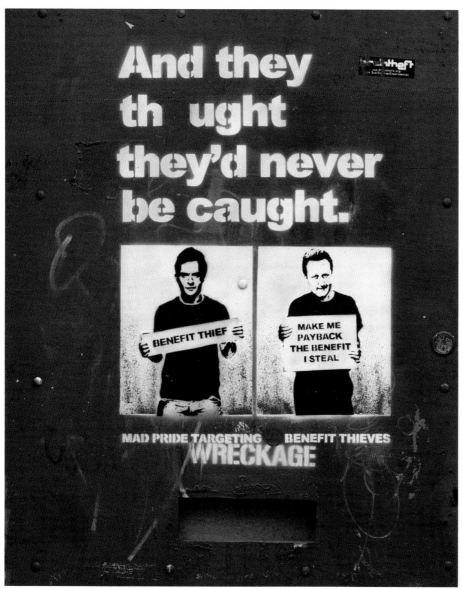

Dotmaster had created street art under the name C6 for more than ten years before he began working with a laser cutter, which enabled him to develop halftone stencils. In addition to pieces like the one shown here, he produced a series of pieces reproducing classic European paintings, to be put up on the walls of galleries and museums; so that putting up a Mona Lisa would become an act of 'vandalism'.

DR.D

www.drd.nu

dr.d works with paper, paint and paste to create his own posters and to change existing ones. He has something to say about the commercial world and politicians that try to sell us their empty or wrong messages. His first 'art on the street' piece involved changing the slogan on a poster that said 'Suddenly everything clicks' into 'Suddenly everything sucks'. Recently he campaigned about the MPs' expenses scandal and the devaluation of the NHS. So, if you happen to see a somewhat unlikely *Evening Standard* poster, it may be the doctor's work.

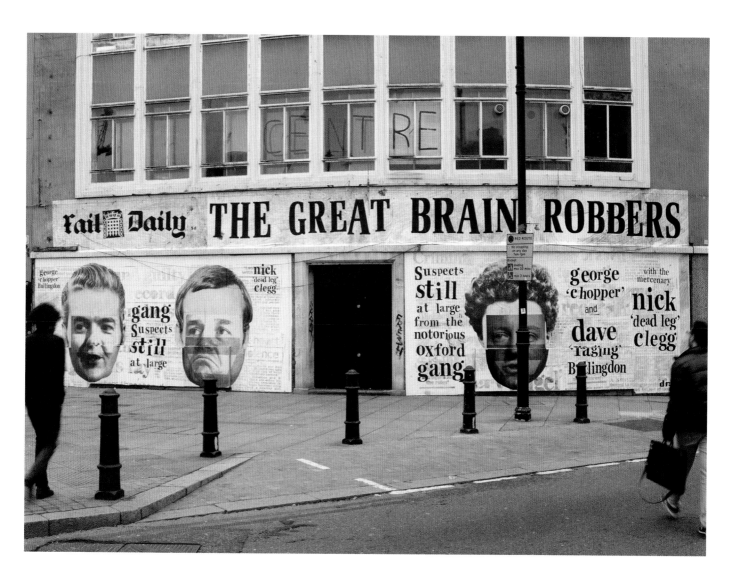

DSCREET

www.flickr.com/photos/dscreet/

Dscreet is fascinated by owls. He says he finds them almost too good to be true, as if they were animals from a mythical world. On the other hand, they also remind him of equally big-eyed CCTV cameras. He was a co-curator of 'Hoo Wot', an art show that raised money for the World Owl Trust. Colour is very important in Dscreet's work, as it is for his colleagues from the Burning Candy Crew (see p58 and p222). He also works as a graffiti artist.

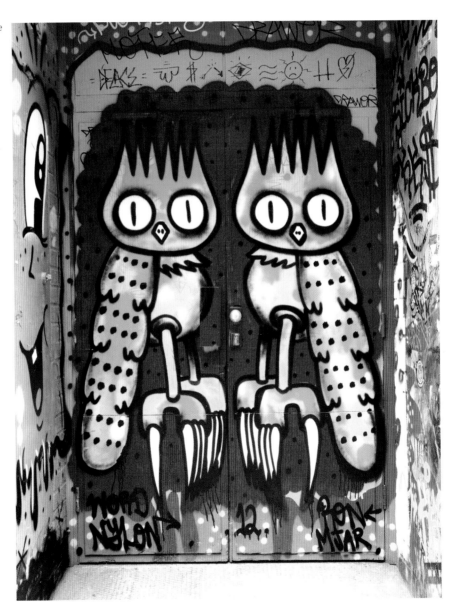

GABRIEL DUBOIS

www.gabrieldubois.com

Half Canadian, half German, Gabriel Dubois grew up in Ontario and Vancouver, and now lives in Berlin. He is one of the few street artists who make abstract work. He learnt how to 'pull lines' working as a house painter during the summers in Canada. Today, Gabriel has become mostly a gallery man, with about two solo shows a year, but he still works on the streets now and then.

DUK

www.flickr.com/photos/only1duk

When I started taking photos of street art
I noticed Duk's (also known as Only1duk)
work, not only screwed onto walls, but
also just standing on the pavement.
I never took them with me then; that
seemed 'not done', and I thought as
many people as possible should be able
to see them. Happily, someone explained
to me that taking them was the whole
idea; otherwise it's the garbage man
who will take care of them the next day.
So, I've got some Duks now. Thanks so
much Duk.

EINE

www.flickr.com/groups/letters_from_eine

Before becoming a full-time artist Eine worked for Lloyds Bank. He eventually resigned and had an arm, a hand and his neck tattooed, to prevent himself ever accepting a 'proper job' again. For the Anti Design Festival in the autumn of 2010 he made a big piece on one side of Ebor Street, East London. In huge characters it read: ANTIANTIANTI. The owner of the building on the other side of the street wasn't amused, and told Eine that he didn't like looking at all that negativity from his window. So he asked Eine to paint his own wall, opposite the 'Antis', saying PROPROPRO, and that's what Eine did. 'The Strangest Week (with the little smiles)' piece was Eine's reaction to British Prime Minister David Cameron presenting a canvas by the artist to President Obama on a state visit. He was suddenly front-page news all over the world. The 'Change' is a memorial to Tom-Louis Easton who was fatally stabbed nearby in 2006.

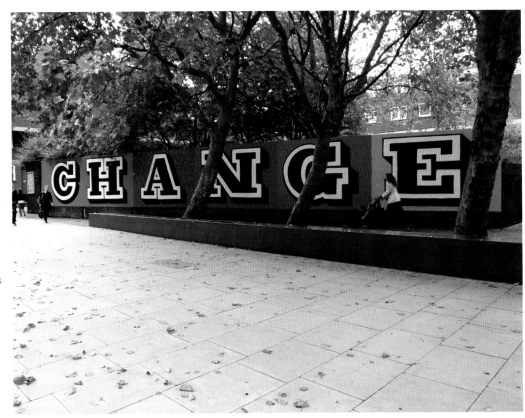

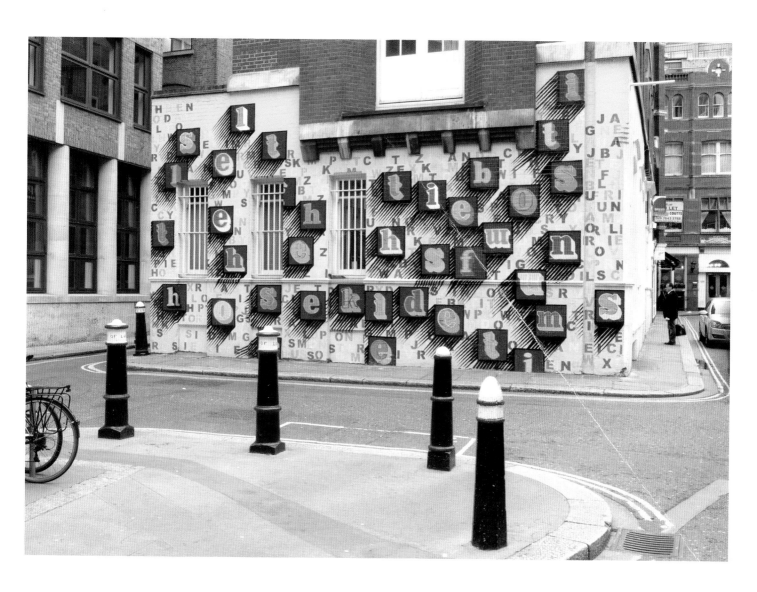

EINE

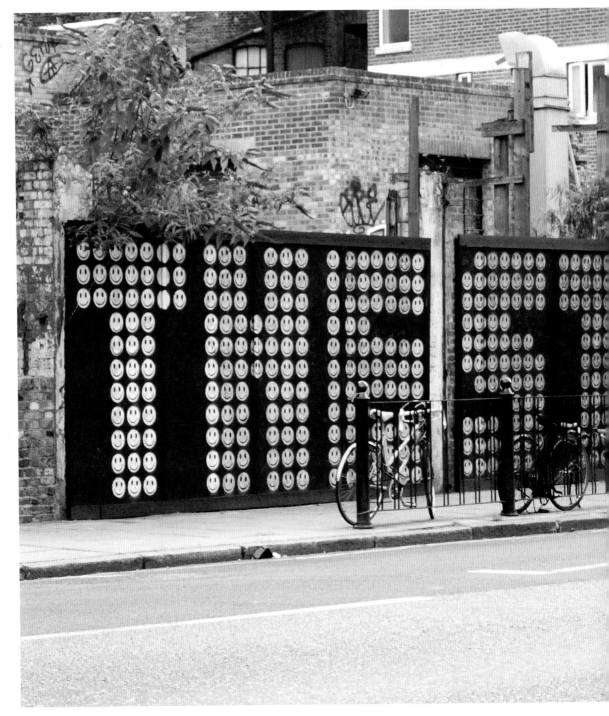

ELBOW TOE

www.elbow-toe.com

A Texan living in New York, Elbow Toe (real name Brian Douglas) was a programmer before he turned to the arts. One evening in 2005 he put up a tag on a pavement. He was intrigued by how this piece lasted and was photographed, and by how it eventually faded away. And so a new career had started. What he likes about his work is the duality between making lasting works for galleries and producing temporary pieces for the street. His paste-ups are hand-painted lino and woodcuts or hand-painted charcoal prints. Unlike most other street artists, he doesn't enjoy the job on the street itself – it makes him nervous – but he doesn't want to leave it to an assistant either.

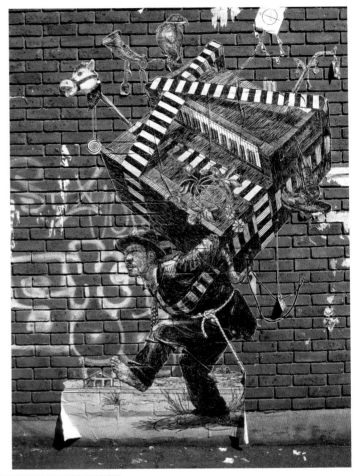

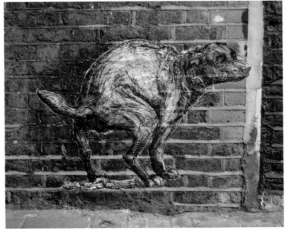

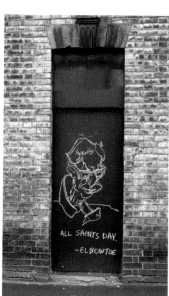

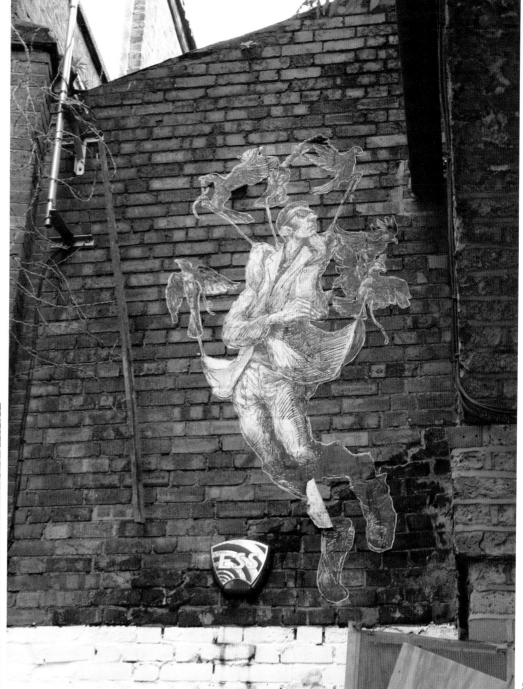

EMA

www.florenceblanchard.com

The only street art pieces I have seen by Ema are these 'Dropmen'. Her studio work is more varied and inspired by styles like art deco, comic book, graffiti, tattoo and science fiction. She is from Montpellier, spent a decade in Brooklyn, New York, and then returned to France in 2010.

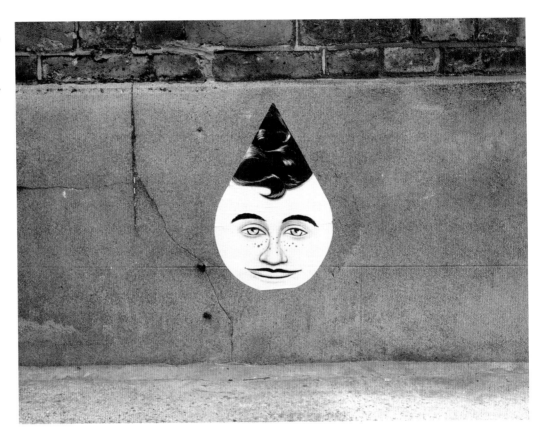

EMESS

www.atmberlin.de/en/artists/emess.php

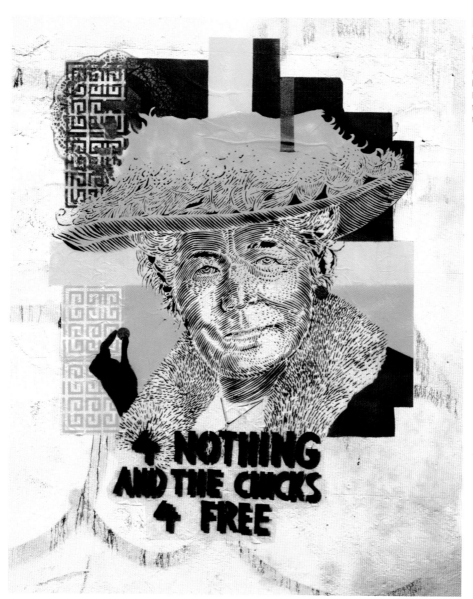

In these prints from the series 'The colour of money', Emess uses pictures of famous people, taken from banknotes like the dollar and the pound, and combines them with quotes from songs by artists such as Dire Straits, the Beatles and Prince. The combination of the old fashioned and familiar faces with the flashy colours works very well.

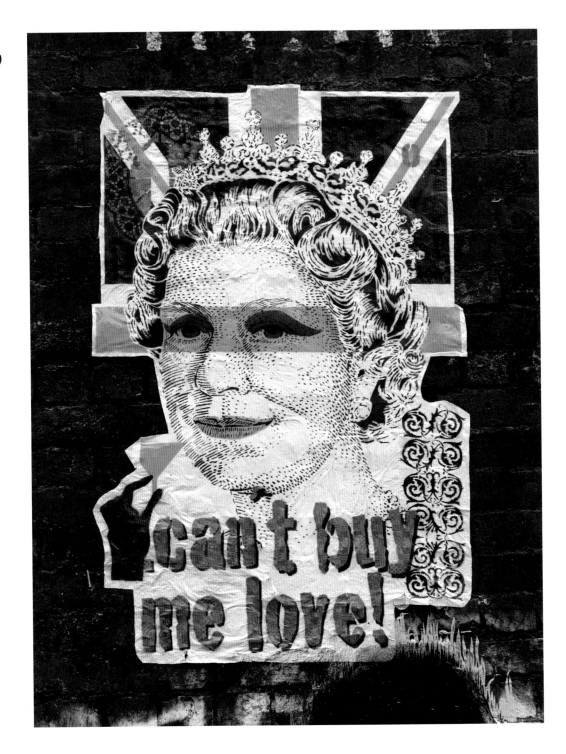

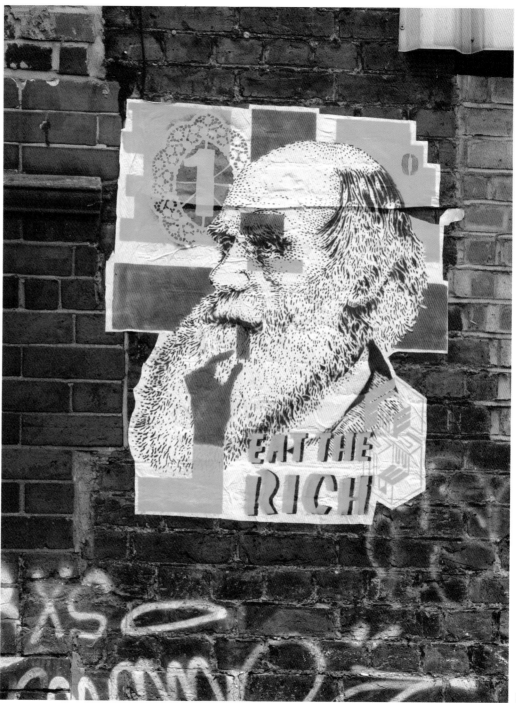

ESCIF

A native of Valencia, Spain, Escif is the maker of wonderful, rather surreal paintings. I haven't seen much of his work on the streets of London, so I was happy to find that POW published *Around the Wall*, a nice booklet of his work, in 2010.

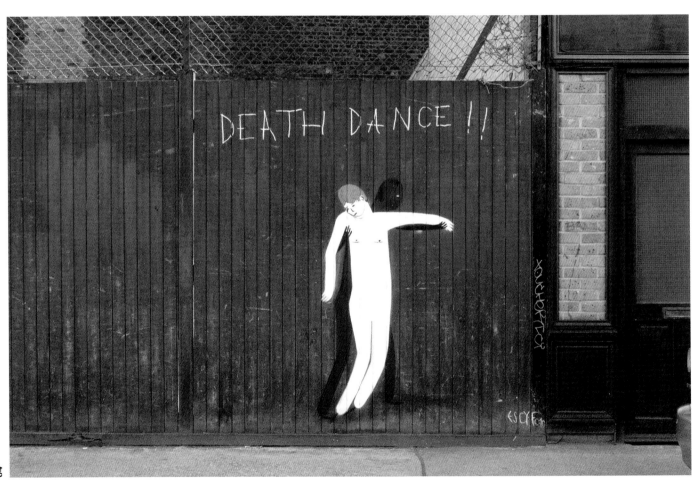

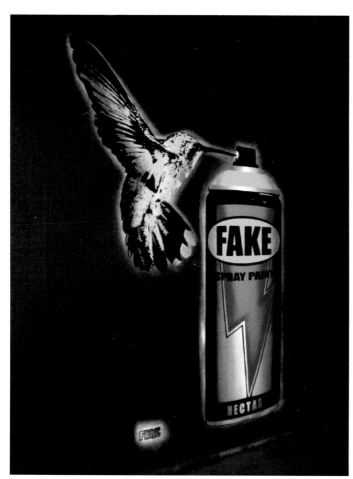

FAKE

www.fakestencils.com

Fake grew up below sea level in the Netherlands. He was a graffiti writer first, but moved to street art in 2007. "I do my art to make people smile, get a discussion going," he says. I think he is pretty successful with that.

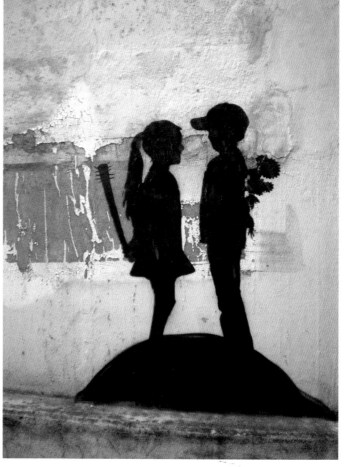

FAUXREEL

http://fauxreel.ca/

Fauxreel, aka Dan Bergeron, uses photography to produce highly realistic posters of people. They draw attention to the not so famous among us, the homeless; like tributes to the 'common people'. He is interested in the notion of public space. In his native Canada he investigated the relations and borders between advertising and street art in a highly controversial project for Vespa, the scooter manufacturer.

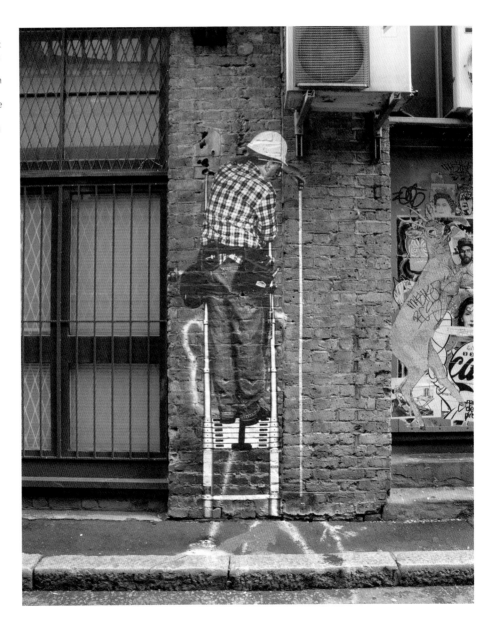

FIN DAC

http://findac.tumblr.com

Fin DAC considers himself an 'artist'
more then a 'street artist'. His pieces are
incredibly detailed, combining stencilling
with free-hand spray painting, a style
he calls 'Urban Aesthetics'. He signs his
work with a dragon logo, DAC, which
stands for Dragon Armoury Creative, the
name he gave to his portfolio. By day he's
a web developer and designer, originally
from Ireland.

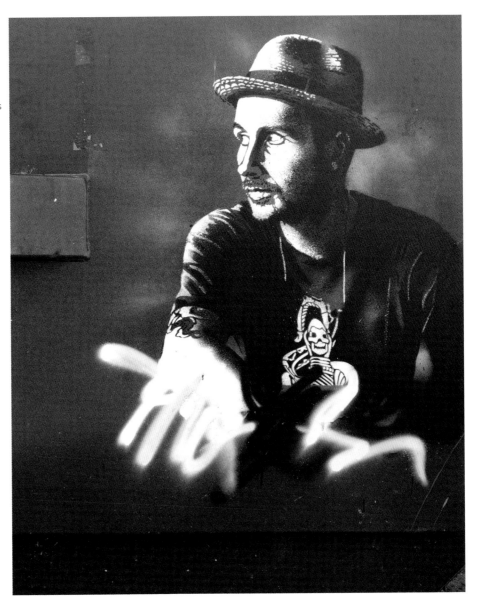

FIVE FOUR

www.thebricklanegallery.com/FIVEFOUR.html

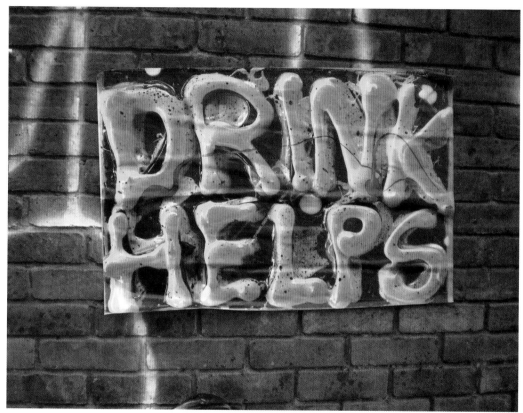

In Five Four's art, the title is the work. He addresses social issues in a very direct way using thickly applied paint in bright colours. For his street pieces he then transforms these three-dimensional works to paper.

FKDL

www.fkdl.com

Perhaps FKDL, from Paris, came up
with his silhouettes of dancing girls
whilst studying fashion design for a
year. He tears and rips up magazines
and other pictures, and glues and tapes
them together to make these wonderful
collages – very strong, striking, simple
shapes, done with great care and full of
colour and detail. Few people take such
care in putting up their work on a wall;
although they're only made from thin
paper, they often last a long time.

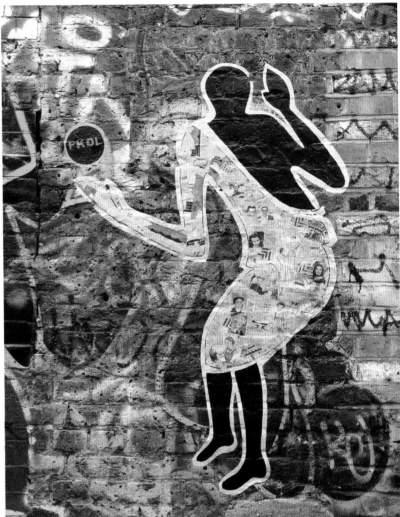

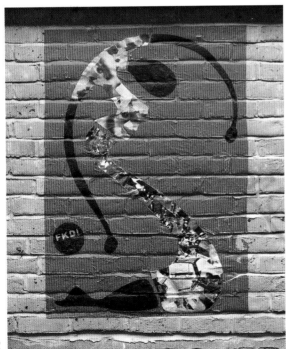

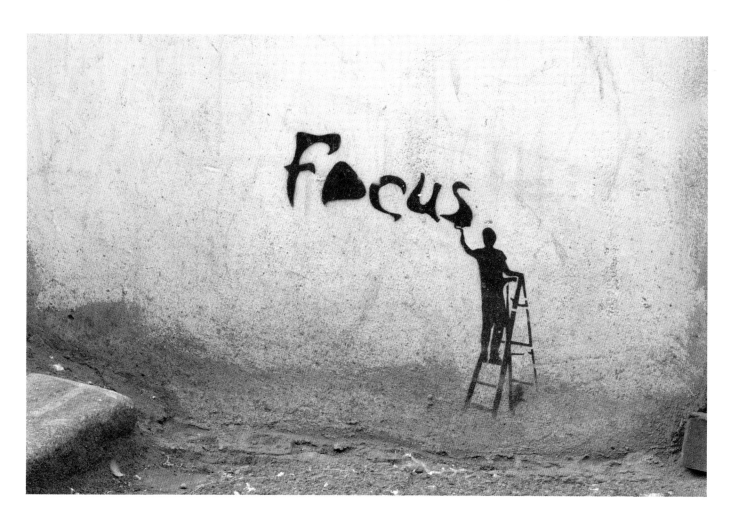

FONTFACE

FontFace, from Italy, likes to change the often-unnoticed parts of a street, to surprise the innocent passer-by. His stickers are very straightforward, created simply in black and white. I find them very funny. He considers himself new school; I think he is right.

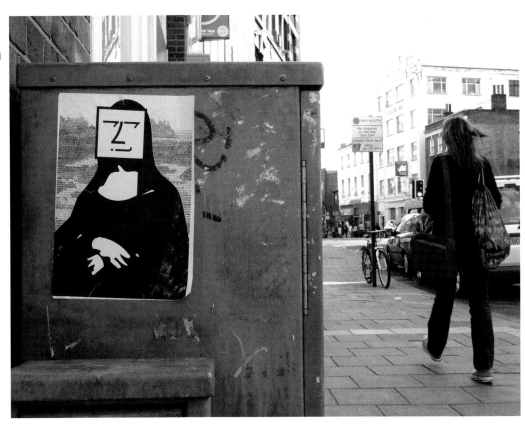

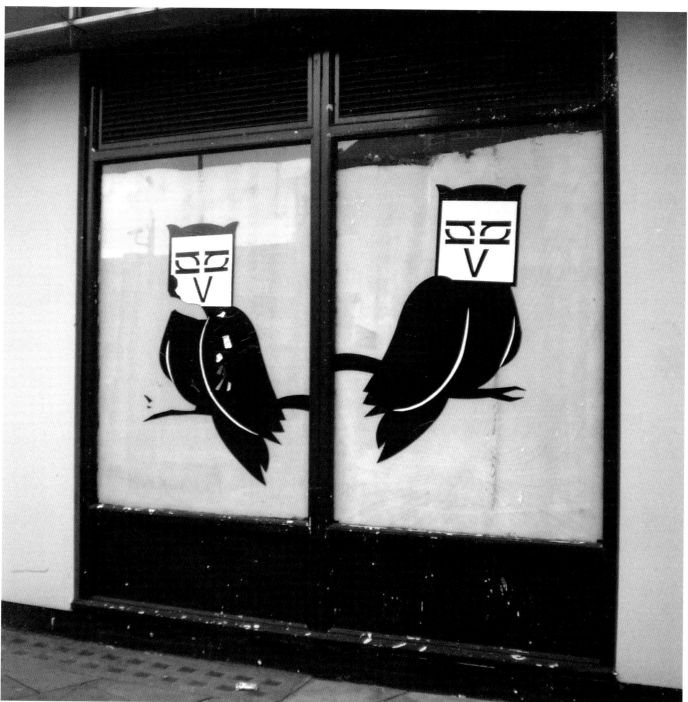

FREE HUMANITY

http://freehumanity.la/

A politically motivated artist from LA, Free Humanity's central message is: "We all suffer, let's alleviate it, Free Humanity!" His first mentors were the streets, his skateboard, Siddhartha Gautama and Thich Nhat Hanh. Other inspirations include the street artists Alec Monopoly (see p156) and Cryptik. He is essentially a human rights activist who wants people to reflect on our society, and to provoke some smiles as well.

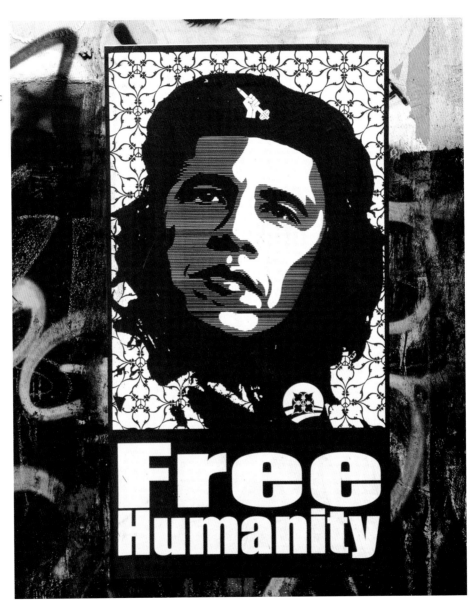

FUNK25

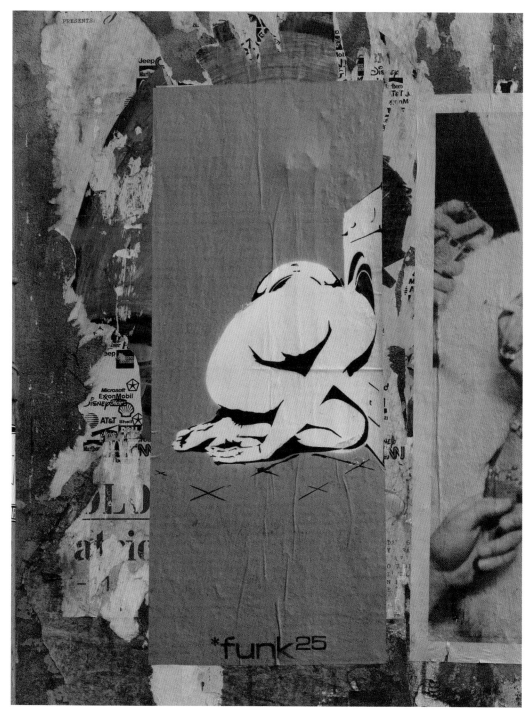

Funk25 started putting up stencils with anti-fascist content in Hamburg, Germany, in 1991, "To irritate and shake-up the viewer" he says. His later work is less political, but he still likes to confront people with his art, to bring out ideas and criticism.

GAIA

www.gaiastreetart.com

Gaia is a New Yorker with a fascination for nature, making prints of creatures somewhere between man and animal. He became involved in the street art world in an unusual way; he "Learned everything on the Internet." Once he found out about wheat pasting on the Wooster Collective website, he decided to try it out himself. Gaia cites Elbow Toe (see p78) and Swoon (p224) as important influences on his work.

DAVID GOUNY

www.davidgouny.com

David Gouny, aka The Pope of Fat, is a Paris-based artist who, according to his autobiography, studied at The Liposuction school of Fat. He creates – you guessed it – images of obese people. He also makes plastic, blow-up sculptures of objects "contaminated with the fat virus."

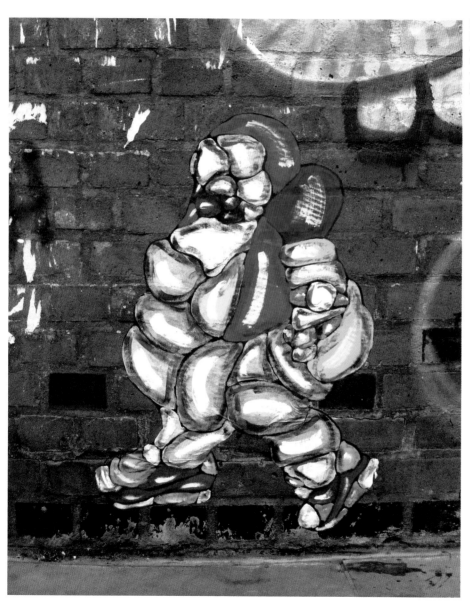

GRAFTER

www.flickr.com/photos/grafter

In his own words: "If I can capture in a snapshot something that lets the passer-by forget about paying the gas bill for a moment and remember that sheer exhilarating thrill we all felt at one time in our life of jumping in a puddle, simply because it's there, then I consider my work here done."

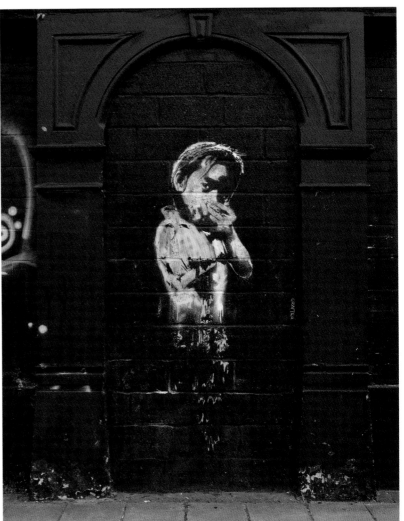

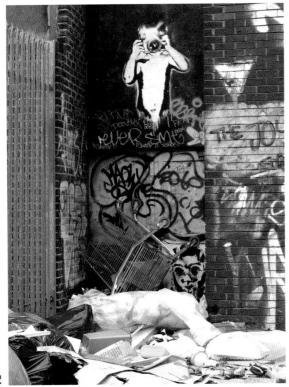

DALE GRIMSHAW

www.dalegrimshaw.com

Dale Grimshaw, a London-based figurative painter with formal training, produces beautiful paintings and woodcut prints about fear, pain and horror. Often they depict an animalistic head on a human body. He exhibits and takes commissions all over the world, but happily also still works on the streets of London; check out Blackall Street and Hanbury Street, which seem to be his favourite locations.

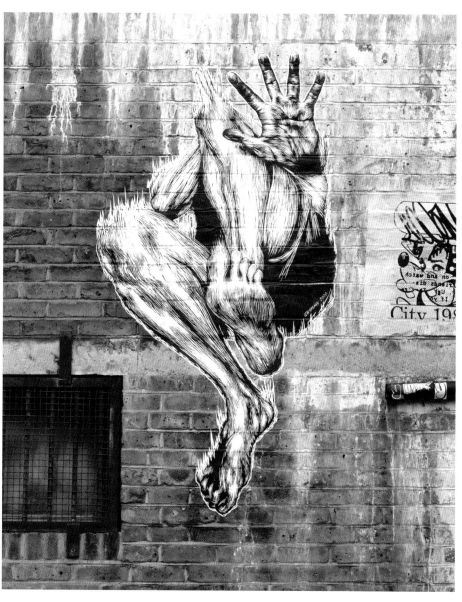

DALE GRIMSHAW

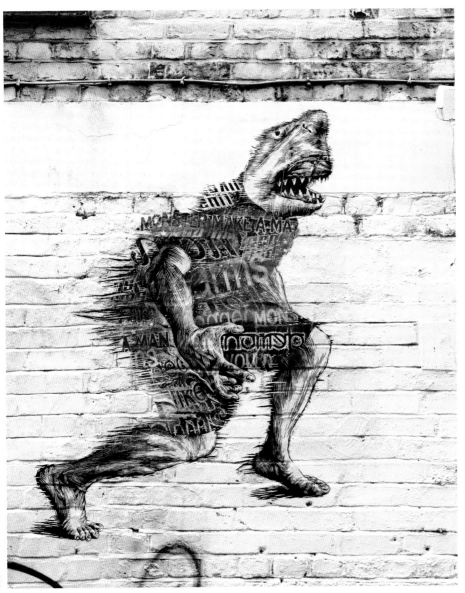

NARCÉLIO GRUD

www.flickr.com/photos/narceliogrud

Narcélio Grud from Brazil has many
talents. He transforms bicycles into paint
machines using brooms as brushes; he
makes installations of hammocks; he
developed 'ataripunk', connecting a spray
can to a synthesizer, itself connected
to a video projector; he invented the
'splay' technique, a low-tech solution for
spray painting; he creates public sound
sculptures; he does the most wonderful
surrealistic paste-ups; and he produces
very high quality videos of all these
projects.

GUERRILLA KNITTING

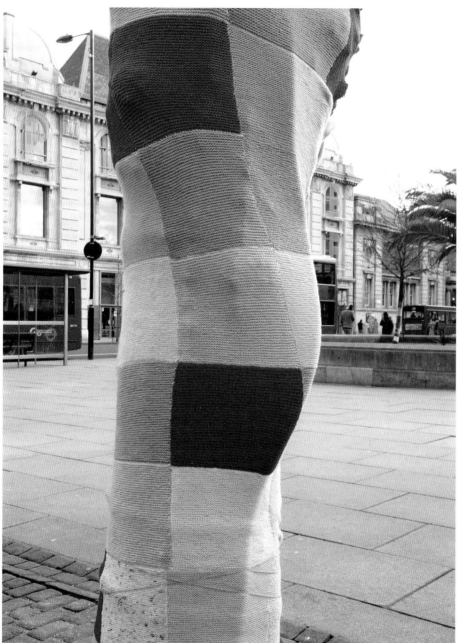

Guerrilla Knitting or 'yarn-bombing' or 'knit graf' is basically street art that uses yarn. Seeing this material – usually considered rather twee – used in street art always make me laugh, as does the often un-yarn-like scale of the work. Few works of street art get as much attention from passers-by, or photos taken, except maybe for new pieces by Banksy. These pictures were taken in February 2011 in Hackney Town Hall Square

GUERRILLA KNITTING

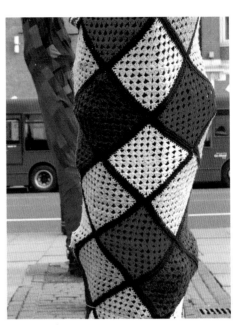

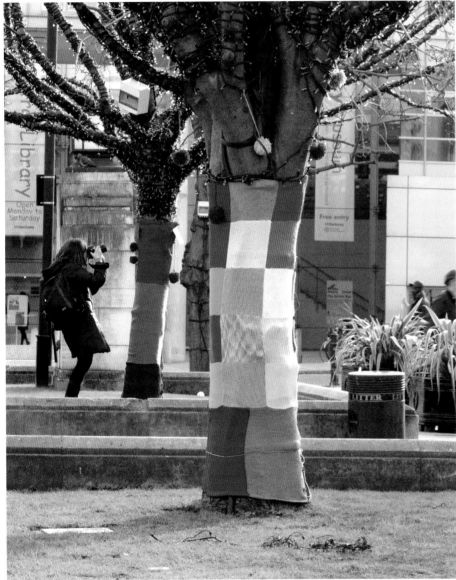

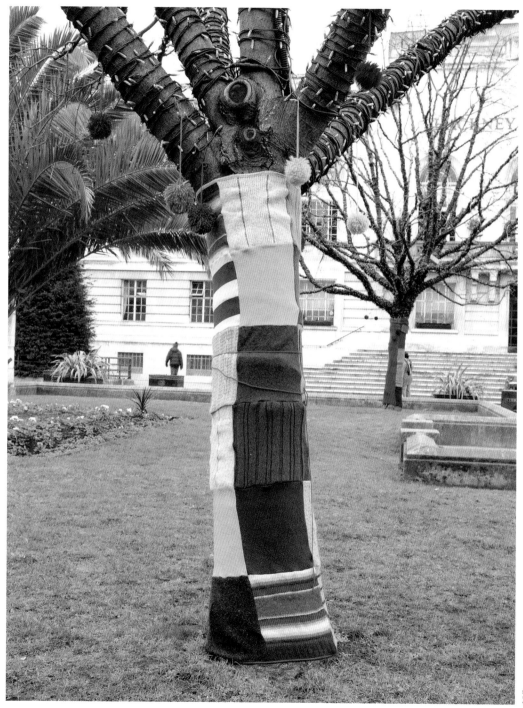

HACULLA

www.harifguzman.com

Harif Guzman, once known to Ha as his friends, became known as Haculla after reading Bram Stoker's *Dracula*. Originally from Venezuela, he ended up in New York in 2000, and has since become very knowledgeable about couch surfing. With art it's like skateboarding he says: "You have to eat shit, or you won't get any better."

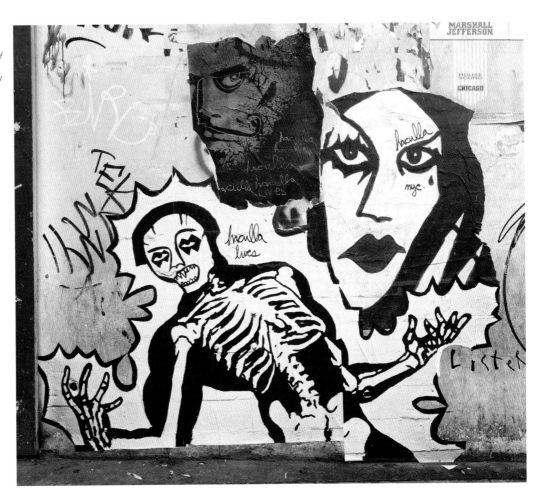

HIN

www.hin-art.com

Hin is from Hong Kong, he came to England at the age of 12. From his website: "Through his experiences, Hin came to understand that one must hold on to their inner child and to persevere, above all things, in order to overcome any painful or traumatic experience while at the same time never to deny any truth of the cruel reality in life. Finding harmony between the two is what he believes one must attempt to achieve."

HOTTEA

Hottea, or hot + tea, from Minneapolis, USA, is a graffiti writer who decided to change medium after getting arrested several times. Still being interested in typography, he went from writing with the spray can to writing with yarn, making pieces that, for example, use a grid of fences or create roofs for walkways. One particular piece comprised of yellow yarn stretched between two fence posts, lasted over eight months in a busy part of East London!

www.flickr.com/photos/30794045@N08

Strong, distorted, rather disturbing pieces about beauty, youth, fame and wealth, created in mixed-media: the ugly side of fashion.

IFC

The Insane Felons Cartel is a collective formed in 2008 by Wolfie 'Satan' Smith. Other members include Brett Ewins, comic book artist (of *2000AD*), painter and inspirator of The Mutoid Waste Company; graffiti and street artist, Charlie Shazer, once of World Domination; Brendan McCarthy, a designer who also works for 2000AD; Cemo and Aseb, graffiti writers; and Deadline 88.

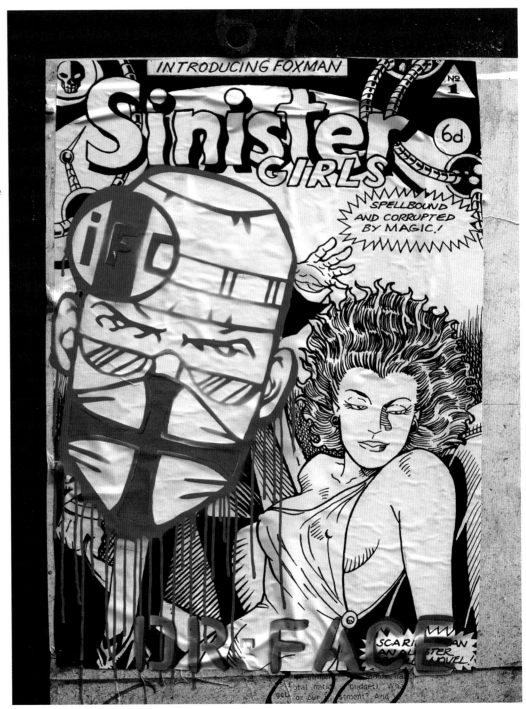

PAUL INSECT

www.paulinsect.com

The fact that Paul Insect's 2007 show at the Lazarides Gallery in London sold out in its entirety before it even opened – with every work purchased by one buyer – must have made a few headlines. He creates rather gruesome, morbid images using vibrant colours. His stickers of baby dolls' heads with a computer chip or something else unusual sticking out of the skull are quite a common sight in London.

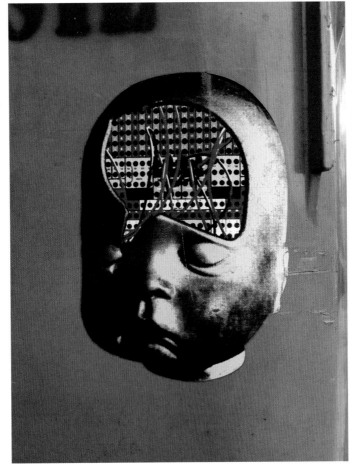

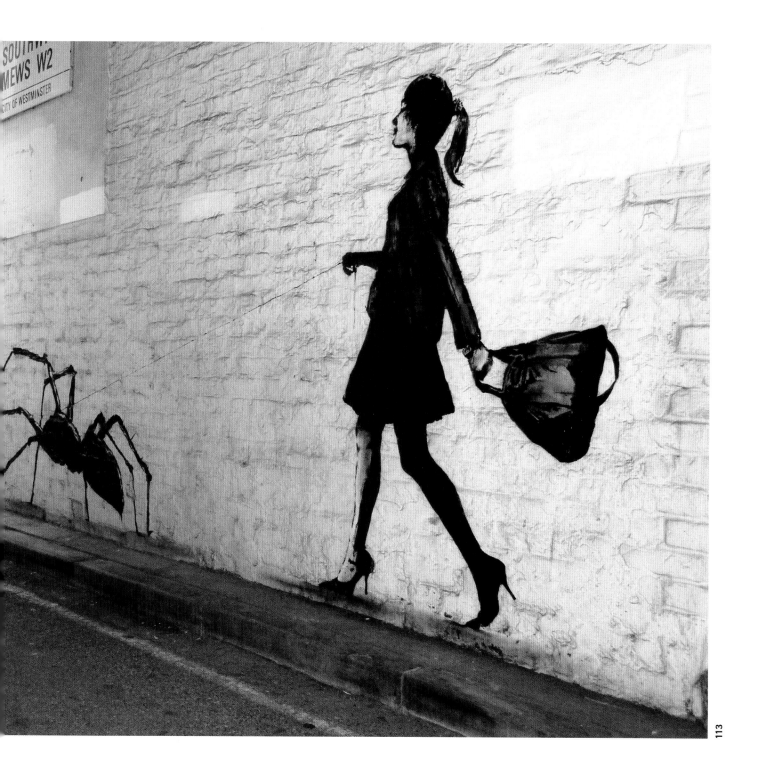

113

INVADER

www.space-invaders.com

When I was still living in Amsterdam there was a Space Invader right around the corner; soon after we moved to London we were literally surrounded by them. Now, three years later, all but one has gone – they are very popular among the street art thieves. His pieces can be found all over the world; his hometown, Paris, hosts over a thousand. The last continent to be 'invaded' was South America in 2011. Most street art has a very limited lifespan, but Invader's glass tiles can last a very long time. Their colour or material doesn't disintegrate, so at least some of them might be there for a hundred years or more, maybe covered by paint or cement, perhaps waiting to be 're-activated'.

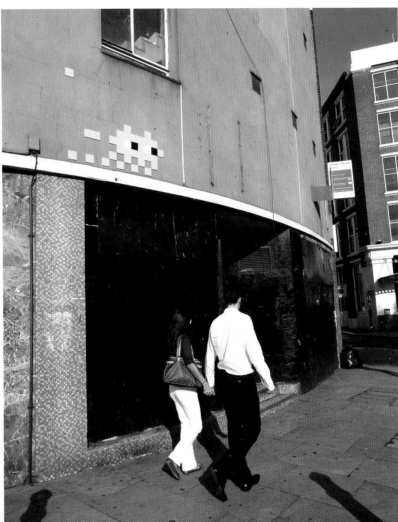

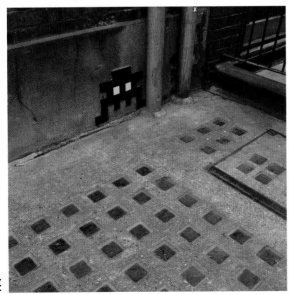

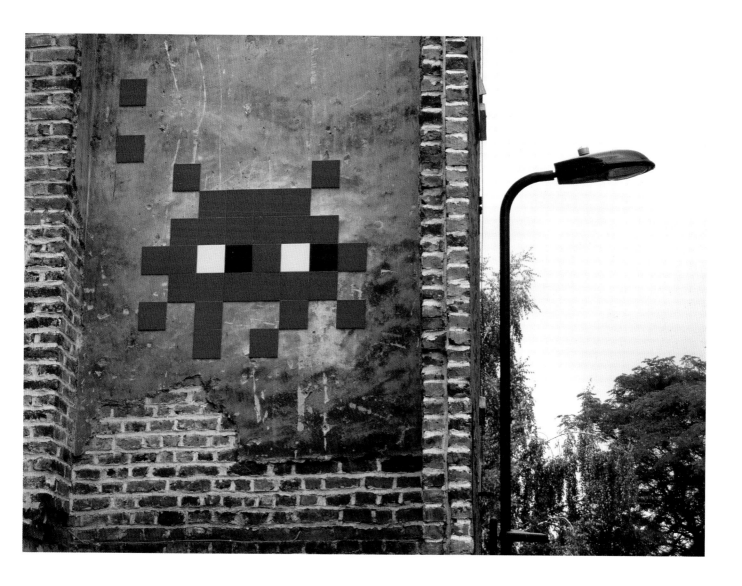

JAK.D

I noticed this small, intriguing poster on Rivington Street, home of a very well-known piece by Eine that says "Scary". I happened to meet Eine (see p74) a day later and asked him if he knew about that poster; he said he had seen it, and that he thought it was a very pleasant surprise.

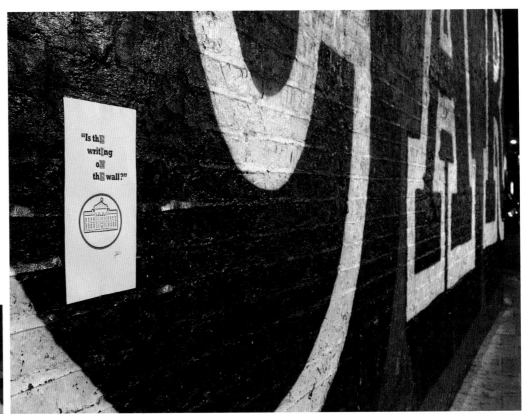

JANA & JS

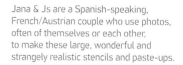

www.janaundjs.com

Jana & Js are a Spanish-speaking,
French/Austrian couple who use photos,
often of themselves or each other,
to make these large, wonderful and
strangely realistic stencils and paste-ups.

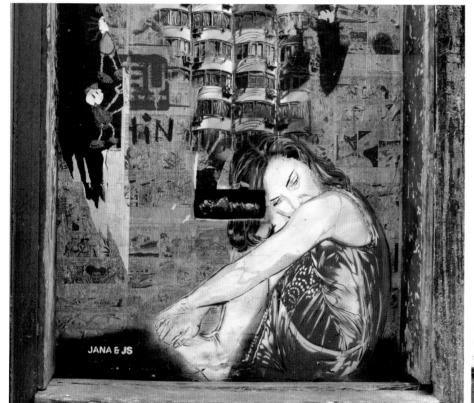

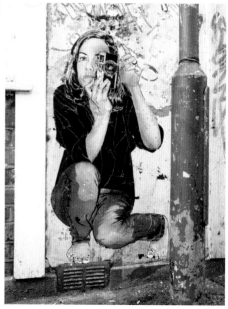

JONESY

www.flickr.com/people/
jonesystreetart

As Jonesy explains on his website: "I am an artist and environmentalist both with my street art and the studio work. I feel, as an artist and someone with a voice, compelled to speak out against the oil and nuclear industries and that is what I am doing."

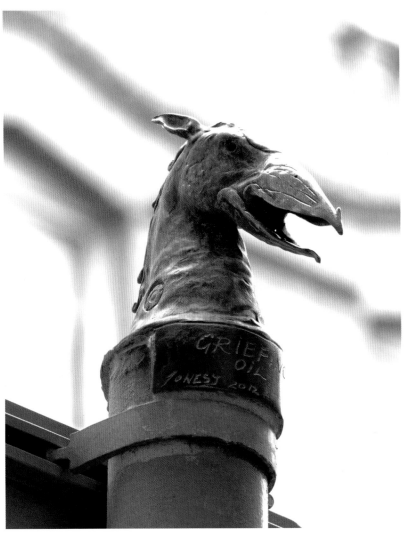

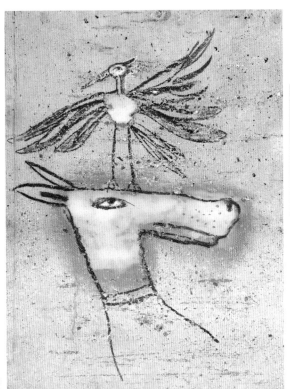

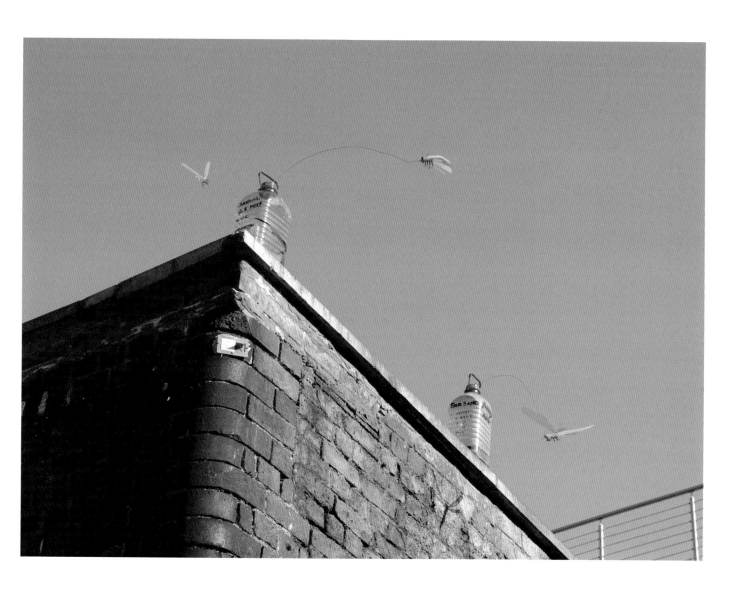

MARCOS JUNCAL

www.marcosjuncal.com

Having studied classical sculpture and
stone carving in Spain, Marcos Juncal
had several exhibitions in Europe before
he began putting up pieces in the streets
of London. "I do not consider myself a
street artist, I simply use the street as
another exhibition space," he comments.
His pieces are a reflection on the ironic
and absurd in our society: consumption,
capitalism, war, love, sex...

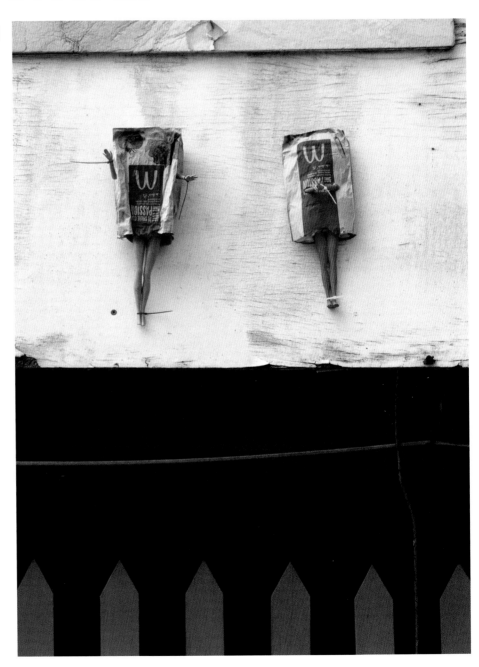

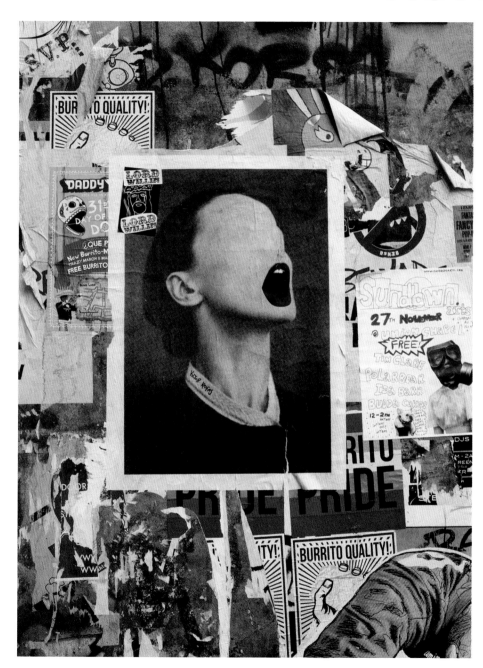

KID ACNE

www.kidacne.com

A street artist, hip-hop musician, illustrator and designer from Sheffield, Kid Acne has put up his work on walls all over Europe and in New York. His first inspiration, in common with so many others, came from Subway Art, then from SheOne and FireDFM and the fantasy art of Frank Fazetta and Boris Vallejo. He made fanzines and a comic book, and records and designs clothes too, but nowadays he is best known for these warrior girls. He creates a fantasy world "which is constantly evolving and becomes more perverted the older I get." Whenever I find one of these wonderful paste-ups, I'll carefully check out the rest of the area, and usually there will be more nearby – but you have to be fast, they tend not to last for too long.

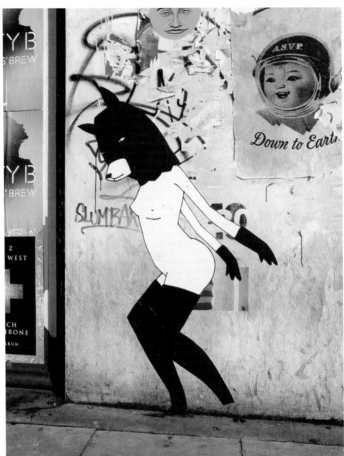

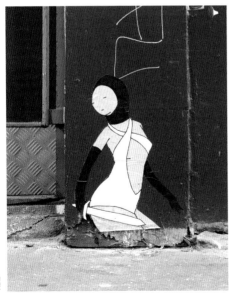

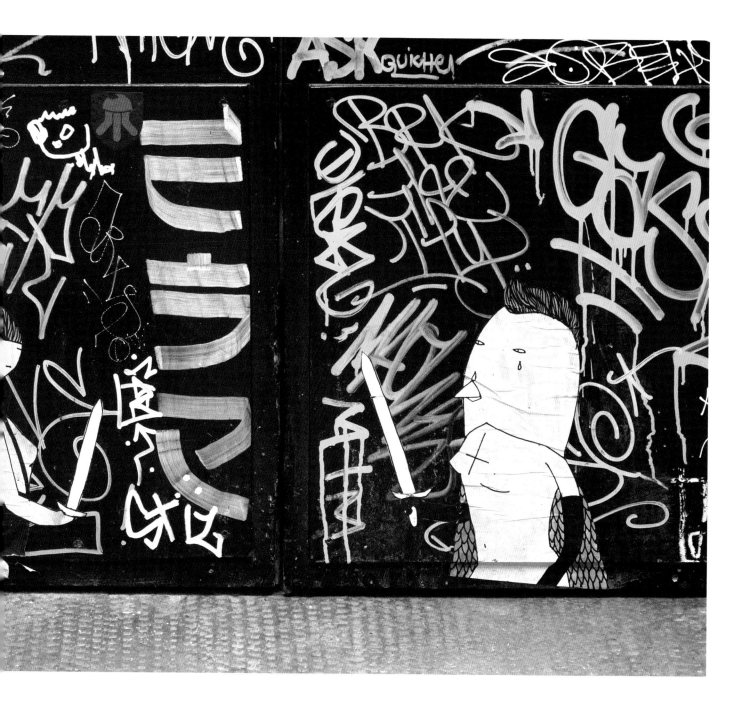

KINSKA

www.flickr.com/photos/kinska

"I just can say that I am never alone in the street, I create all the characters, but I am always surrounded by my friends who help me and encourage me all the time," explains Kinska. "For me street art is just about having fun. I feel like I am playing on the street and not that this is part of my job or work as an artist. I don't consider myself a street artist; I just love the idea of street interventions." A recurring figure in Kinska's street art is La Peregrina, the (female) pilgrim. She creates very distinctive, wonderful images, often of women – look at those eyes! It's always a great joy to find one of her new street art pieces.

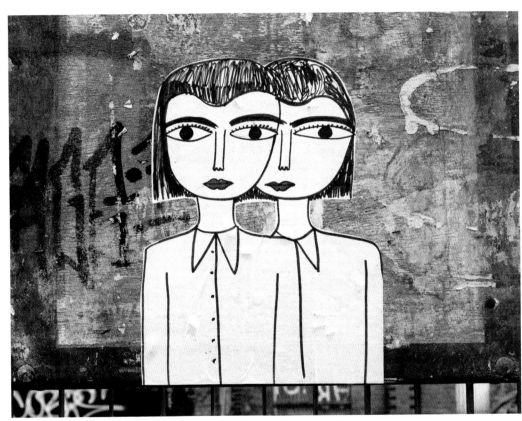

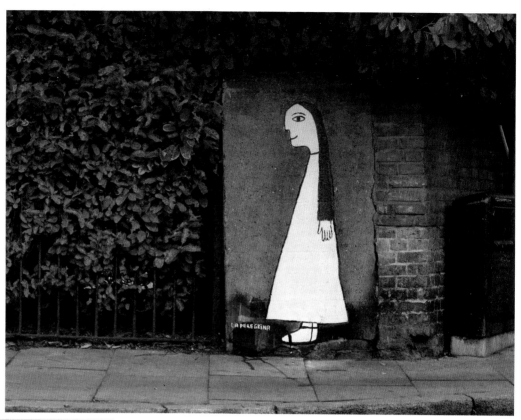

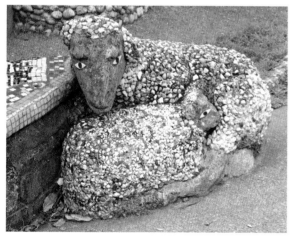

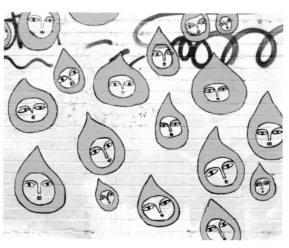

DAN KITCHENER

www.dankitchener.bigcartel.com

Dan Kitchener is an English artist,
designer and illustrator. I especially
like his very high-contrast paintings
of tunnels, mainly in black and white
with a little red. If you think great art is
unaffordable, look at the website above.

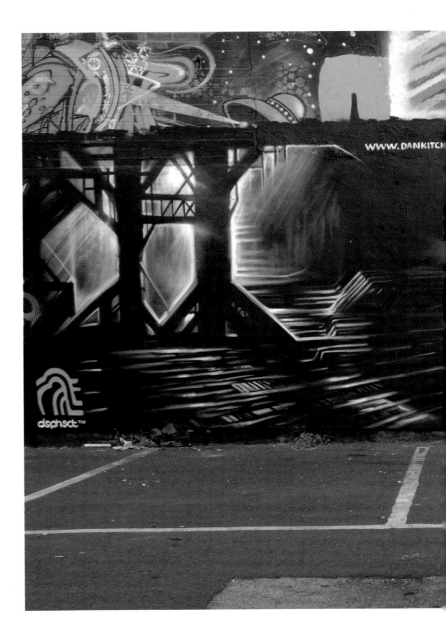

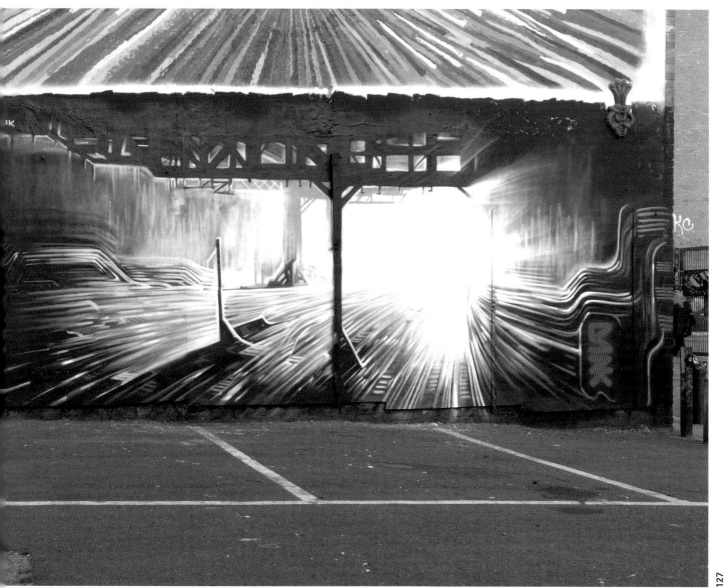

KLONE

www.kloneyourself.com

Klone was a metalworker and printer before, and he still works with metal and he still prints. However, these days he mostly paints. He is from Ukraine and lives in Tel Aviv, Israel. He says his characters "at first appear unreal, but by looking at them deeper you will always see something of yourself." He sees people basically as predators. He published a book of his work and participated in the Inside Job exhibition about street art at Tel Aviv Museum in early 2012, a show that attracted 40,000 visitors. Know Hope (see p129) and Broken Fingaz (p42) were showing there as well.

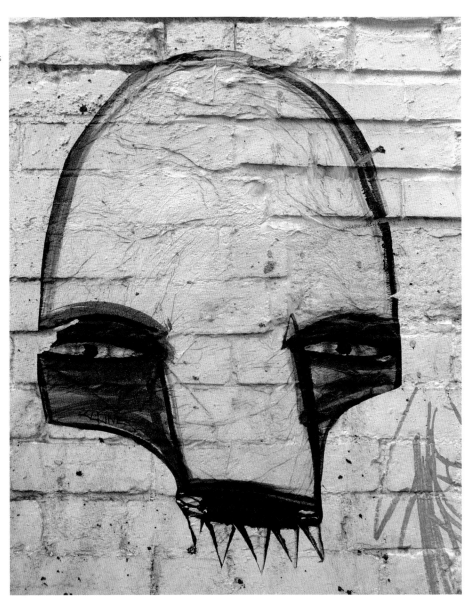

KNOW HOPE

www.thisislimbo.com

Know Hope's work is a narrative. It's about one easily recognisable, struggling figure with long limbs and a removed heart who strongly interacts with his surroundings, such as the wall he is painted on. Know Hope was born in California but moved to Israel at a young age.

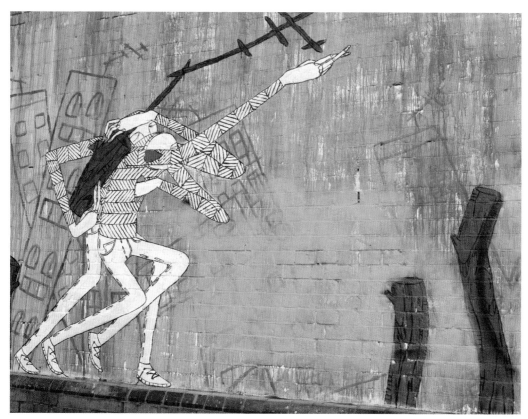

THE KRAH

www.thekrah.com

The Krah, whose name derives from a Greek phrase for the corruption of a political regime, moved to East London from Athens. He is a freelance illustrator who still frequently works on the street, but who also shows his art indoors.

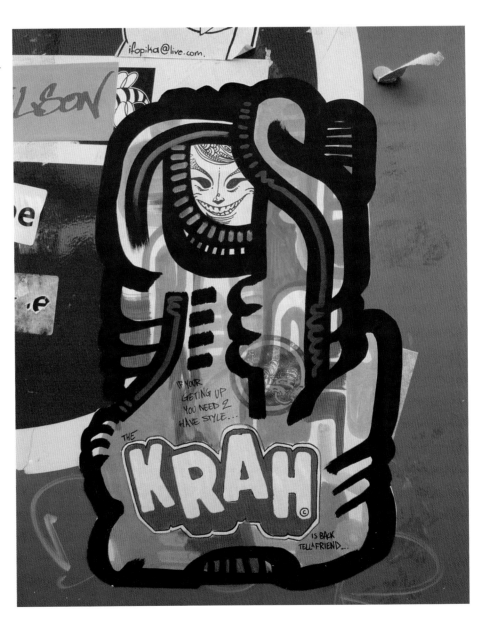

KRAP

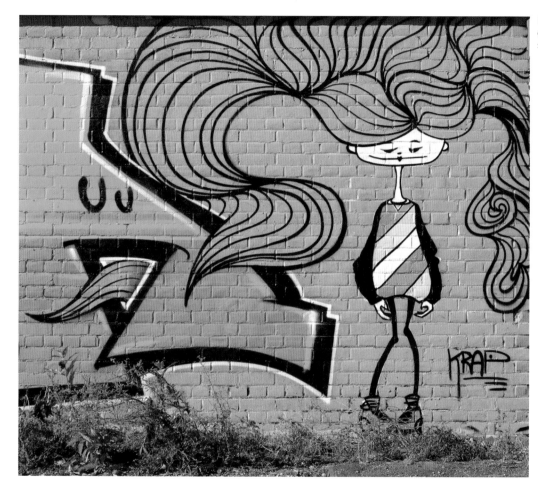

I know nothing about Krap, except that he or she chose a pretty silly name. I like the style though.

KRIEBEL

www.flickr.com/photos/kriebel

Kriebel is a street artist and street art
photographer from Ghent, Belgium.
If you think I have a lot of photographs
on my site, he has ten times as many.
Check him out.

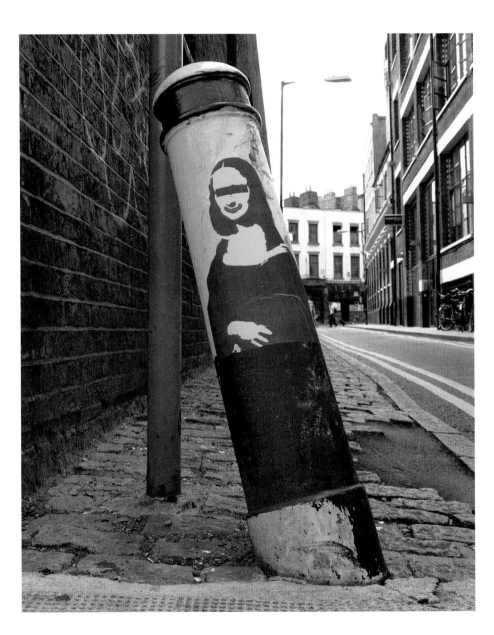

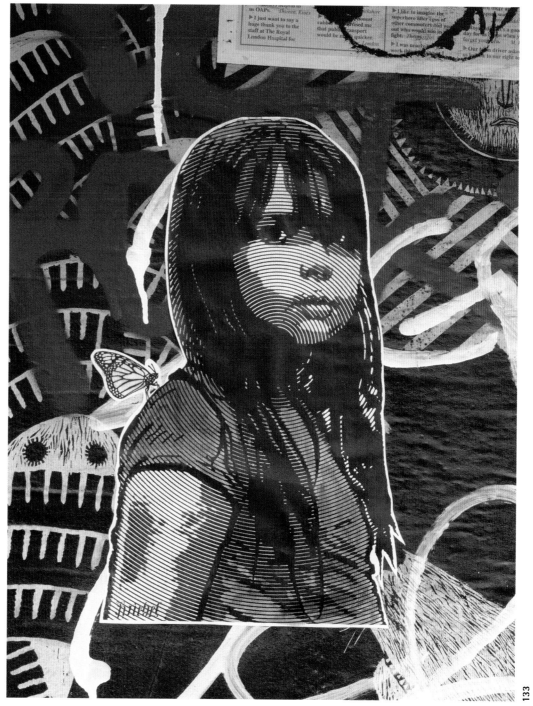

LASER 3.14

www.laser314.com

Before I came to London, I lived in
Amsterdam. There, a guy calling himself
Laser 3.14 would put up intriguing
slogans on hoardings and walls. Some
people thought maybe they were quotes
from songs by Bob Dylan. Now, that's a
compliment I'd say. Then, much to my
surprise, I started noticing them in our
new neighbourhood of Shoreditch too.
Having always been into documenting
and collecting things that I find interesting
and important enough, I started taking
pictures of Laser 3.14's work. But there
was much more than just his work on the
streets of London – and that's how this
book came to be. Thanks Laser 3.14.

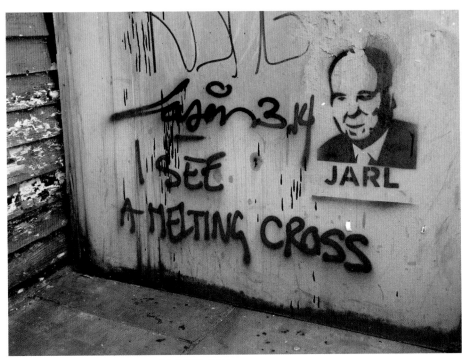

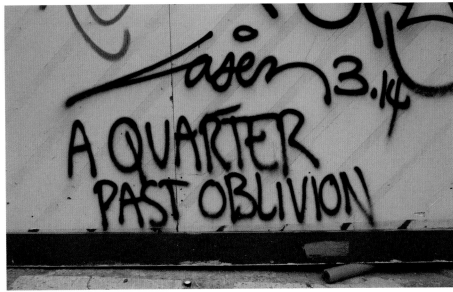

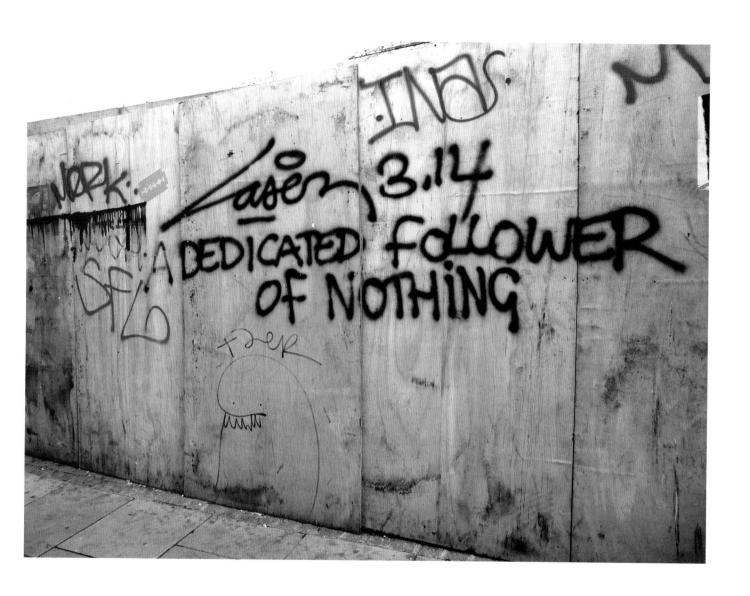

BORTUSK LEER

http://www.flickr.com/groups/
bortuskleer/pool/

The artist's biography offers some insight
into his style: "The fruit of forbidden love
between a lion tamer and a candy floss
seller, Bortusk Leer was forced to find
his own way in the Socialist Republic
of Slovenia. Though his early years are
shrouded in mystery (some say circus,
some say tractor barn), by his teens
Leer could be found joyfully daubing the
walls of his homeland with fantastical
childlike characters, psychedelic vermin
and inhuman collage. Art comedy
was born and Leer never looked back,
particularly when being chased by the
secret police with big-headed pictures of
Lenin streaming out behind him, always
sporting the trademark top hat and cane
he had won wrestling a Turk on the quay
of Messina."

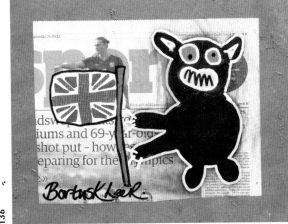

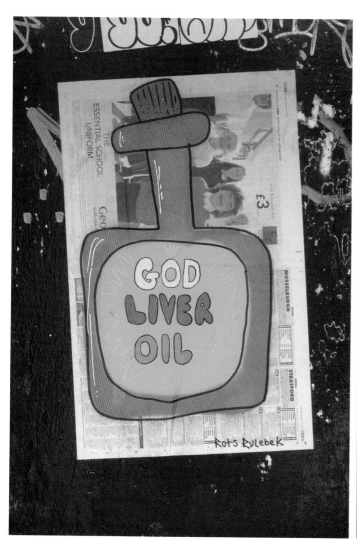

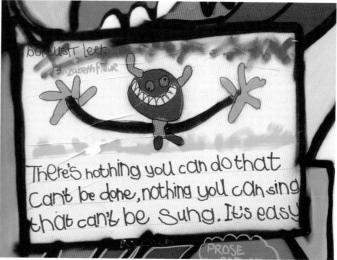

LISK_BOT

www.flickr.com/photos/liskbot/

Lisk_Bot, a "part-time vandal" from Birmingham, has been stickering since 2004. He is building an army of robots, but is not sure what the army will have to do eventually. This video shows him working in the streets of Shoreditch with his friends Wah and Mew: www.youtube.com/watch?v=mjqbrIK3nLY

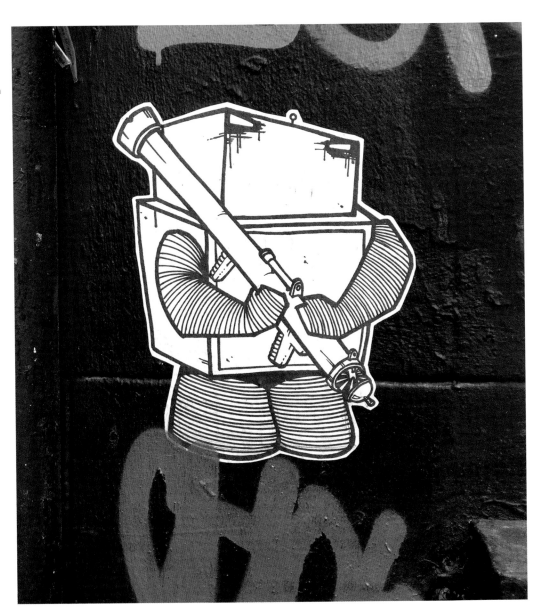

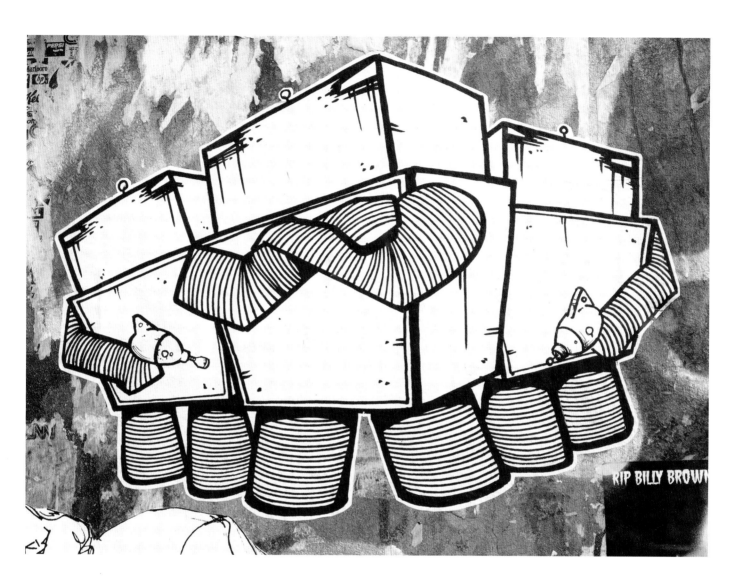

RIP BILLY BROWN

139

ANTHONY LISTER

www.anthonylister.com

Anthony Lister grew up around
skateboarding and graffiti. He is a
classically trained artist from Australia,
living in New York, showing his work
in galleries and in the street. "I test
myself in my books. I test myself in my
paintings. In the street I just want to
enjoy it," he says. "I'm not out there in
the street really trying to prove anything...
that's just what I do for fun."

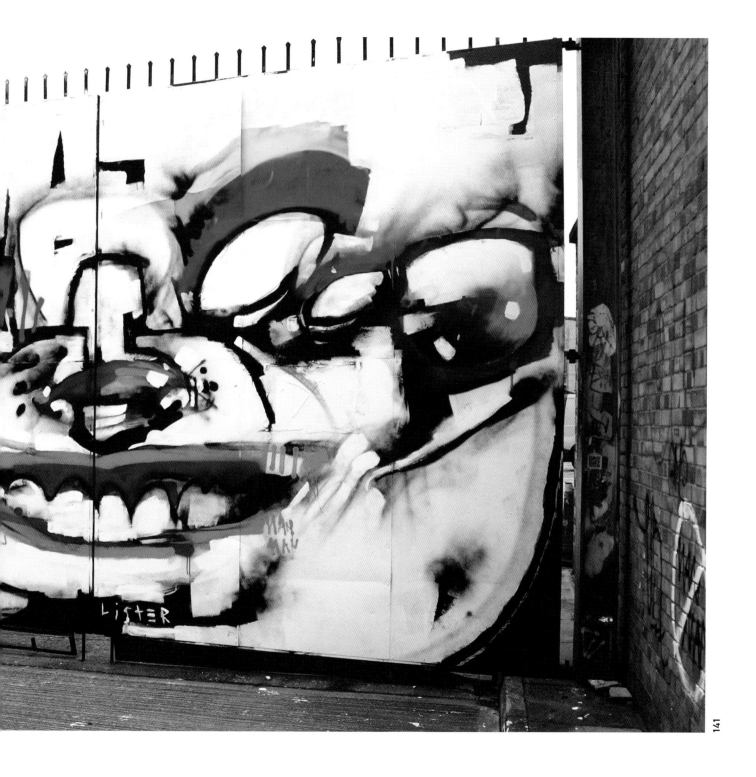

LISTER

LOVE PIEPENBRINCK

www.lovepiepenbrinck.com

Love Piepenbrinck, from Hamburg, Germany, are crazy about piggies. I love their piggies. Indeed, I am the happy owner of one that came down from a wall, and which I picked up and brought home. It's too bad that many people like them so much that they steal them. But be warned, this is what they have to say on the subject: "If you find them in town, smile at them. If you have to, touch them, they like streicheleinheiten. But don't remove or take them away! Cos sooner oder later I will get you, you Hosenscheisser."

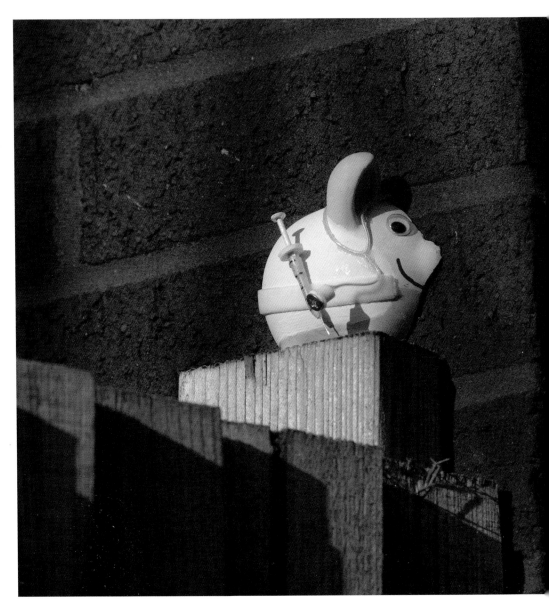

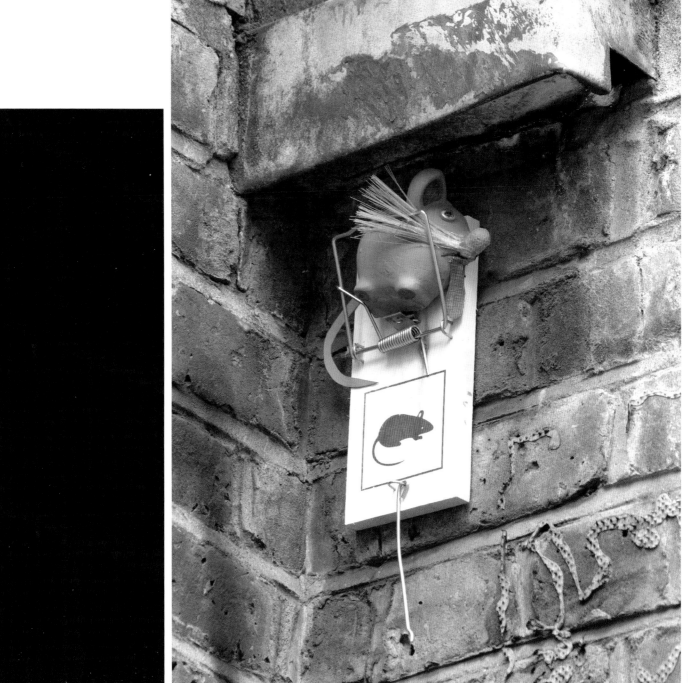

LOVE PIEPENBRINCK

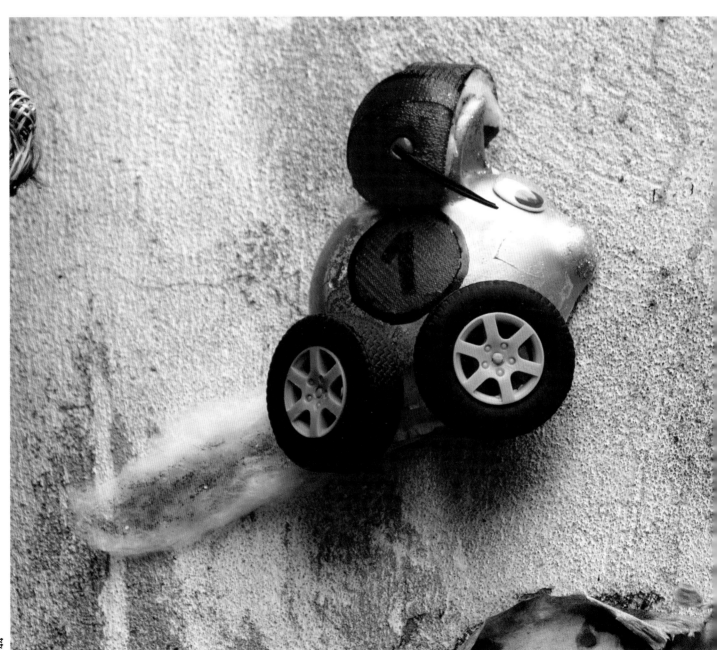

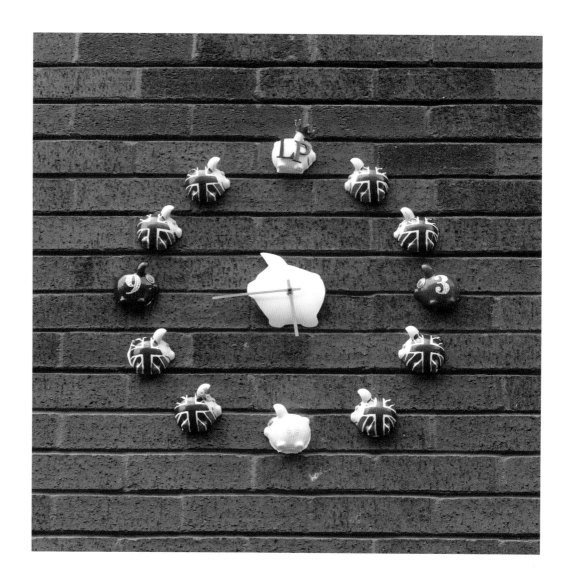

MACAY

www.macayanez.com

Macay was the first street artist I met in person. She was quite thrilled when one of my photos of her work made it into *VNA Magazine* shortly after. Her first street art was making suits for street dogs in her hometown, Santiago de Chile, and later she gained a Masters of Fine Arts from Central Saint Martins, London. With her photocopied collages of weird creatures, often in holiday-like situations, I think she tries to bring a little nature and holiday feeling into the city.

MALARKY

http://malark.blogspot.co.uk

If you were ever in Shoreditch in 2012 you will have seen the work of Malarky. It was all over the place and very hard to miss. Maybe it still is. Too bad his pieces sometimes get vandalised by people angry with him for doing commercial jobs; he keeps coming back to fix them up nevertheless.

MANTIS

www.themantisproject.co.uk

Mantis had a spectacular exhibition in Hackney Wick in 2010. The show was more like an installation; the rooms in the derelict ex-pub were furnished with old tables and chairs, the old wallpaper was still there, and there were no prices or nametags with the pieces. It was like visiting an abandoned home with the pictures still on the wall. Mantis' work is often taken for Banksy's; the artists share the same technique and both comment on consumerism and the hypocrisy and self-destructiveness of modern society, albeit always in a humorous way.

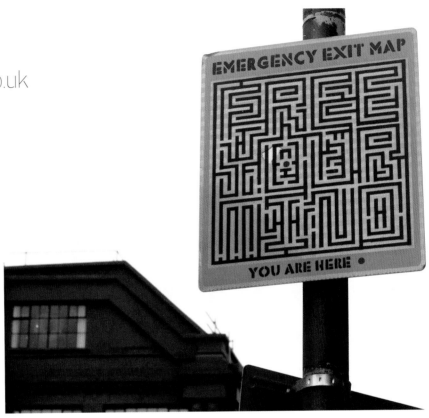

MASAI

www.louismasai.com

Masai is best known for his large humanised animals, or 'humanimaltations' as he calls them, created to investigate the animalistic background of mankind. Early in 2012 he and Linda Zina created Nice Up the Walls, a very successful project taking street art to Jamaica to brighten up the walls of the hurricane-stricken island in the 50th year of its independence.

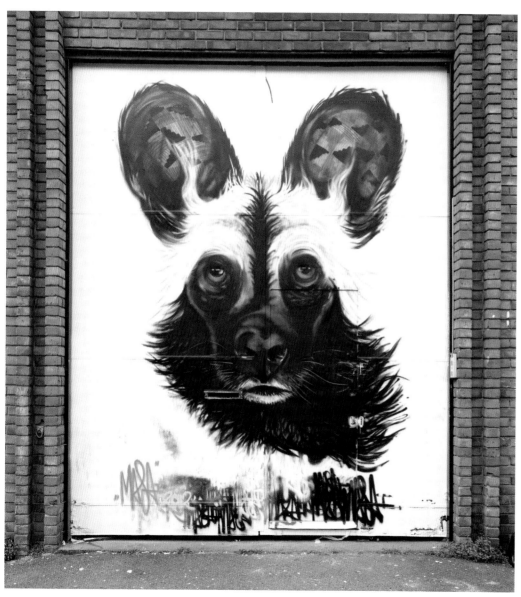

MISO

www.cityofreubens.com

Miso is from Ukraine but lives in Melbourne, where she studied philosophy. She creates her work "to document characters and ideas that would otherwise be forgotten." Working mostly in pencil, there is something wonderfully modern and old-fashioned at the same time about her art. She has made a lot of drawings of women in folkloristic outfits, like these two ladies in cut-out paper, guarding the entrance of a house on Charlotte Road in East London.

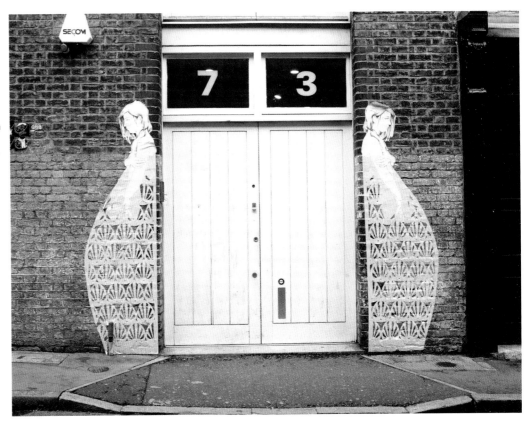

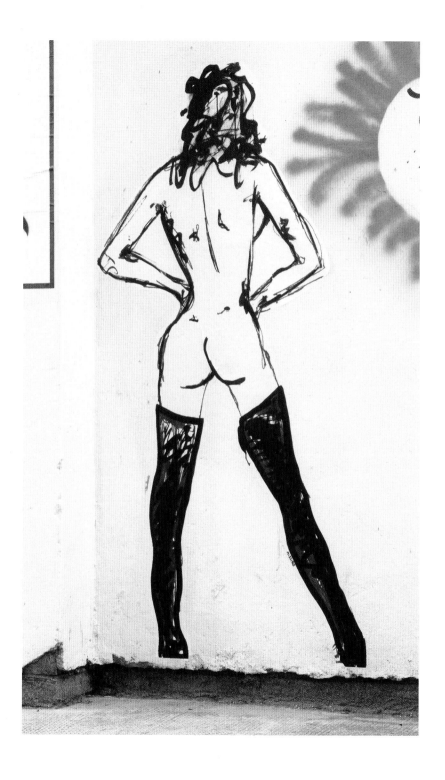

MISS150

www.flickr.com/photos/ odipuss77

Miss150, or Odette as (his or her) real (?) name might be, is from Birmingham. Odette wrote to me: "My ladies are quick sketches inspired by the women depicted on 'calling cards' that I have collected from London phone boxes for the last few years. They are representing strong sexual female characters! I am absolutely not a feminist; I just love the fact that some women take control of the male gaze and use it to their advantage."

MISS BUGS

www.missbugs.com

I found this piece some time in 2011 and I was really confused. The thing was just standing there as if it was waiting to be taken home by somebody. I had heard of 'free drop-off' pieces that are left on the street by the artist for the lucky finder, but this was way too good. It definitely didn't feel right to take it; it blended in with the background so perfectly. So I took a bunch of photos and left it there. Should I have taken it...? The work is from Miss Bugs' Cut Out/Fade Out series. There are more here: www.creativereview.co.uk/cr-blog/2011/october/street-installations-by-miss-bugs

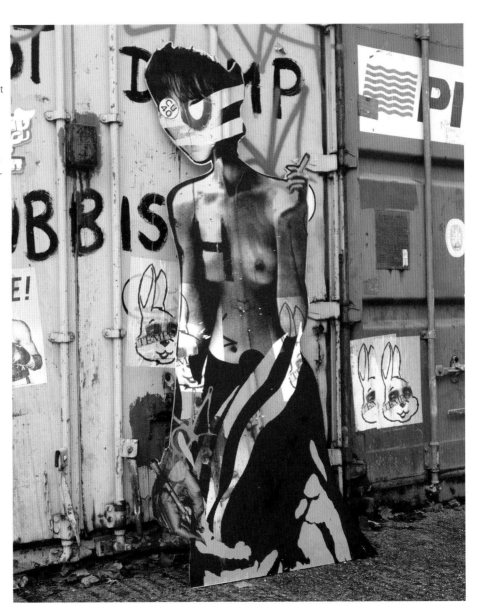

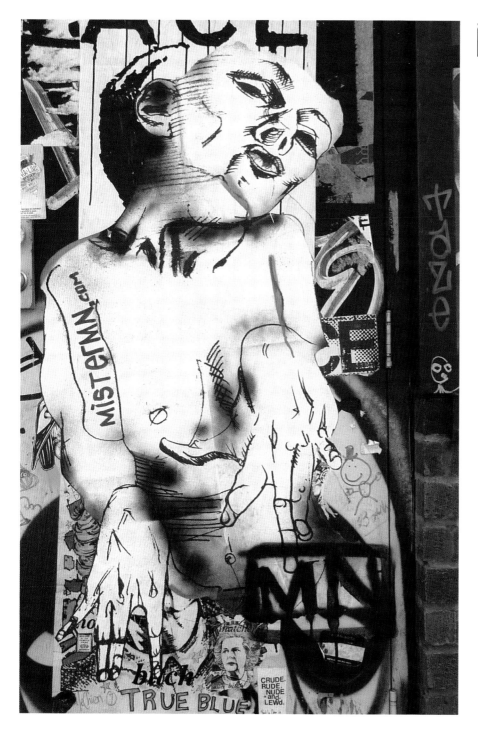

MISTERMN

www.facebook.com/
mistermn

Mistermn, aka Ese Nag Nam, from
France, combines spray and oil paint, in
the same way that he uses a modern
style of painting while being inspired by
mythology, philosophy and esoterism. He
photographs his models to create images
with strong expression and emotion and
then uses an array of techniques to get to
the final piece.

MJAR

Little is known about this gentleman, except what Olive47 (see p178) has to say about him: "Mjar is cool 'cause he gets mistaken for an American often and I get mistaken for Irish. So maybe we can trade identities. He is also very fun to go to art openings with. Yes, he is cool."

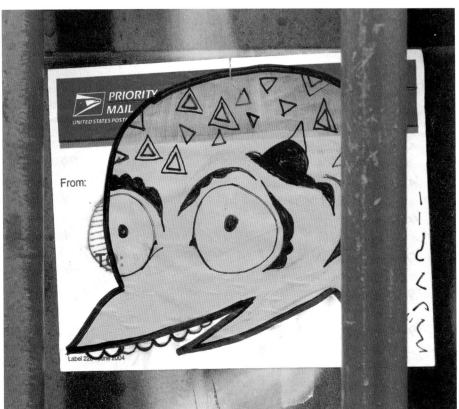

MOBSTER

http://mobstr.org

In his own words: "I like to take the piss out of advertising but I use it also as an excuse. If they can put up massive billboards wherever they want just because they've got money to do it, why shouldn't I?"

ALEC MONOPOLY

www.alecmonopoly.com

Alec Monopoly is the guy behind
Monopoly Man, his way of reminding us
about the state of the economy and of
society. He was taught to paint in New
York by his mother, an artist, but later
followed his girlfriend to Los Angeles,
where the ever-present billboards
became his favourite type of canvas. It is
important to Alec that through his work
people are confronted with art; people
who normally aren't.

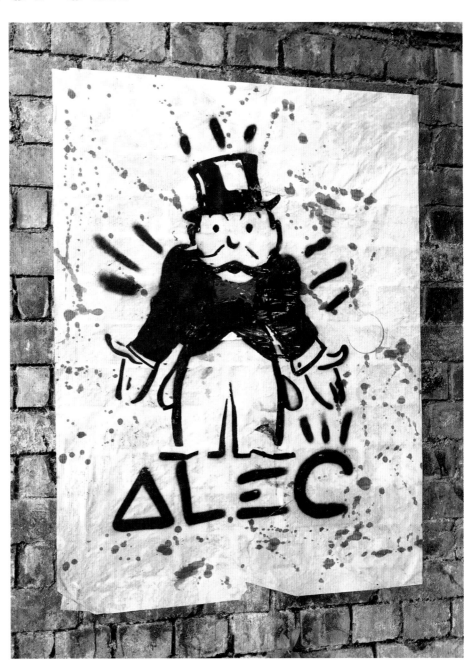

MORLEY

http://iammorley.squarespace.com/

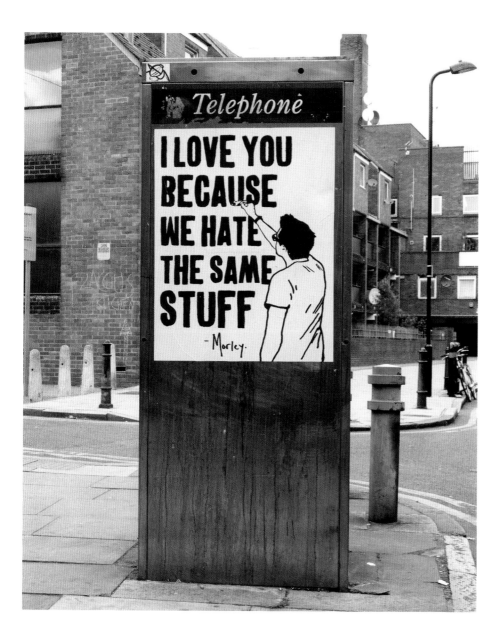

I don't usually take photos of slogans because, well...because they are slogans, but I do make exceptions, like for Laser 3.14's work. Morley's pieces are much more than slogans though; by including his own image in the picture as the writer, they have a very active feel. He has got something to say and to make you think about, and he does that in a very effective and funny way.

GEORGE MORTON-CLARK

www.gm-c.co.uk

George Morton-Clark says he is probably the most unspiritual person in the world. You don't often hear that. My kind of guy! His colourful but dark and distorted figures show strong emotion and can be quite breathtaking, literally. In 2010 he had some paintings removed from a US-based group show for being too disturbing – quite an accomplishment these day.

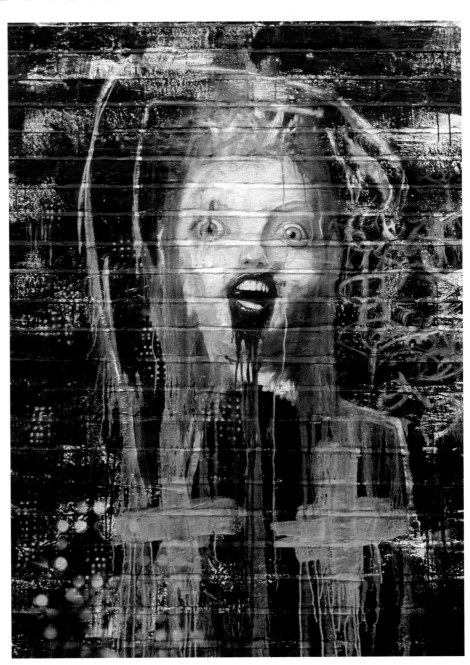

MR FAHRENHEIT

www.mrdotfahrenheit.wordpress.com

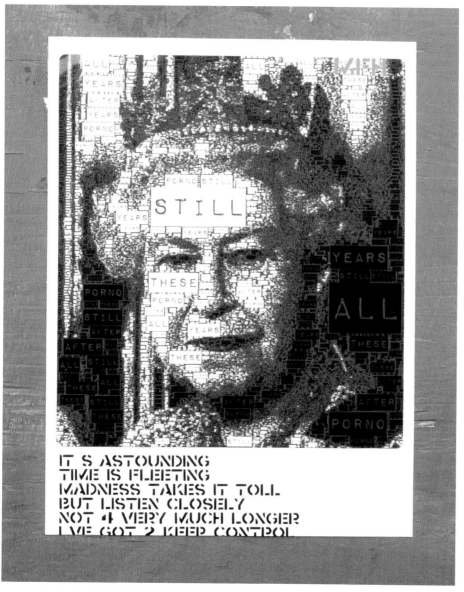

Mr Fahrenheit was born before the Internet in the town with the biggest canvas in Europe – Berlin. He grew up with graffiti on his doorstep. Instead of listening to his mother, he bought some blades, cans and cardboard and took his father's unread *Financial Times* to create his unique style. And he got to the point – telling everybody "U R SO PORNO BABY!"

MR FAHRENHEIT

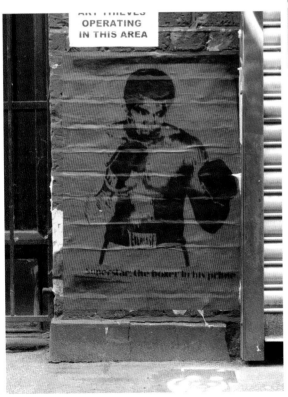

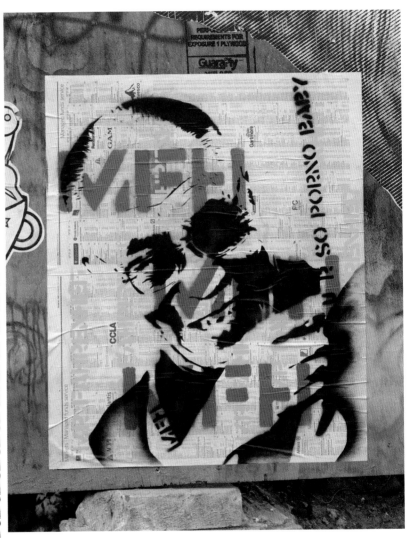

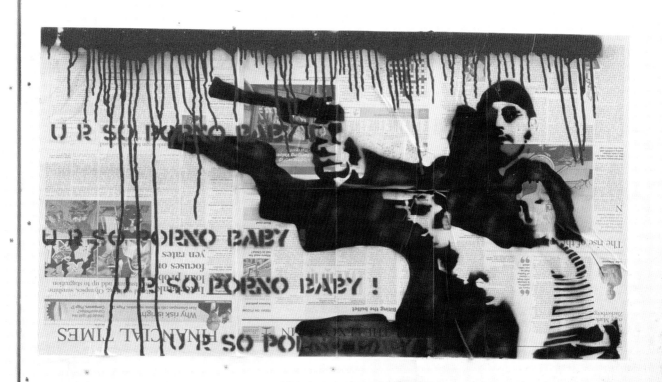

DELIVERY

ERNESTO MUÑIZ

www.youtube.com/watch?v=p24jm6tC1ZU

This collage by Mexican artist Muñiz is from 2011 when he visited England for an 11-day stay at the Corke Art Gallery in Liverpool. The show was called Unholy Heart.

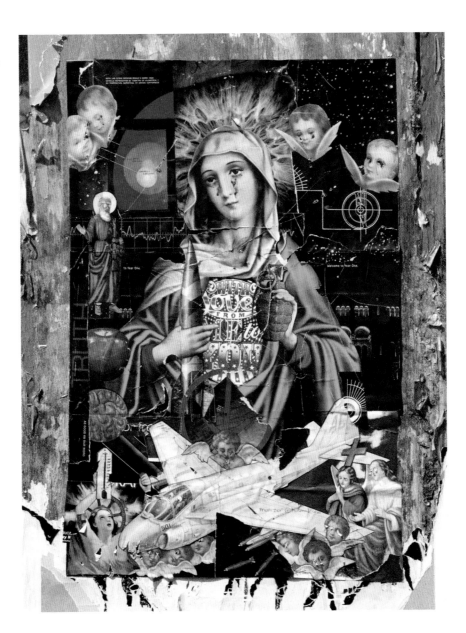

CHRISTIAAN NAGEL

www.christiaannagel.co.uk

Nagel's enormous polyurethane mushrooms were all over the East End in 2010 and 2011. They are like ideas that can pop up anytime, anywhere. He had a wonderful show in the Rich Mix on Bethnal Green Road; it must have been the most colourful exhibition in London that year.

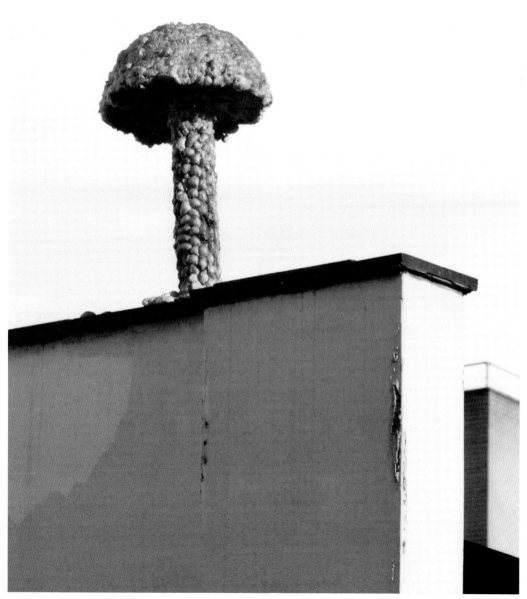

NATURE'S REVENGE

www.thisisludo.com

Nature's Revenge is a project begun in 2006 by Ludo, a Parisian who studied sociology and art. He paints a terrifying picture of how nature might get back at us at some point. His grey, white and green paste-ups of mutated plants and animals armed with every imaginable weapon, CCTV cameras, syringes and skulls are all about how mankind has lost touch with nature, and the eventual consequences thereof. Ludo's work is not a radical ecological concept though; it's about respect for the world we come from, a world we are supposed to take care of. He doesn't think about his pieces as science fiction. Instead, he warns us that the world of science fiction has already entered our world; that the boundaries between these worlds are rapidly fading. Ludo makes the original drawings himself and then reworks them using CAD (computer aided design) software that helps to give his work its futuristic appeal.

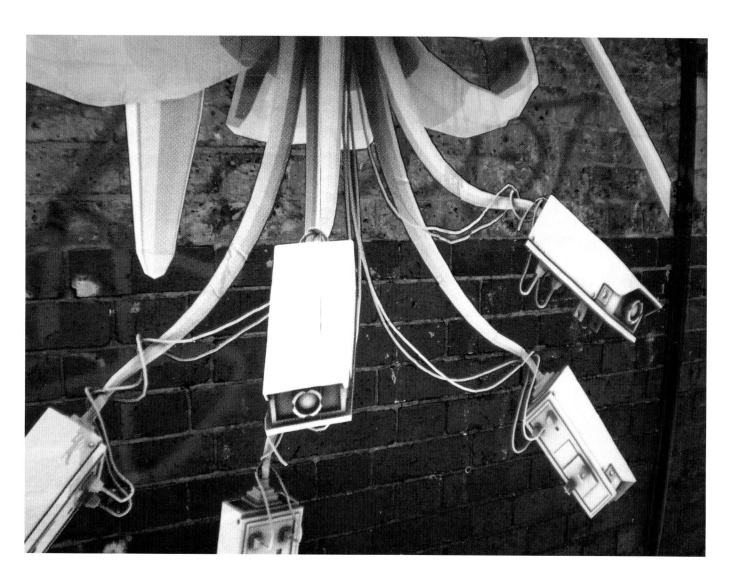

NATURE'S REVENGE

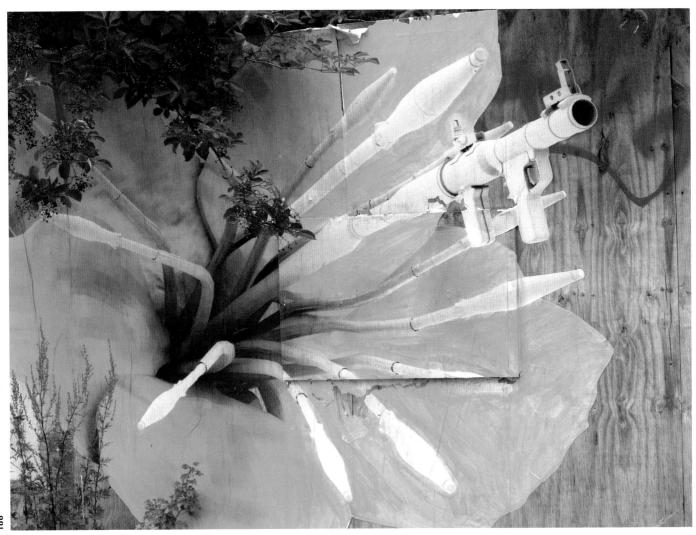

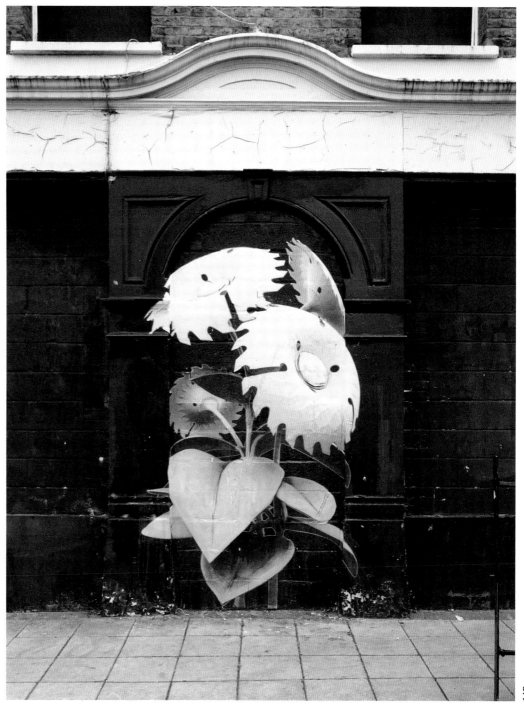

NIKITA

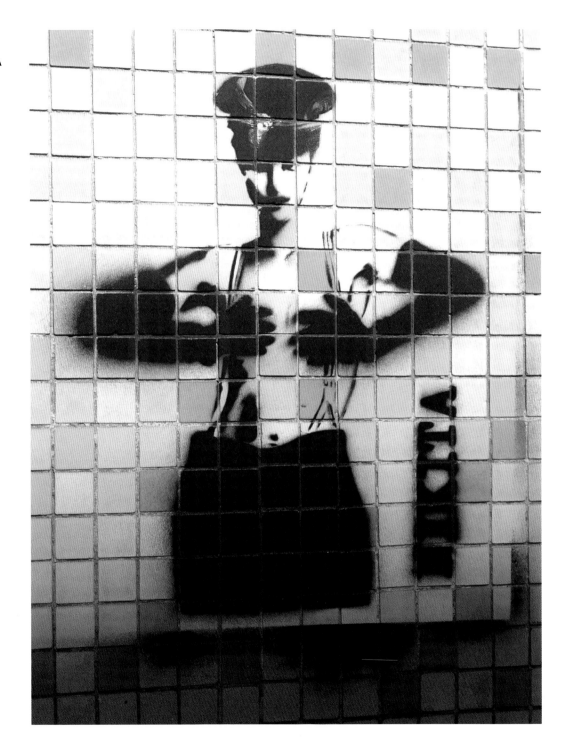

NONOSE

www.flickr.com/photos/dgbalancesrocks/143639184

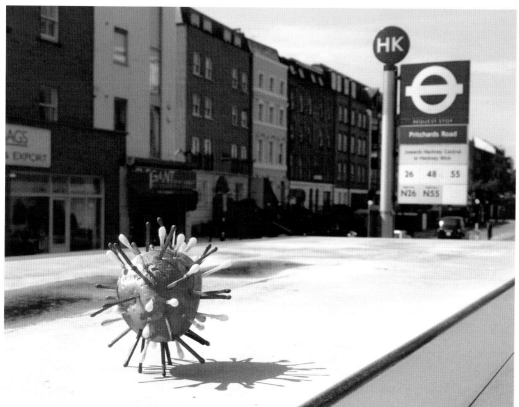

Nonose paints, lacquers and decorates large potatoes, and then puts them on top of all the bus shelters on a certain stretch of a London bus route, often the Number 55 I think. It's interesting to sit on the upper deck of one of these buses and to study the reactions of the passengers. Many do not notice them; others get all excited and can't wait till they get to the next stop. When I saw them first, I got myself a stepladder, walked the route and photographed each one. I've done that a couple of times now. Once, while on my ladder, a young man approached me. "Hey man! Do you know about these things?" he asked. "Please tell me, that's one of the main questions in my life man! What are they? I am wondering about those for years – please?!" I was happy I could help him out – I solved one of the crucial questions in somebody's life!

NONOSE

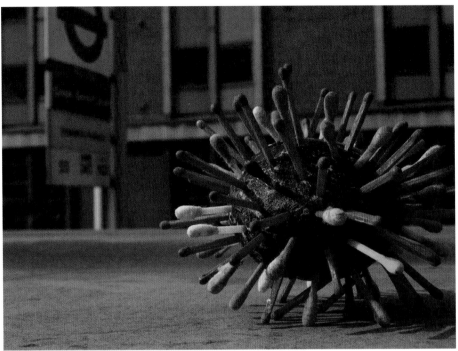

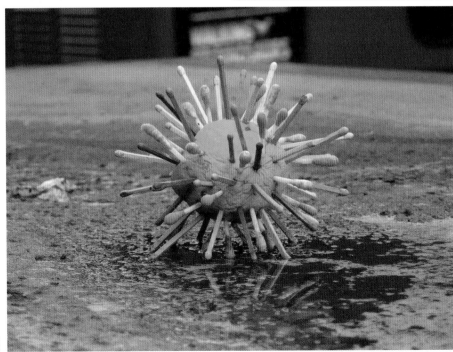

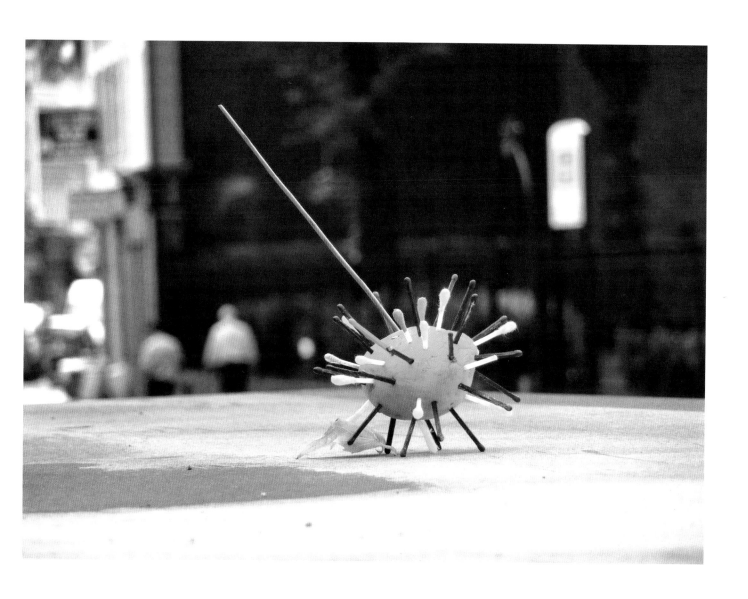

NOT SOUP

While taking a photo of this work, the maker introduced himself to me. "Andy Warhol drank soup, not me, I drink ouzo," he explained.

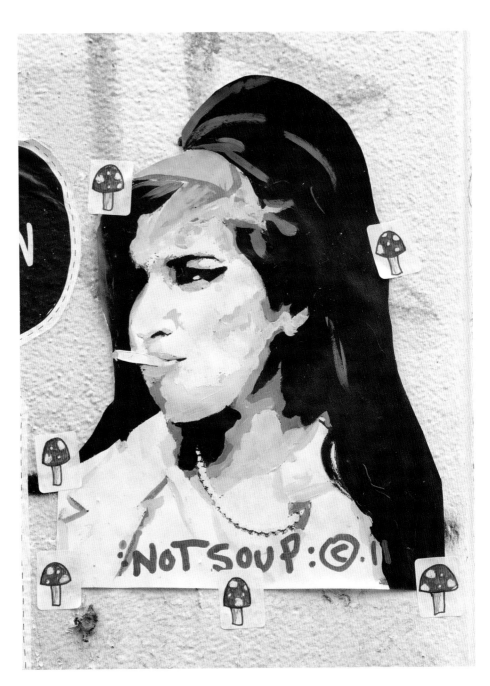

BEN OAKLEY

www.benoakleygallery.com/

"Why listen to other people's preconceptions about how to pigeonhole yourself; the whole purpose of art and creativity is to be free and express oneself." So reads Ben Oakley's life statement. He runs a gallery in Greenwich, where he has shown, amongst others, Jo Peel, David Bray and Otto Schade. The image here is a drop-off piece by Ben that I found on Whitby Street, Shoreditch. Thanks very much Ben!

OEPS

www.flickr.com/people/oepscrew/

Oeps is two anonymous girls from Copenhagen. When they started making signs on pegboards using Hama beads they had no idea of the concept of street art, but before they knew it they were part of the movement. I confess I had to think a bit about whether I was going to photograph this when I first saw one of their pieces, but hey, they are great. I always love to see new material up there!

OLEK

www.agataolek.com/home.html

The most famous photo of Olek's work depicts the Raging Bull sculpture in Wall Street dressed in a crochet cover made especially for it by the Polish artist. Although she works with wool, Olek doesn't consider herself a 'knitting graffiti' artist. Her goal is to create a response to the economic and social reality and share it with the public. She had a great show in 2012 in Tony's gallery in East London, when she turned the whole place into one big crochet apartment.

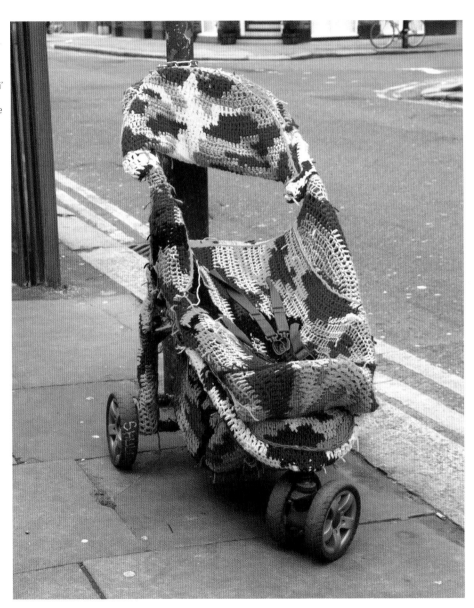

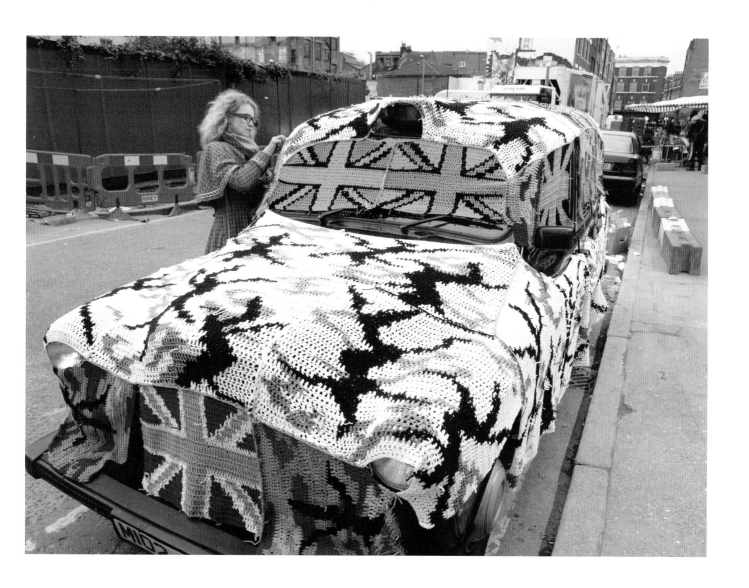

OLIVE47

www.olive47.com

In her artwork Olive47 combines her love of nature with her interest in the concept of 'cuteness'. She lived and pasted in London for a while, but her birds there are becoming increasingly rare. I hope she'll be back soon. She's a member of an interesting cult: The Children of the Multiprismed Light.

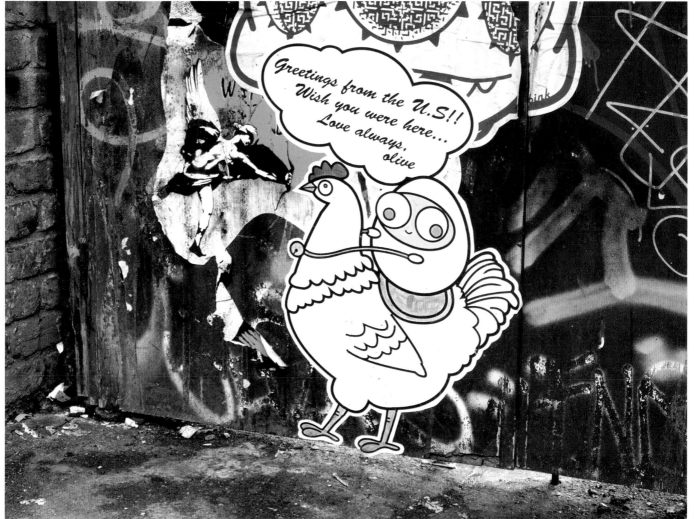

OLIVIA

www.flickr.com/ people/Olivia

Olivia is a Spanish woman living in Barcelona. She's a textile designer for the fashion industry and teaches plastic arts to high school children. Having started creating street art at the age of 35, she depicts the type of women she likes – strong but feminine. When she was condemned to do community work for the city after having been arrested for her street art work, she got the chance to teach some kids how to do graffiti!

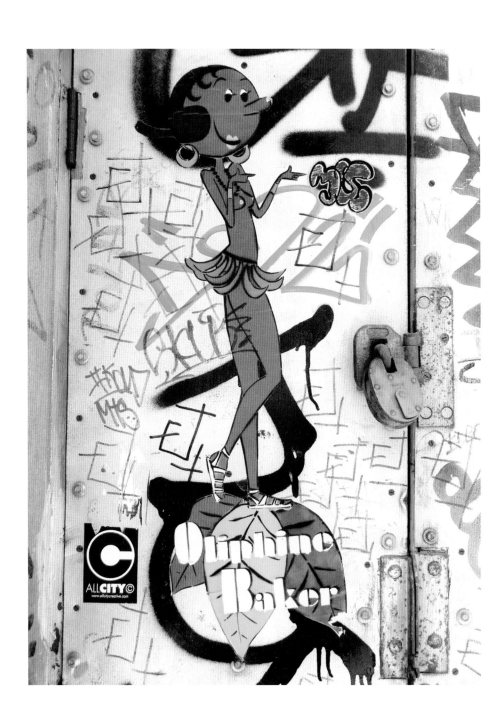

PHLEGM

http://phlegmcomics.com

Phlegm is a Welshman living in Sheffield, where he makes and sells comic books. While studying fine arts he was often rather bored with the material being taught, and would amuse himself by sketching in class; after finishing his studies he continued sketching, which led to him making comic books. Nowadays he also creates street art and prints. He uses colour in the prints, in contrast to his other work, which is in black and white. He uses the same unique pen and ink style for his graffiti (as he calls it) as he uses for his comic books.

STEVE POWERS

www.firstandfifteenth.net

Steve Powers from Philadelphia signs
with his graffiti name ESPO (Exterior
Surface Painting Outreach). This piece is
on the Village Underground in Shoreditch.
He started out doing illegal stuff, but
was eventually awarded a Fulbright
Scholarship and had a solo exhibition at
the Pennsylvania Academy of the Fine
Arts. Steve has published several books.
I tend to ignore slogans, but his work
is much more than that; his texts are
created like paintings.

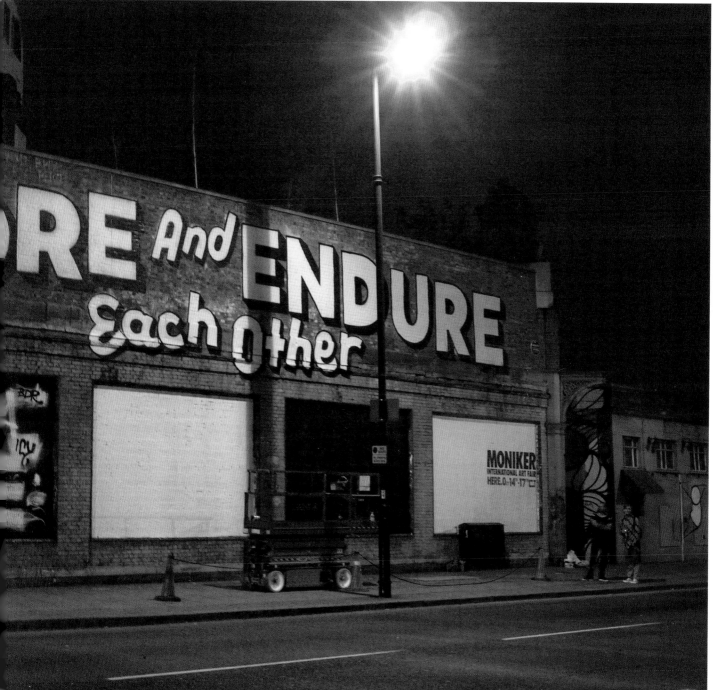

PUBLIC SPIRIT

http://publicspirit.net

Sometime in 2011 Stik (see p214) called me up. I had just come home from a very long photo-round in Shoreditch. I was tired and hungry. "You have to come over here; I'm in the Signal Gallery. Public Spirit is here!" I had to get up and go – the chance to meet this guy might not come again in years. I knew that he was a very enigmatic person. Very little is known about him, but rumour has it that he doesn't have a phone – not even a landline – and that he doesn't participate in shows. I went to the gallery and we were introduced. He turned out to be a super-nice guy. He said that when he saw the photos of his work on my site, it "blew me away," and he gave me one of his stickers. A memorable evening.

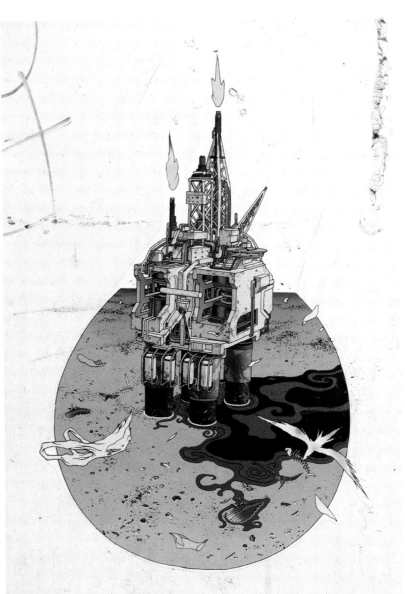

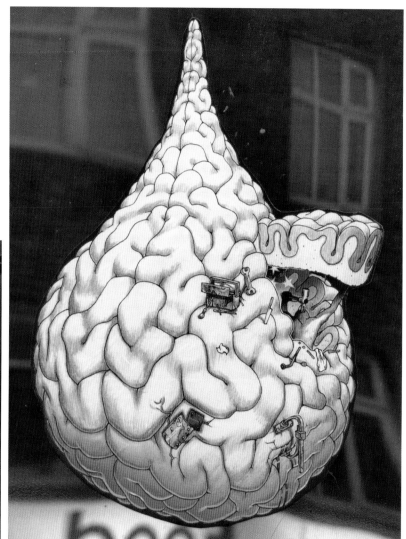

PUBLIC SPIRIT

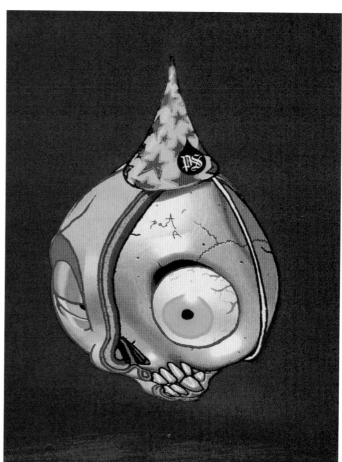

PUBLIC SPIRIT

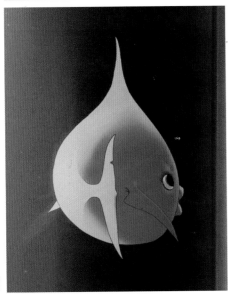

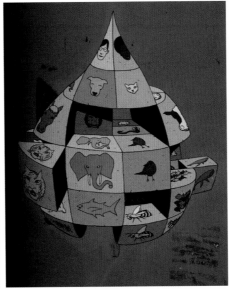

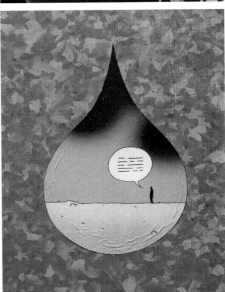

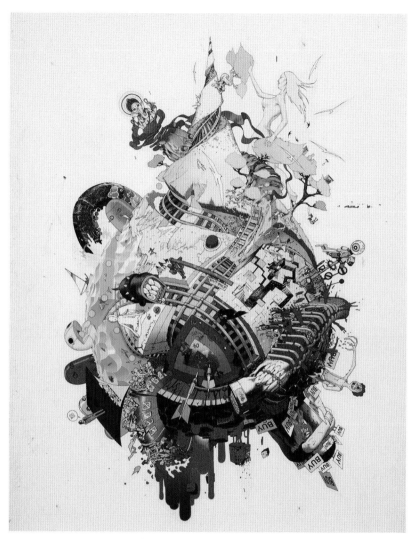

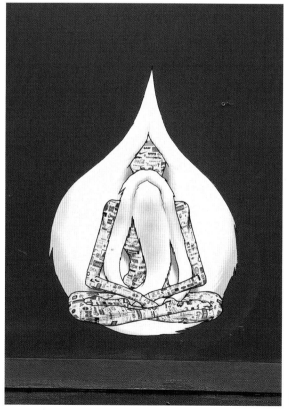

PURE EVIL

www.pureevilclothing.com

Pure Evil is an artist who runs a great street art gallery in East London. Raised as a catholic, he knows all about evil. He was involved in an exhibition in Libya organised by the Victoria and Albert Museum in 2012. This is part of the statement he read out at the opening in Benghazi: "I have always thought that if you can say ANYTHING then why not say SOMETHING, and Libyan graffiti/street art (call it what you will) is born out of this necessity to say SOMETHING, to express their own voice. Libya has reached such an important crossroads and it's great to be there in some way and to share in this moment." He put up a wonderful recreation of a portrait of Charles Darwin in Shoreditch in the year before, made out of little monkeys.

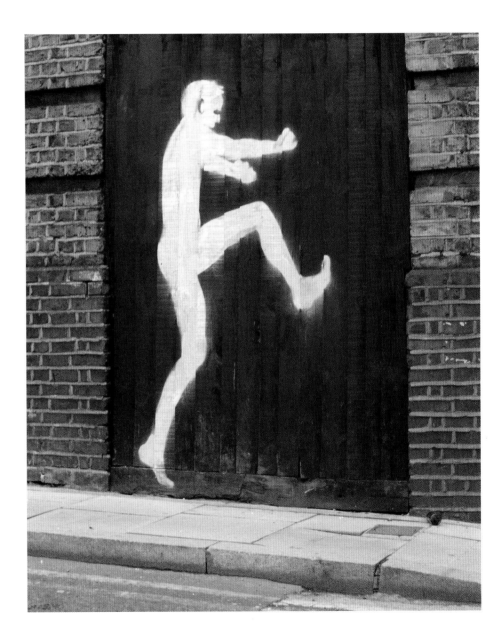

ROA

www.flickr.com/groups/roa

Roa usually begins by outlining his subjects, then fills them in with white and finishes off with black spray paint, creating giant animals – sometimes alive, but more often dead – in varying states of skinning or decay. Some of his work shows the bone structure, the digestive system or the bloodstream of the animal. He once explained in an interview that he was an educated veterinarian, but apparently that was a joke. But he must always have had a fascination with the animal world; watching birds, collecting bones and feathers and fossils as a child, I am sure. And he might very well still do this, although if you google Roa, it looks like he is the busiest man around – he must have an incredible zest for work. Many hundreds of his enormous animals seem to cover walls all around the world. The scale of his work means that he usually paints with permission, which explains the longevity of many of his pieces. His animals are very real, rarely cute, if alive at all, but attentive and on guard. For me, Roa is a true naturalist.

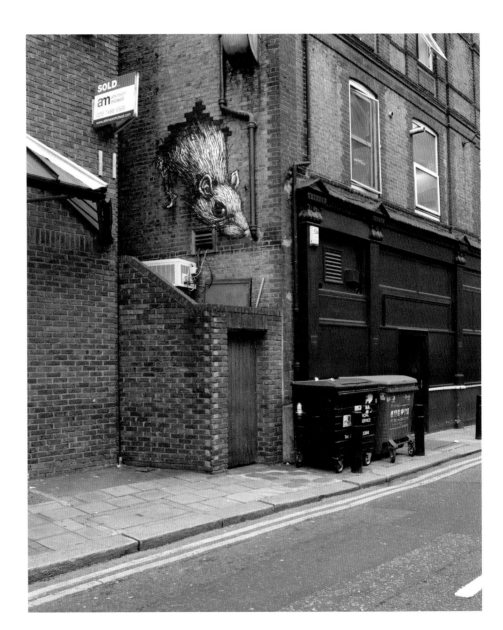

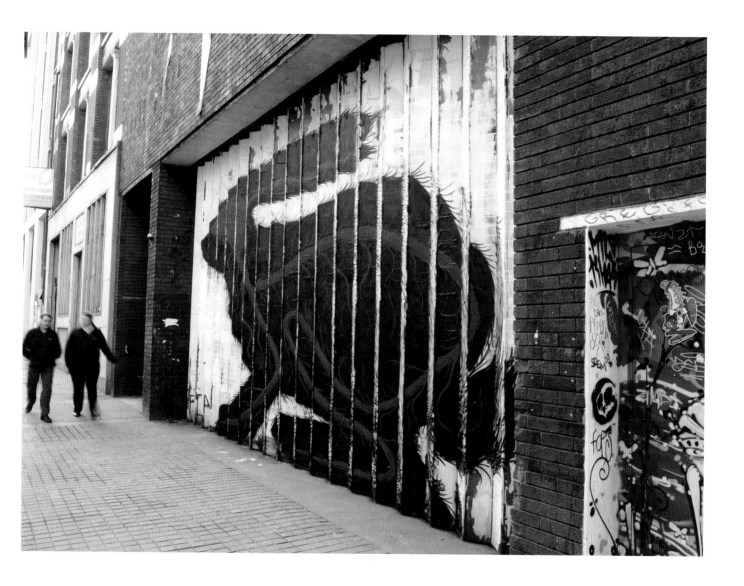

ROA

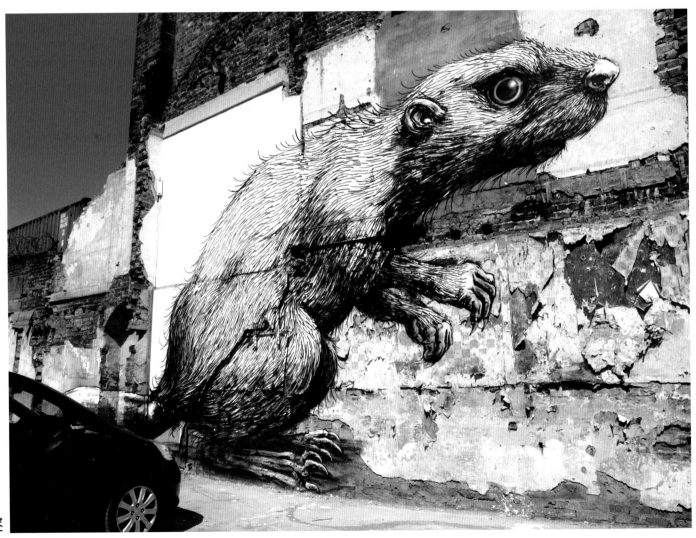

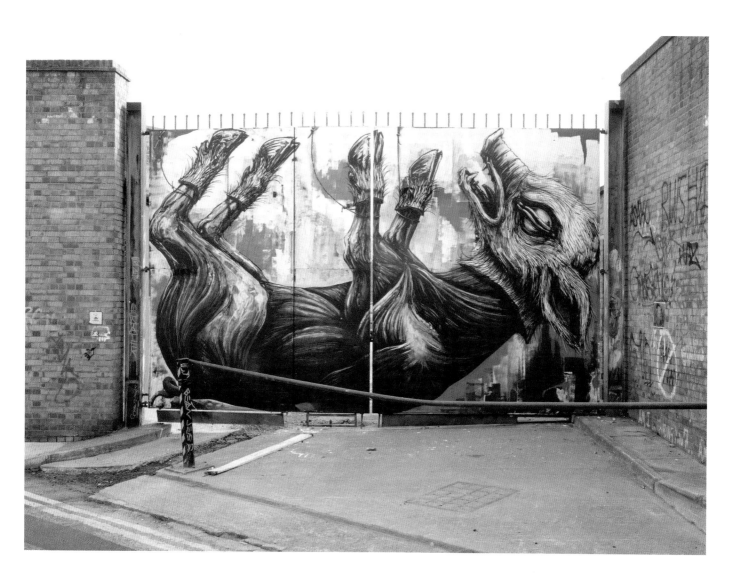

RONZO

www.ronzo.co.uk

Ronzo works as an illustrator in Germany
and London. His most famous piece is
the Credit Crunch Monster that used
to sit on top of Village Underground in
Shoreditch, overlooking the City, literally
crunching a pound coin.

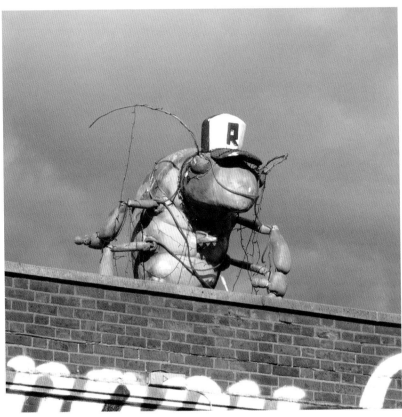

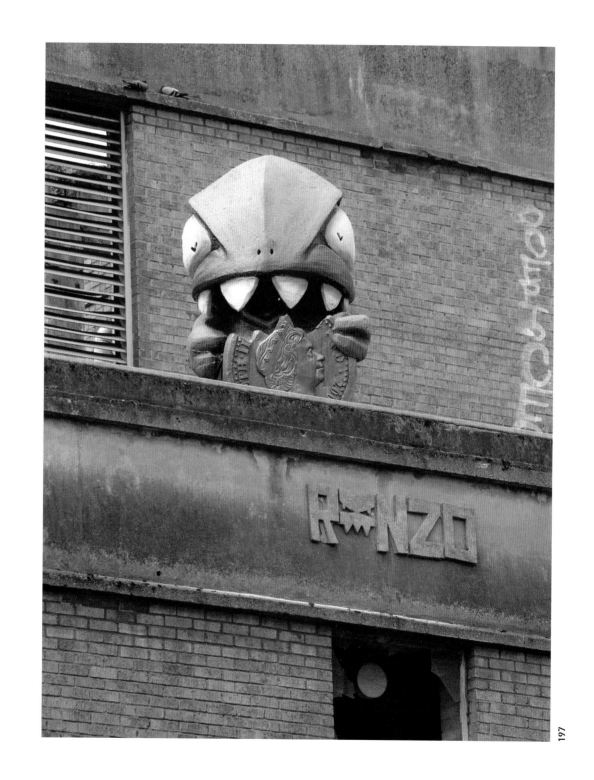

RUN

www.runabc.org

RUN is an Italian living in London. I always thought his name came from 'running', the thing street artists do when the police show up, but that is not the case. He started out as a graffiti writer; in 2003 he painted his first wall and now his pieces can be found in China as well as all over Europe – he paints because he wants to travel. By working on such a large scale he's able to compete with the massive advertisements that dominate the city.

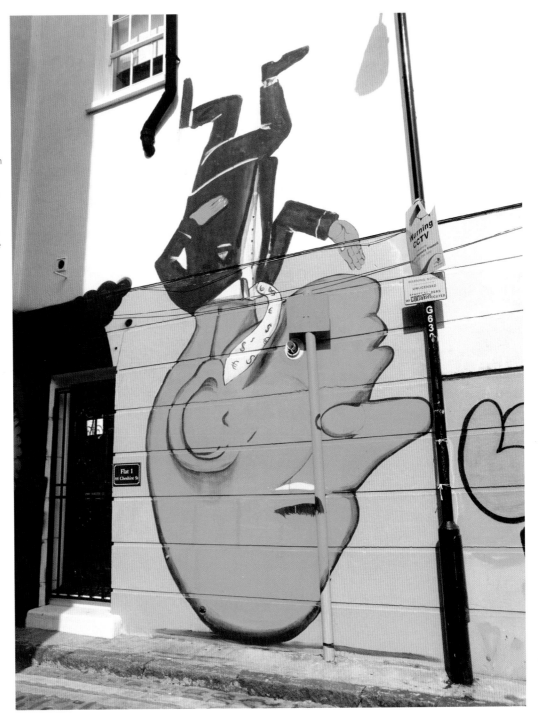

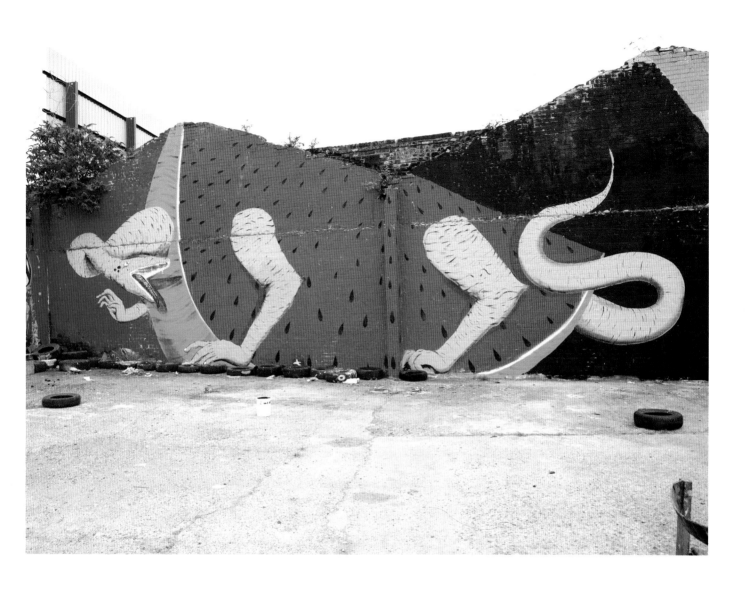

SAKI & B

www.flickr.com/
photos/49302801@N05

When I went to see an exhibition of Saki
& B, also known as Skull, in a studio
on Quaker Street, East London, I was
surprised to find the artist was a woman!
She was happy to meet (so was I); I was
the first one, she said, who realised that
all those different types of pieces she did
were the work of one person.

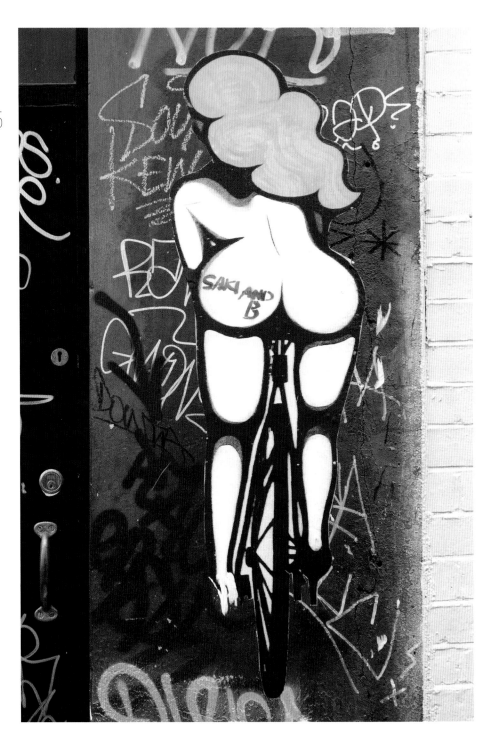

OTTO SCHADE

www.ottoschade.com

Otto Schade is an architect from Chile who has been painting on canvas since 1996 and started doing street art seven years later because no gallery in London would give him a show. That changed after he turned to the street. At first his pieces were more often stolen than sold, but that's no longer the case, and he's had several solo exhibitions in the last few years. His multi-layered ribbon-style work is unique, with pieces that could be categorised as surrealistic but which feature abstract elements too. He clearly has a liking for the free love, illicit substances and rock music culture of the sixties. I first met Otto Schade when he was in the process of creating a work, and he was quite surprised that I knew who he was. The piece took hours to make, so I came back later that day to photograph the finished work. The next morning it had been painted over...

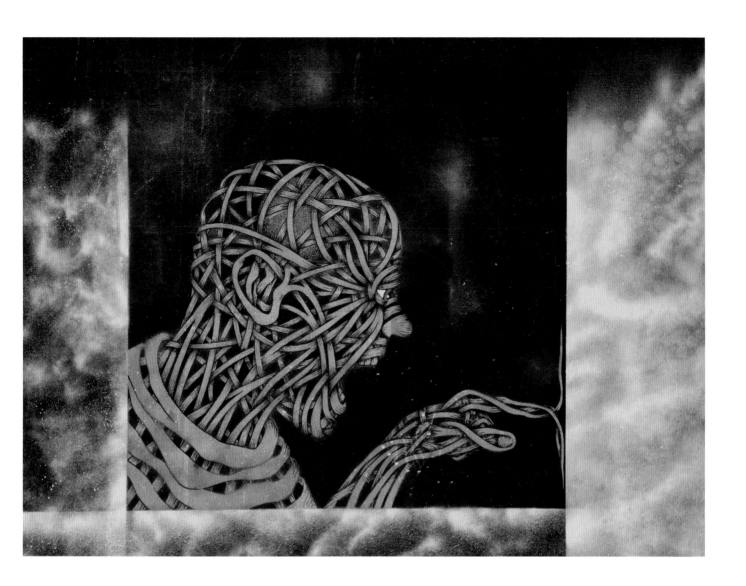

OTTO SCHADE

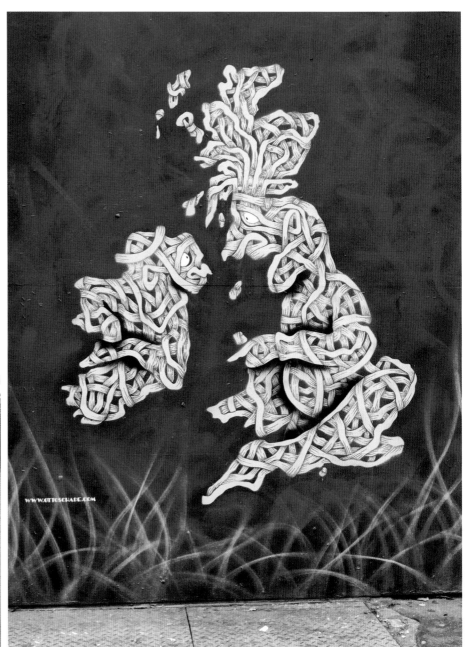

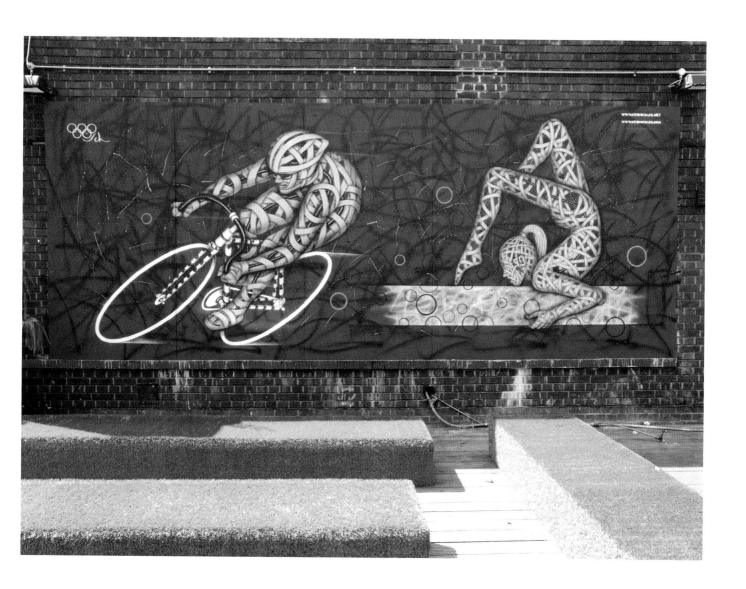

SHUBY

www.facebook.com/
shubyart

The recent royal wedding and jubilee
were the inspiration for some hilarious
royal portraits with bunny heads by this
Ramsgate-born artist. She's a painter,
printmaker and street and gallery artist
who uses a variety of techniques and
materials, often found or reclaimed, like
old photographs.

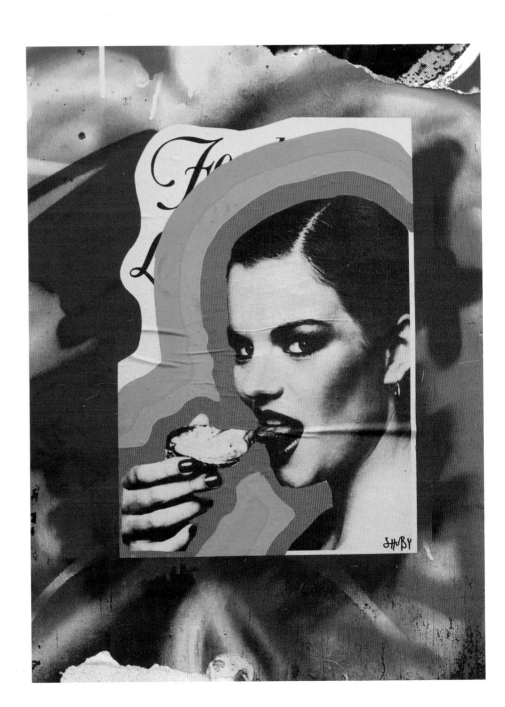

SKULL FACE AKA SKULLY

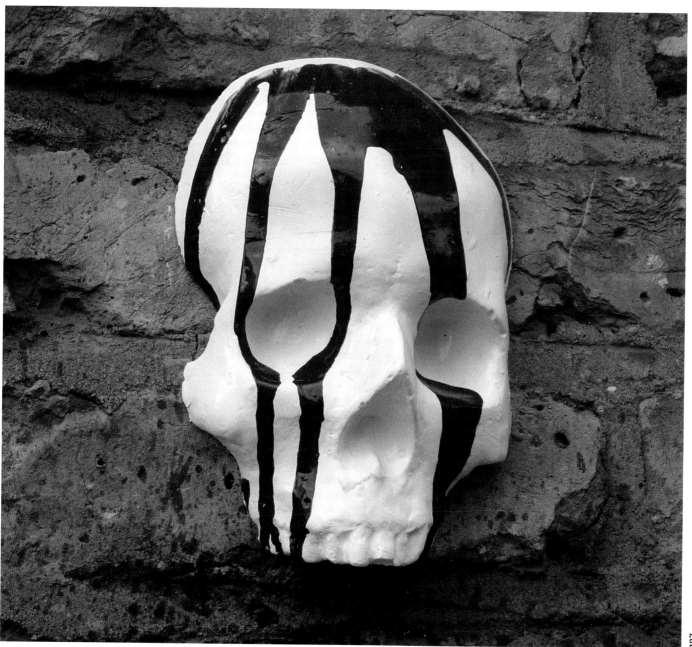

BEN SLOW

www.slowbenart.com

Ben Slow is a Fine Arts graduate from
UCA Canterbury. These three photos were
taken on Hanbury Street in the Bengali
area around Brick Lane. The mother and
child piece was created in 2010, and the
two extremists in 2012. The third piece
took Ben two days to make, but was
painted over a couple of days later.

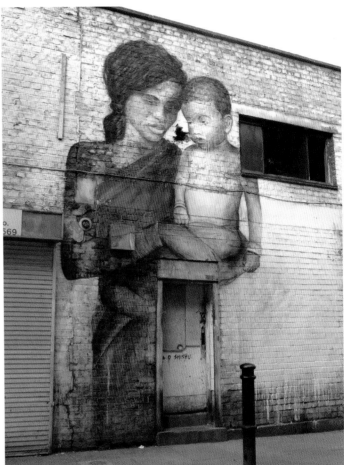

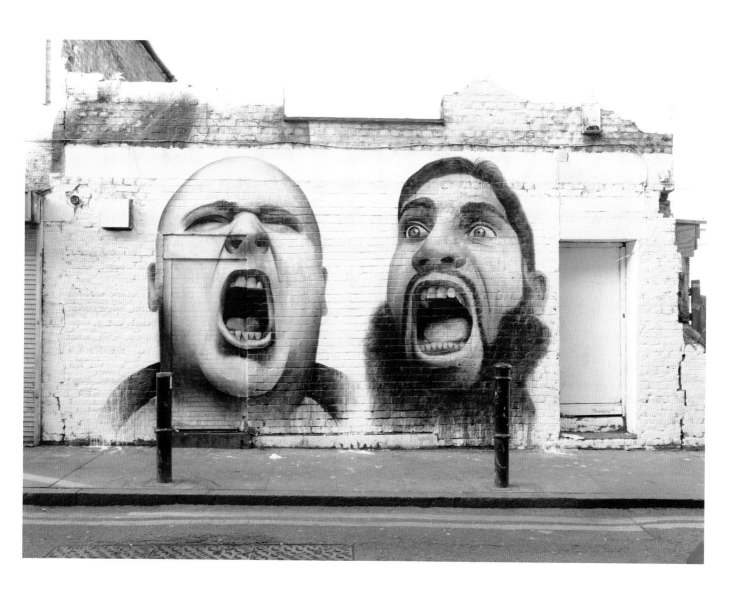

SONOFRECESSION

http://bricklanearts.blogspot.co.uk/2010/07/
interview-with-street-artist-son-of.html

This Italian artist, easily recognised by his wonderful fifties hairdo, draws our attention to the more fragile things in the street, like shadows. He is the first artist I know of to use his own bank statements in his work.

ST8MENT

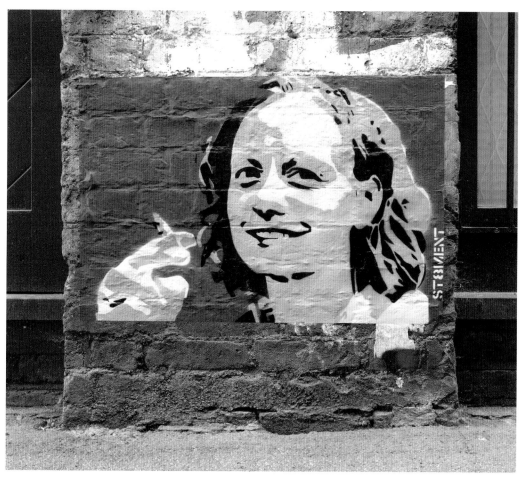

St8ment started as an artist in Bristol, where he turned parts of the harbour into a Bra Exhibition and went around symbolically clamping cars. Today he works in various different countries, using his art to comment on political processes. His main theme at the moment reflects people in their everyday lives. I like his paste-ups – they are intriguing. Somebody wrote on one of them: "Saying what exactly?"

STAGGER

Like many of his colleagues Stagger mentions skateboard graphics as a big influence. I found his paste-ups mostly on garbage containers. I think he might have been a punker in the old days.

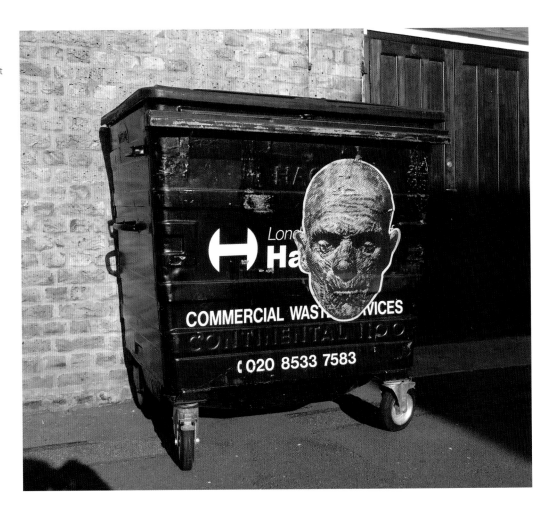

STEWY

www.stewy.eu

Stewy brings British wildlife into town with his life-size stencils. In 2012 he surprised everyone, changing tack with a picture of Tracey Emin; it didn't last long though. He is one of the artists I met working on the street; when he was done he stepped back and had a look at his new piece. Recognizing his style, I said "Hi Stewy." That's always a big surprise for the artist!

STIK

www.stik.org.uk

After having settled down in Shoreditch, we began checking out the neighbourhood. One afternoon we discovered a nice little gallery on Bethnal Green Road, under a coffee shop plastered with street art: Benny's Bar and the Austin Gallery. Downstairs there was a wonderful show of paintings of 'stickmen'. A month later I went back to see the next show, and after I came upstairs again a nice guy started chatting with me, asking if I enjoyed the exhibition downstairs. I told him it was ok, but the show there last month, that was something else, that was fantastic stuff, that was an amazing show – I really loved those paintings. Hearing that, his face and all the rest of him became one very big smile. "Wow man, great hearing that – that was me! Wow, hi, I'm Stik! That was my show!" I soon found out that we both love the work of Dutch artist Dick Bruna, known mostly for his Miffy character.

That was in 2008. Stik had been homeless for years and was living in a squat at the time. However, he eventually got himself an apartment and a studio. More exhibitions followed, his star quickly rose, and he is now one of London's most celebrated street artists, able to sell his paintings and prints for a lot of money. Even so, he still often works for charities, especially those that cater for the homeless. For some people his work is a little too subtle, but for me he is the grandmaster of body language.

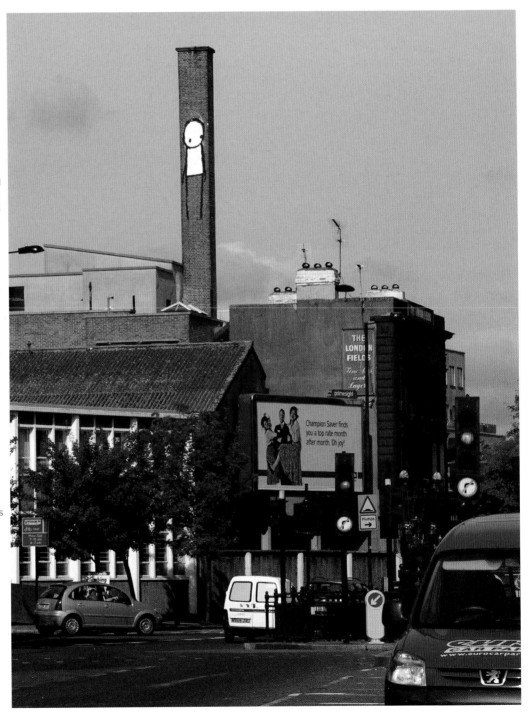

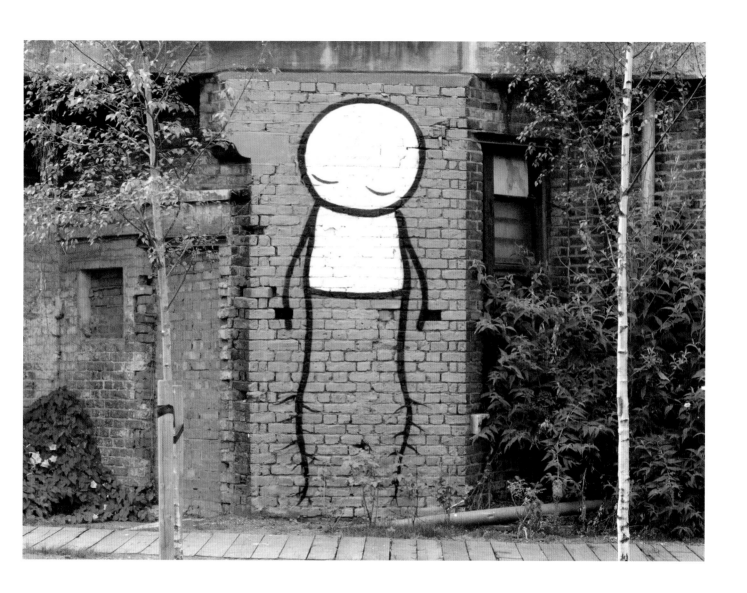

STIK

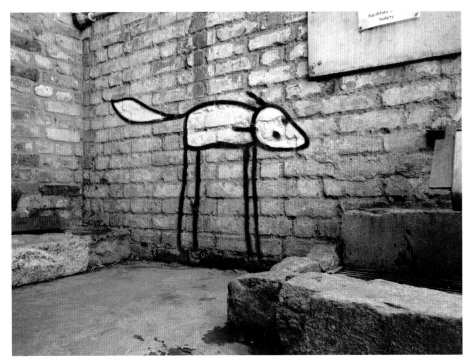

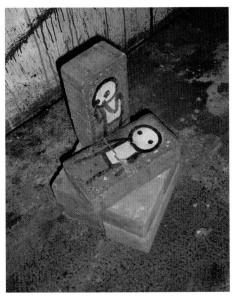

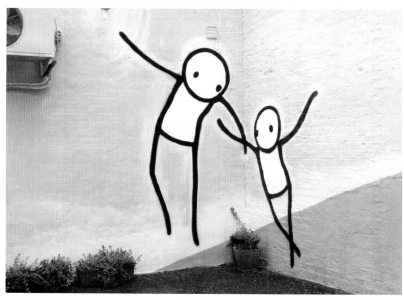

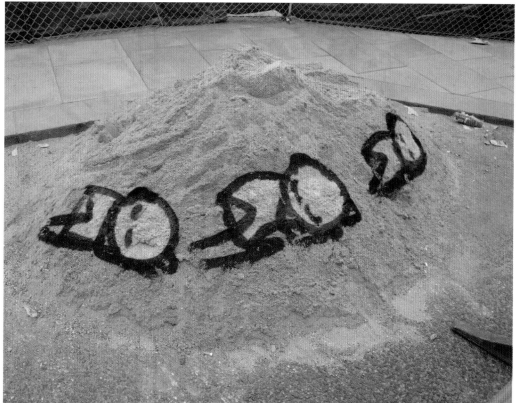

STIK

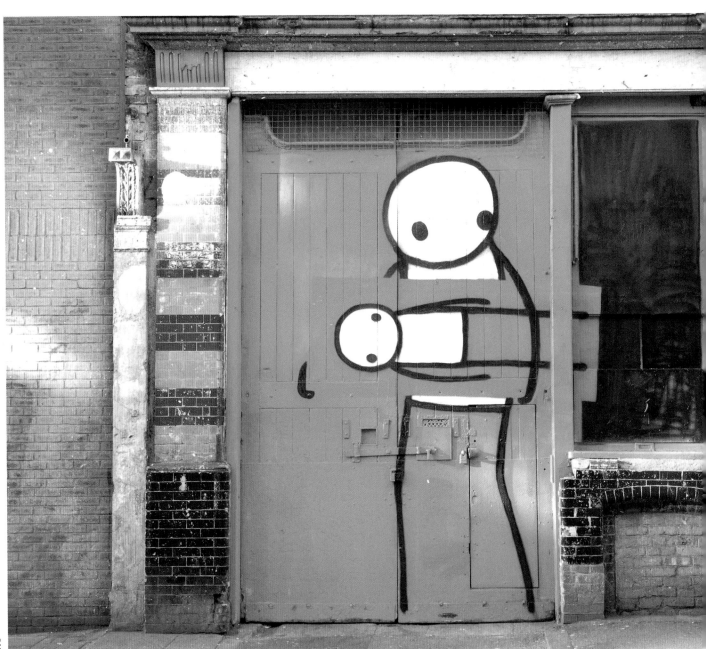

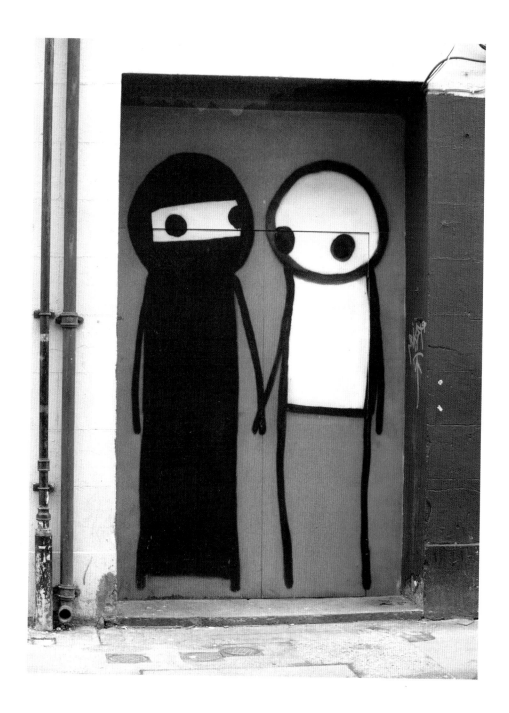

STINKFISH

www.flickr.com/photos/stinkfishate

Stinkfish, a member of the international and colourful APC graffiti crew, is from Bogotá, Colombia. He was in London in 2011 for the launch of Maximiliano Ruiz's book, *Nuevo Mondo, Latin American Street Art*. He says: "Graffiti is not art, for me art is commercial, a thing that belongs in galleries, but graffiti is about freedom."

SURIANII

Surianii, a Brazilian-French artist with degrees from Sao Paulo University and who lives in Paris, is known for his animals and human/animal hybrids. He has also created some nice interpretations of classic paintings, such as Gabrielle d' Estrées and One of Her Sisters from the Fontainebleau School.

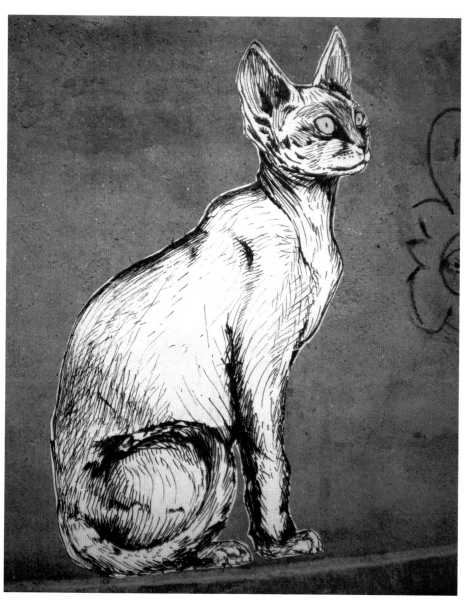

SWEET TOOF

http://sweettoof.com

Sweet Toof is one of the founding members of the Burning Candy Crew. They create a lot of pieces together and might even use each other's styles and characters. He is much influenced by the vanitas paintings of the 16th century and images from the Mexican Day of the Dead celebrations. His studio work can be quite different from his street art; take a look at his bank robbery paintings.

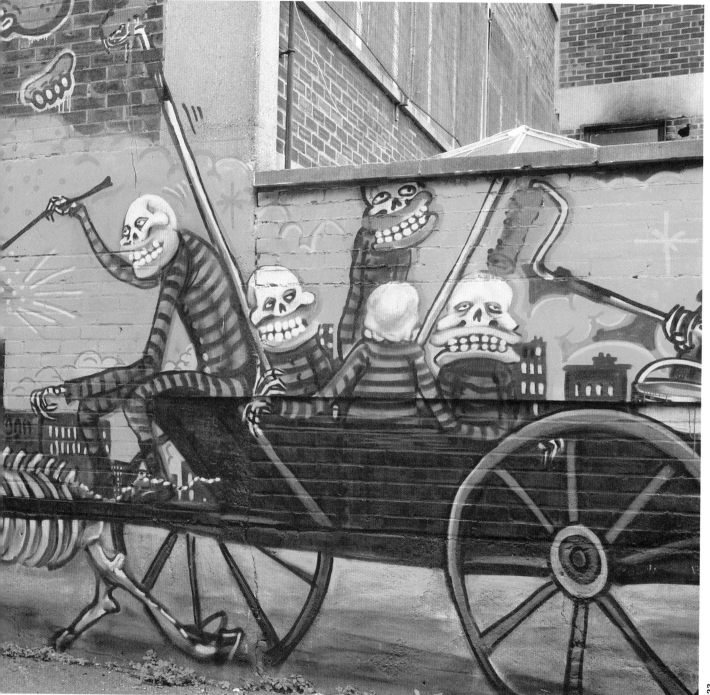

SWOON

www.flickr.com/groups/swoon

Born Caledonia Dance Curry in Florida, USA, Swoon creates the most wonderful, life-sized paper and wheat paste print cut-outs of figures based upon people in her life. She tries to use as much recycled material as possible, including recycled newspaper. Similarly, for one of her other passions, building fleets of boats or rafts, she uses found materials and trash. In 2009 Swoon and her fellow builders and sailors paid a surprise visit to the Venice Biennale on two boats, each about 6x6x6 meters, that they had put together in Slovenia. One boat was built with garbage from New York, shipped over in containers, and the other with rubbish collected in Slovenia. She explains: "You start to build something like these boats, and you can't believe it yourself, but enthusiasm has a way of sparking other people. What this project has shown me is that there is no place for pessimistic disbelief in the world; it's just not useful. Once you've decided to be on the side of audacious wonder, beauty and joy, you can't go back." Her work is in the collections of the Tate, MoMA and Brooklyn Museum.

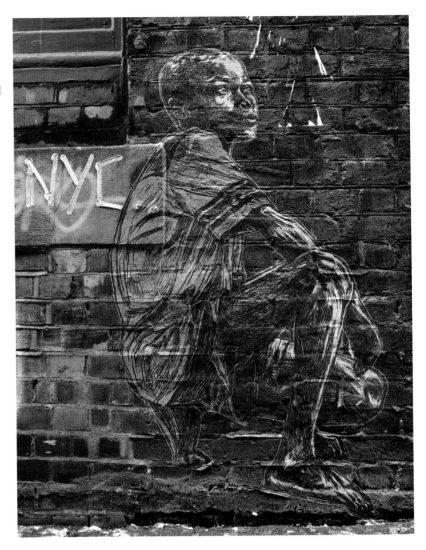

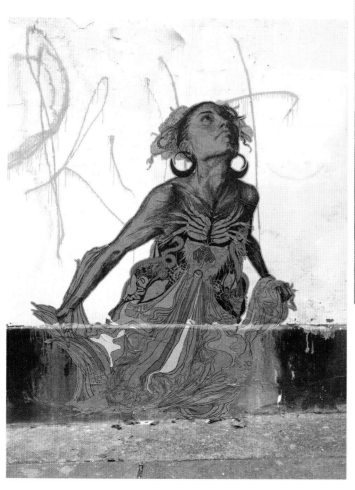

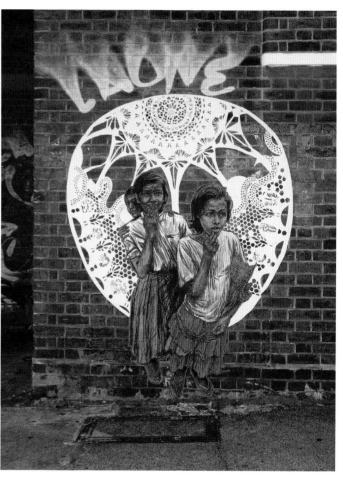

T.WAT

www.flickr.com/photos/the_twat

T.wat's most famous piece is his portrait of the Kray Brothers, notorious gangsters from the fifties and sixties, whose funerals he covered as a journalist. Here is a version from Hackney Road that stayed in great condition for a very long time, except that a small handbag was added, to the left. I think T.wat has always had a liking for the somewhat less legal side of society; he used to be a hardcore acid house man before turning to street art. There is always a humorous touch to his critical and anti-authoritarian pieces.

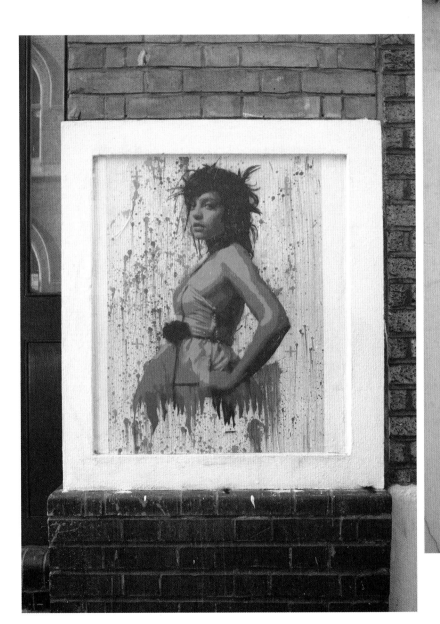

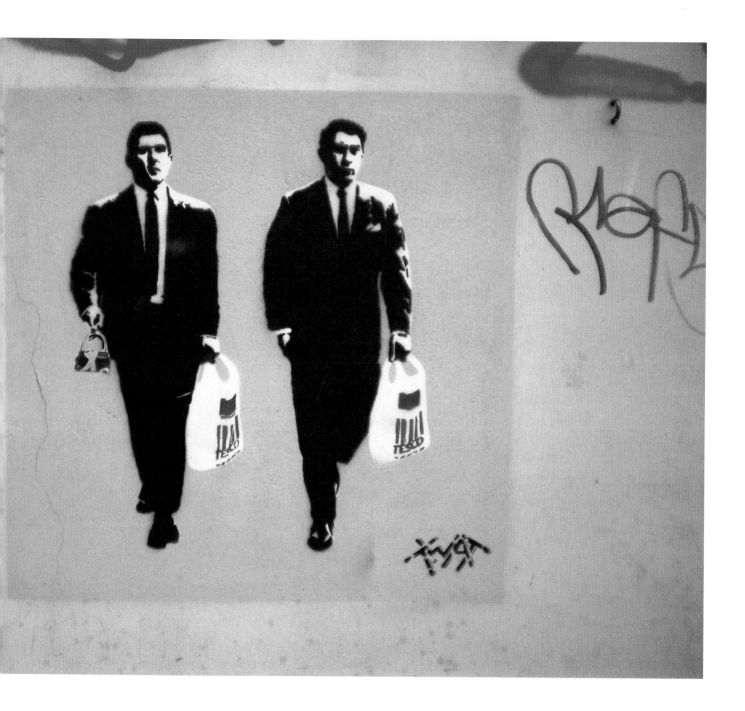

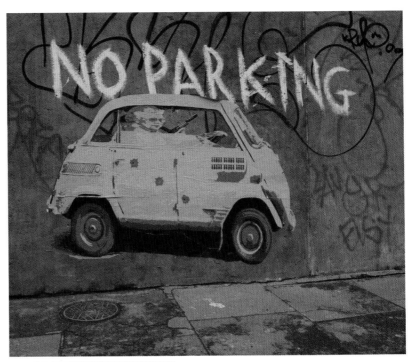

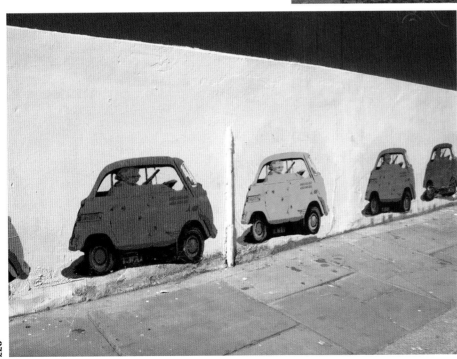

TITI FREAK

www.tfreak.com

Titi Freak had a job drawing figures for
comic books before he started inventing
his own characters and took to painting
in the streets and showing in galleries.

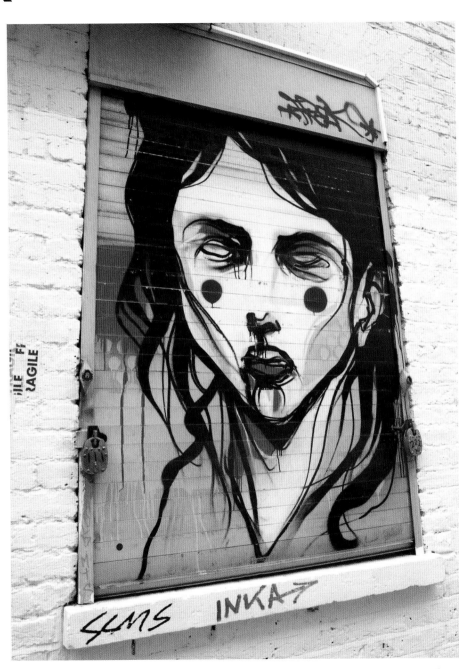

THE TOASTERS

www.thetoaster.co.uk

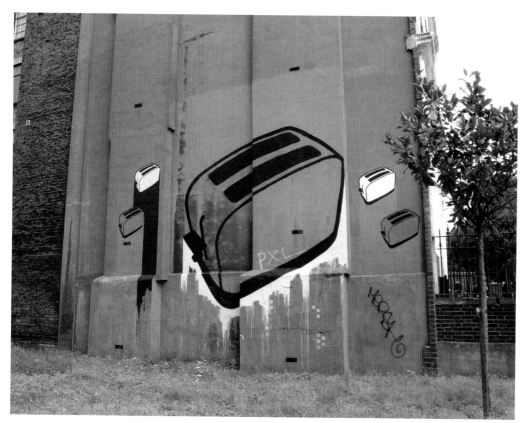

Not everybody will immediately recognise the outline of an old fashioned toaster in some of their work, but for the trained street art spotter, this is clearly a work by The Toasters, three guys from Wolverhampton who have been spreading their toaster image all over the world since 1998.

UNOME

Unome came to see me once to talk about street art. When he pulled his laptop out of his bag I couldn't believe what I saw. I said 'wow you've got that sticker, that's my all time favorite sticker, that is so funny, where did you get it' ? With a big smile Unome told me he was the maker, the next time we met he gave me one!

VHILS

www.alexandrefarto.com

Alexandre Farto, as Vhils is also known, was born and raised in south Lisbon, Portugal, surrounded by the political posters of the left-wing parties in the period after the revolution of 1974, and later by the commercial posters of the nineties, when consumerism hit the country. This world of contrasting images was a big influence on his work. He uses a range of techniques, such as the carving seen in this picture.

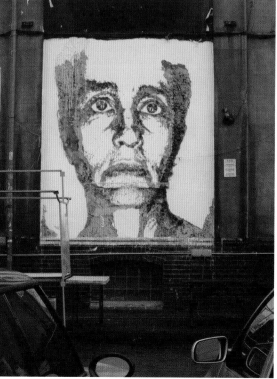

WALALA

www.camillewalala.com

Camille Walala is an optimist whose
street art reflects her love of bold
colour. She has been inspired by a mix
of pop art, African art, and the Memphis
group, among others. Based in London,
she also designs textiles, fashion and
jewellery and other products and has
her own brand. In addition, she has done
collaborations with furniture designers
Atum Design and provided the concept,
design and styling for numerous
exhibition spaces in Europe and the UK.

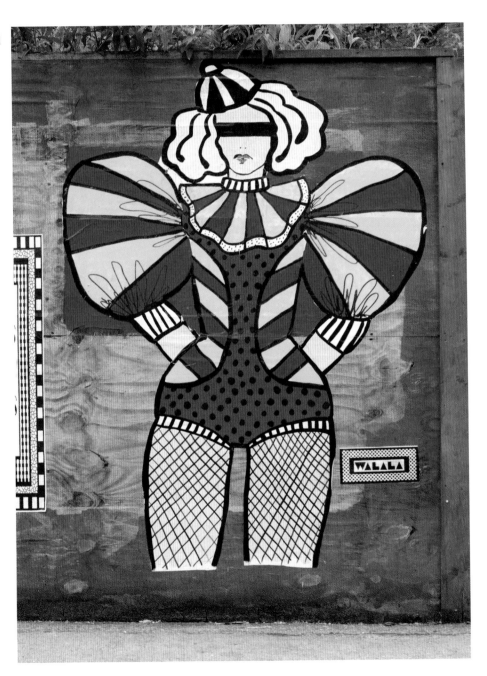

DAVID WALKER

www.artofdavidwalker.com

Nobody on the streets of London paints lips like David Walker. He creates the most beautiful, vibrantly colourful women's faces, all done in spray paint. Strangely, it took until 2012 for him to have his first major solo show.

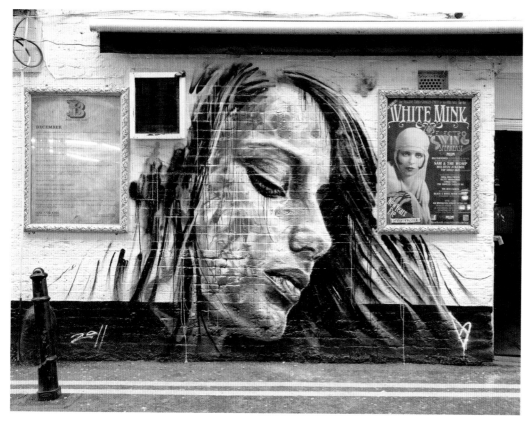

BEN WILSON

http://en.wikipedia.org/wiki/Ben_Wilson_(artist)

'The chewing gum artist' uses spat-out pieces of gum as his canvas. Once, he told me, he came across a book in the Tate bookshop that featured two pages of photos of his work. He took out a marker and started decorating the book with some drawings. A shop assistant rushed over and told him to stop, but he explained, "Somebody used my work without my permission, now I use his work without his permission". Cleverly, she didn't call security, but alerted her boss, who, seeing what Wilson was doing, gave the artist permission to continue. I'm sure the boss knew very well what to do with that volume after the chewing gum man had left.

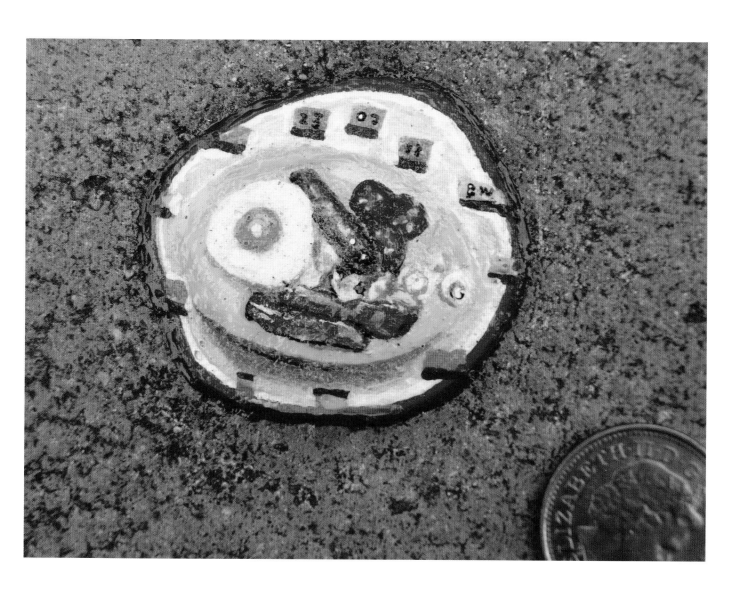

XENZ

www.xenz.org

The 'Monet of Graffiti' is from Hull, moved to Edinburgh to study arts, and then went to Bristol to participate in an event called Walls on Fire and stayed for nine years. Today he lives in London. Being a birder, I naturally like his work!

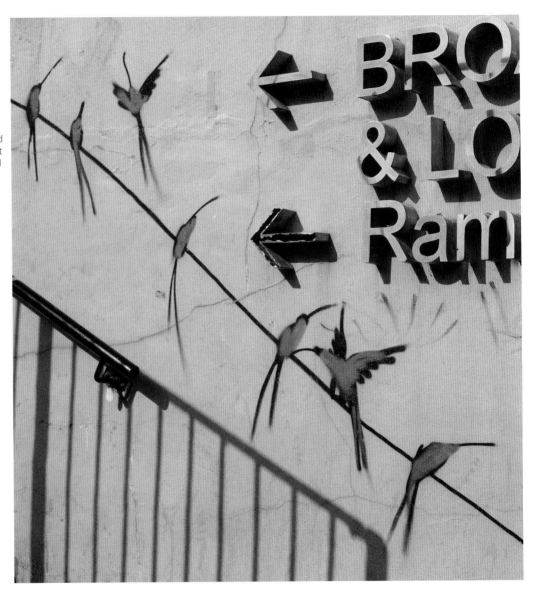

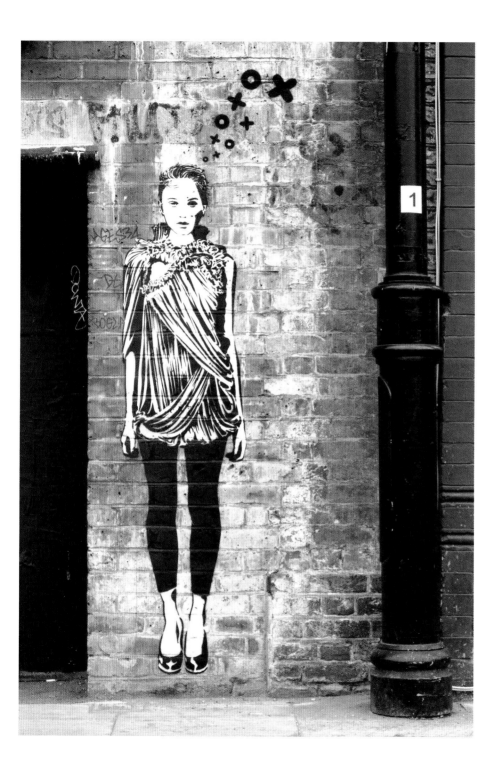

XOOOOX

WWW.XOOOOX.COM

XOOOOX stencils beautiful women in beautiful clothes on the walls of decaying old buildings. His work is about the shallowness of the fashion world; the women will eventually crumble away with the walls, as they have become a part of them. He is a very versatile artist, and his gallery work can be quite different from his street art. A monograph of his work was published in 2012.

XYLO

Xylo's Panamanian Golden Frogs should remind us of the fact that this animal, like so many others, is threatened with extinction. His work is always topical, dealing with issues like exploitation, privacy, teenage violence and consumerism. In 2010 he mounted fake iPhones on London walls to raise awareness of the maltreatment and suicide of workers in the Chinese factories that produce the smartphones. He sent me a very nice email not so long after I started my website: "Nice pictures man. Am enjoying seeing your shots lately, you get the real underground stuff that most people don't notice." It was a big stimulus for me to continue.

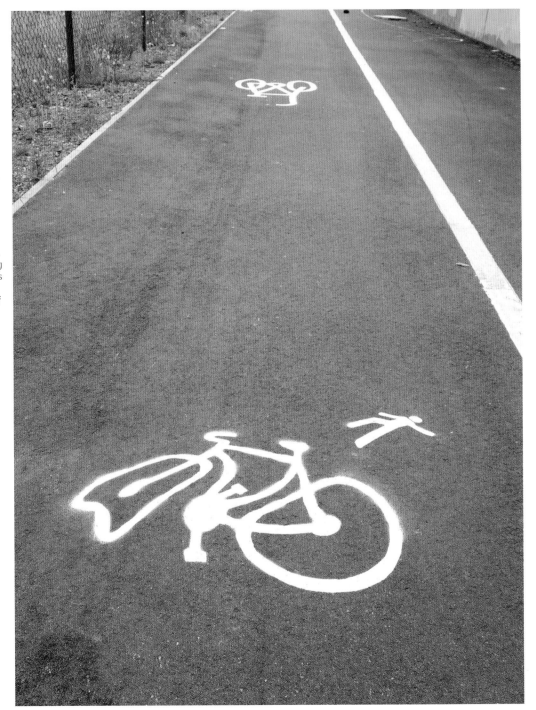

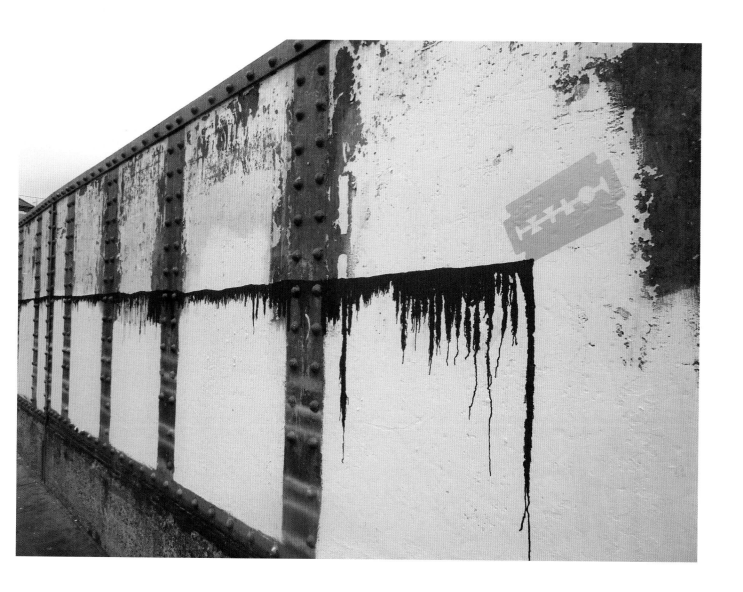

XYLO

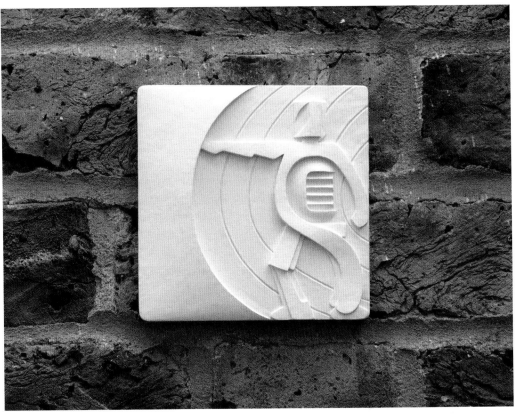

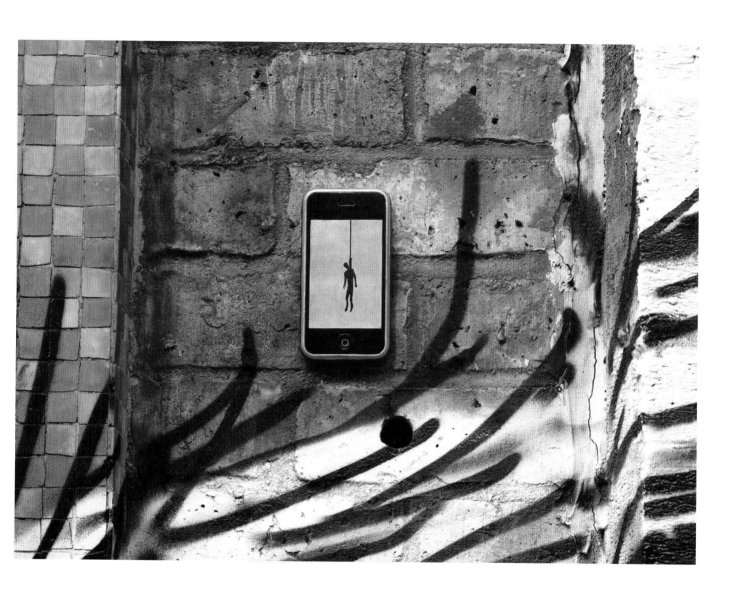

YT

BLAIR ZAYE

www.blairzaye.com

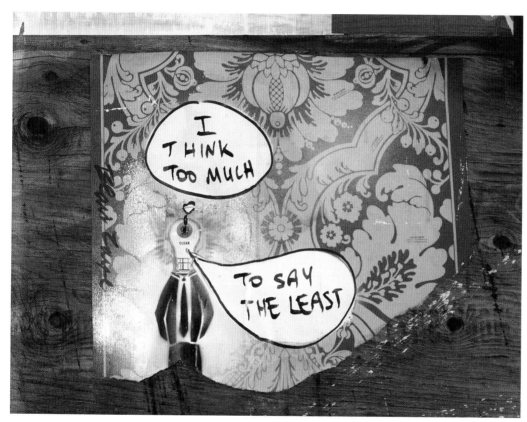

New Zealander Blair Zaye has been living in London since 2008. "As an artist I endure to express the internal, either in myself or in the murmured mutterings and general feeling of faceless individuals which make up the populous," he says of his work. "I express ideas and beliefs of implicit society and culture. Creating and uncovering utopian ideas, ideologies for a better self and society and social commentary which bares all."

ZOMBEENIE

As I pressed the shutter button to take this photo, a busy, talking lady moved in between me and the wall. She heard the shutter, turned around, stopped and apologised: "I am sorry love, so sorry, hadn't seen you at all! I do apologise! Have a nice day anyway darling. Byeeeee!" I was perplexed; I knew that face and that voice...the great and ever so charming Joanna Lumley!

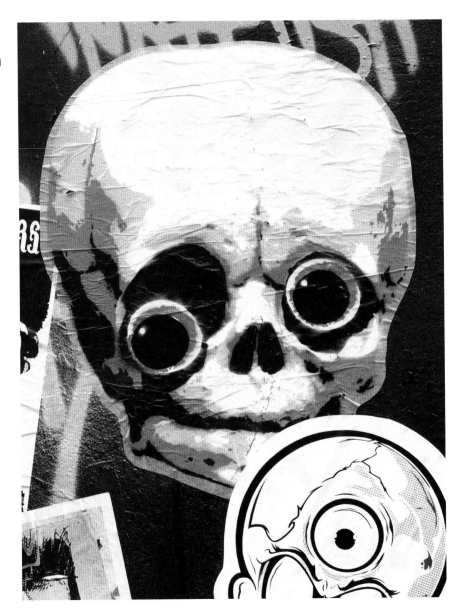

THE UNKNOWN ARTISTS

The moment I spot a new piece of street art, I ask myself 'Who's the artist, do I know this artist's name?' Sometimes you can identify the maker's name right away, the piece might be signed, or with a little research you can find out. If this doesn't work, I'll put the picture on my website as "Artist?" and often somebody is able to help me out and name the maker. But many pieces are still anonymous. Here is a selection of those pieces. Many of them will be by people, new to the street art scene, whose work only a few people will recognize, but in due course they might become a known name. Others might have put up work once or twice and decided it wasn't their way of working. Some will like the mystery of being anonymous and still others probably don't really care whether they are known or not. While I have focused on the pieces I have been able to credit, I couldn't neglect at least some of the best anonymous ones. If you can identify any of these pieces, please send me an email with the name of the maker and hopefully we can include it in the future. You are also kindly invited to check the set "artist unknown" on my website; there are hundreds more works there waiting to be credited.

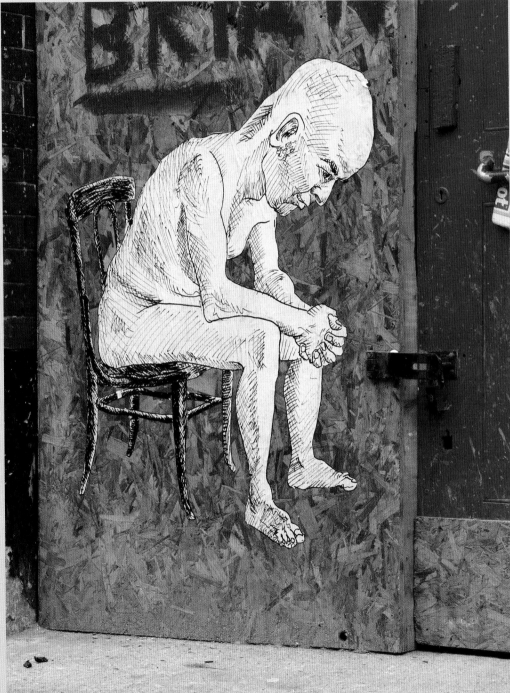

A paste-up of a lonely man by a great artist.

The ugliest roundabout in London
does need some decoration!

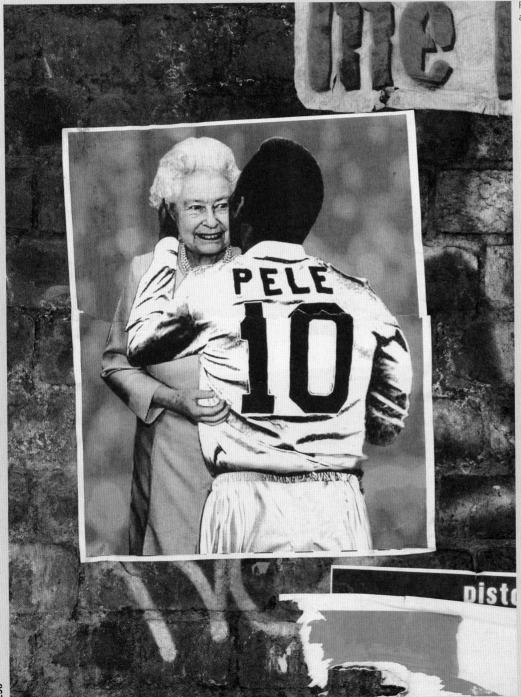

From a hilarious series of photo collages, all featuring the British queen.

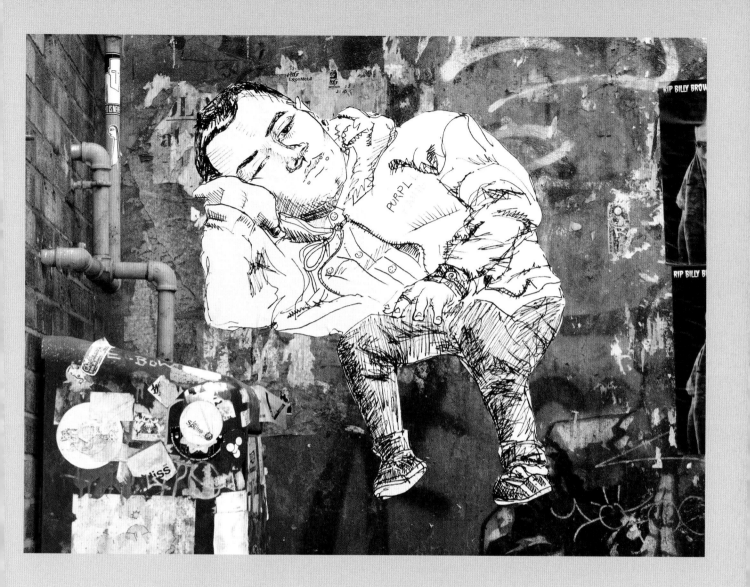

One of the most visited photos
on my website.

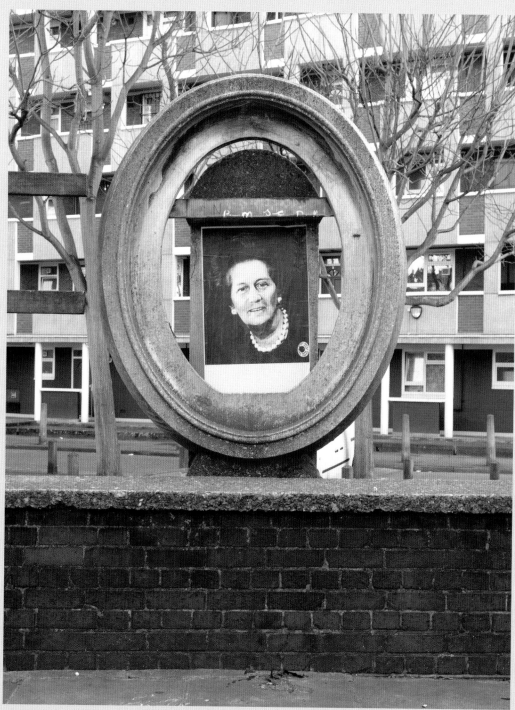

Strangely this is the only piece of street
art I've ever seen at this great location.

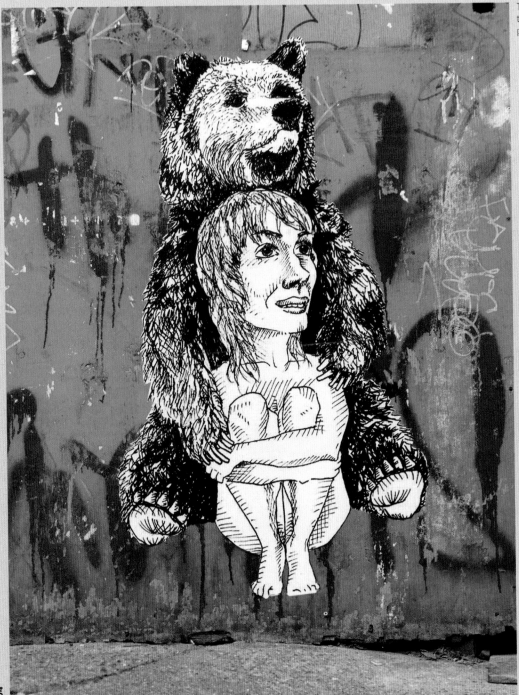

These pieces appeared at the same time as the 'lonely man' and are probably by the same artist.

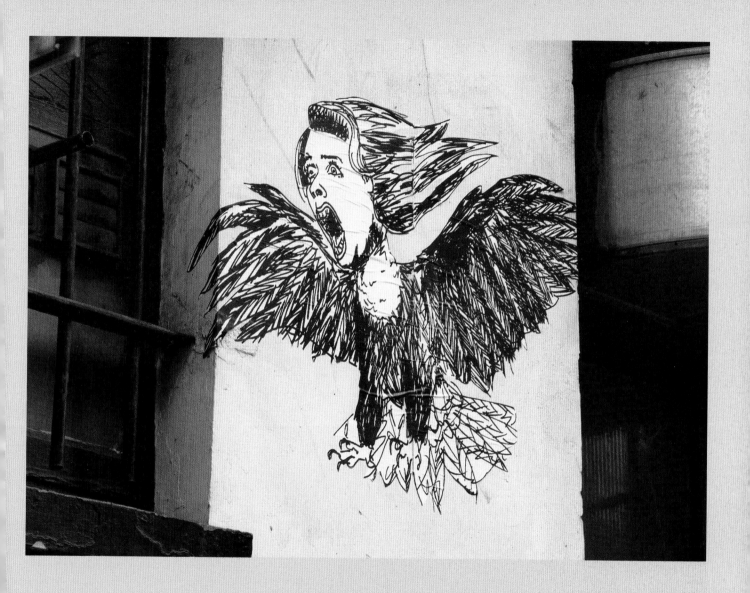

One of several bags left behind around Brick Lane.

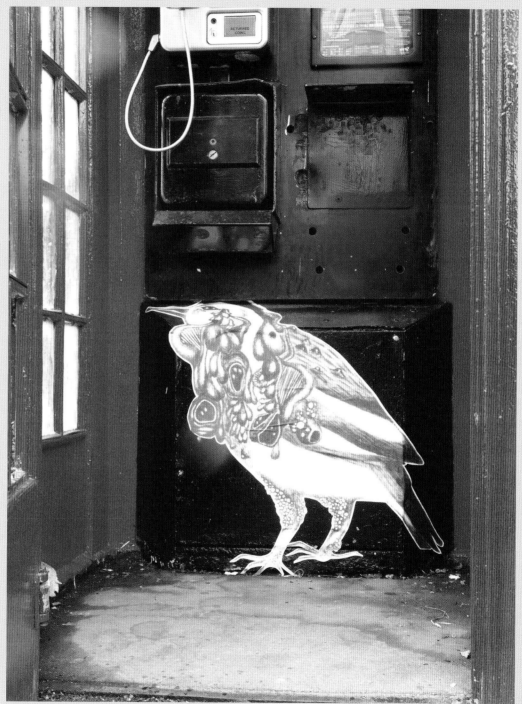

I love it when people think of putting their work on a wall like this!

A nice simple piece in plasticine, put up before the start of the Olympic Games in London.

I have found a couple of similar images by this artist in Hackney Wick, London.

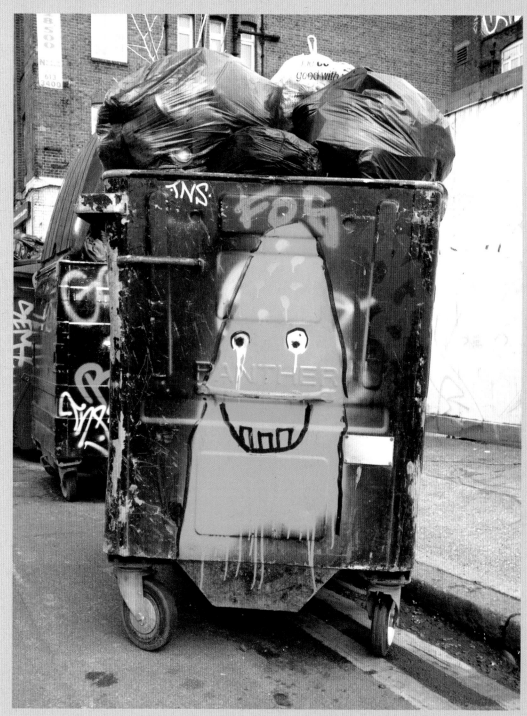

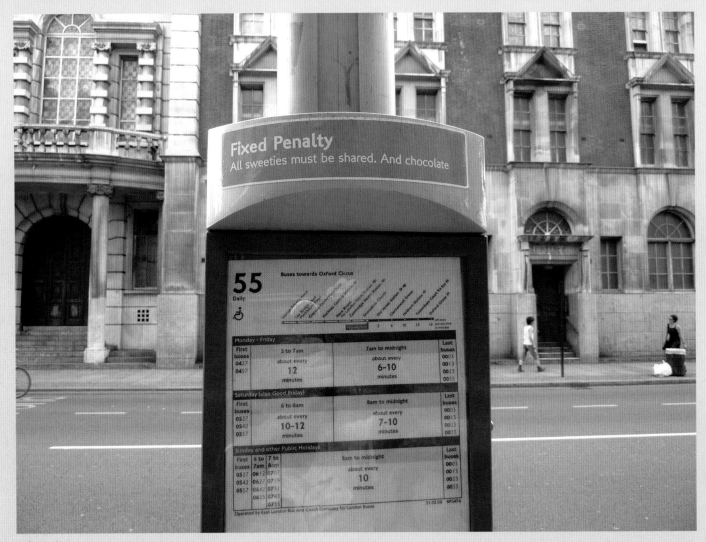

A clever piece.

This mask was covered by Eine.

This is actually two pieces, I call the
artists 'Hurray' and 'The Dripper'

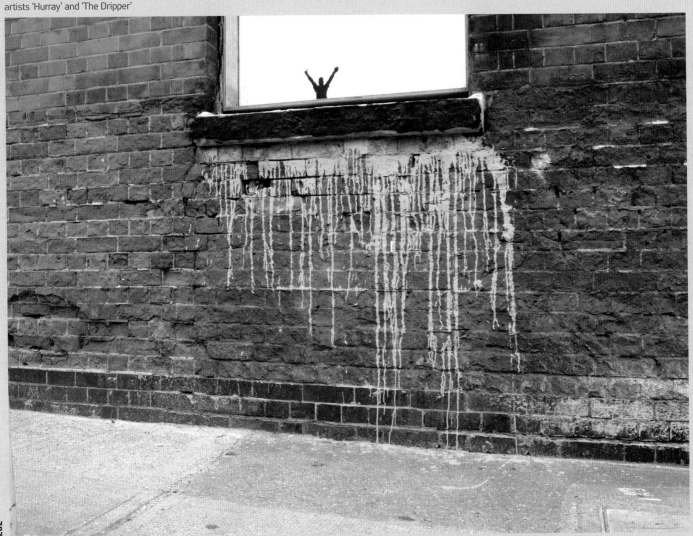

Have a careful look at this one,
it's not what it seems!

Every year a piece featuring black tape pops up in Shoreditch, London.

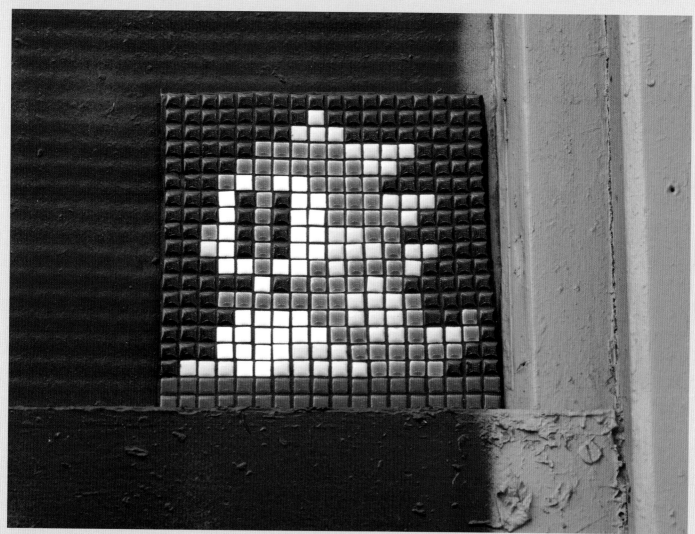

Small and simple, a very strong piece,
beautifully placed.

I love this one, if only for its originality.

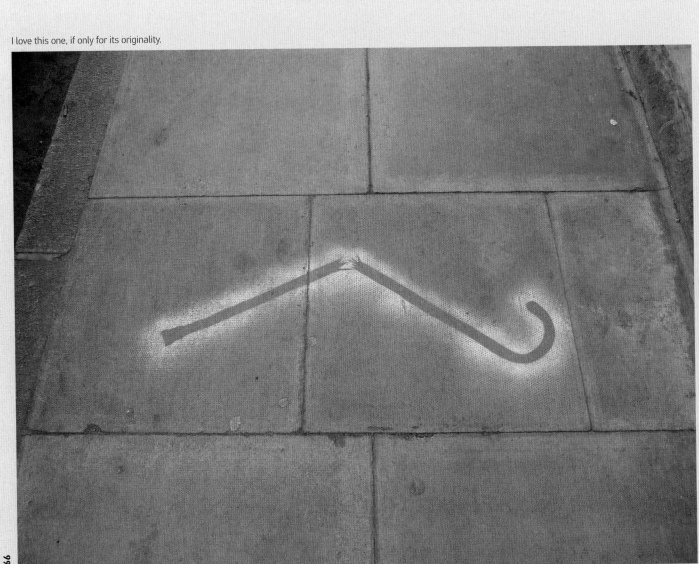

I like the use of existing elements in the street, this one is a burglar alarm.

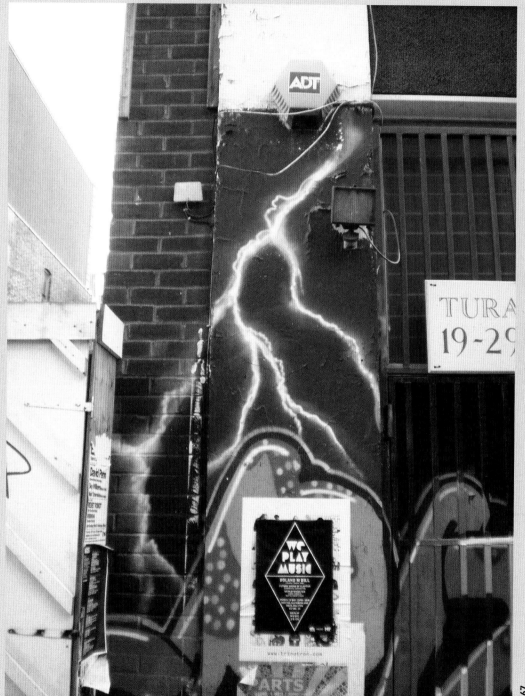

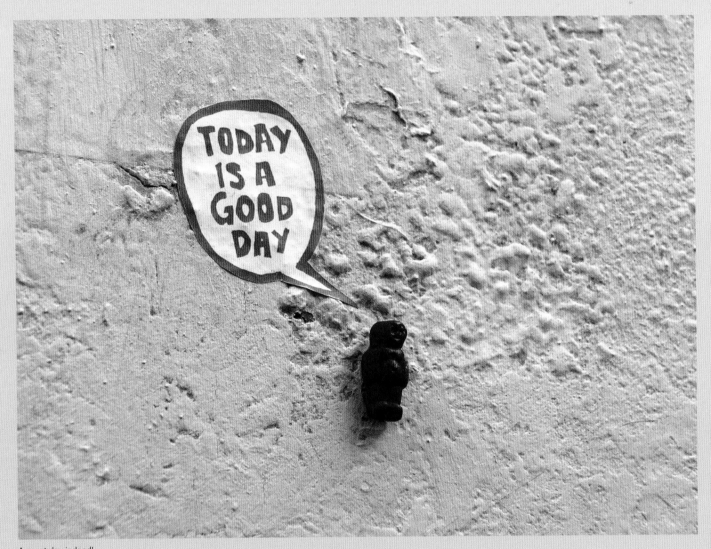

A great day indeed!

The only piece I have ever found by this artist. I love it for its originality. I have never seen anything like it before.

Rumour has it that this is by Mobster.

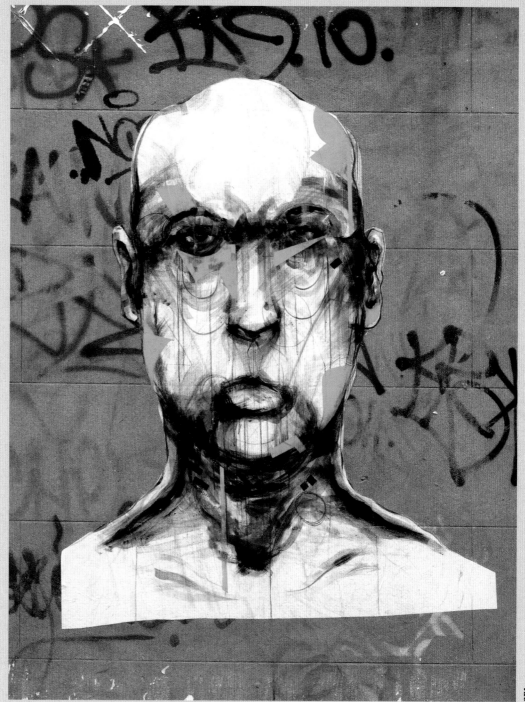

ACKNOWLEDGEMENTS

I would like to thank the following people:

First and foremost, thank you to all the artists represented in this book, and the many hundreds of you that I didn't have room to include. I am having so much fun finding and photographing your wonderful pieces!

I am also grateful to everybody who helped me in different stages in my career and of this book, especially Wim van Sinderen, Paul Dekker, Robert Schlingemann, Peter Giele, Dirk Vermeulen, Henk Tas, Stik, Jane Andersen and Lee Bofkin, and In memoriam my parents.

Most of all, I want to thank my wife Alice Gee who made it all possible.

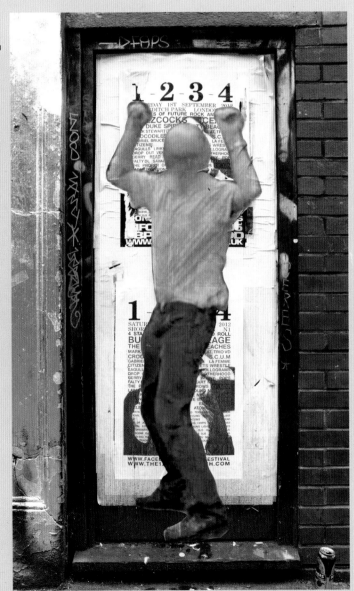

Artist unknown
Paste-ups like this appeared in September 2012, with the words: Google 2012